the genius of
WILLIAM HOGARTH

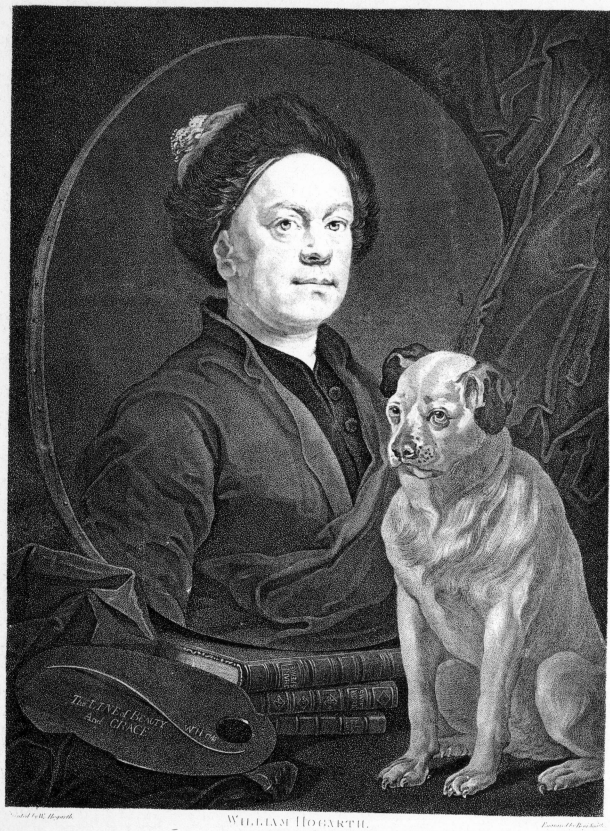

Painted by W. Hogarth.

WILLIAM HOGARTH.

Engraved by Benj. Smith.

From the Original Picture in the Collection of John Ireland, Esqr., &c.

Published June 4 1795 by J. & J. Boydell, No. 90 Cheapside, & at the Shakespeare Gallery Pall Mall.

the genius of
WILLIAM HOGARTH

Published by Lyle Publications Glenmayne Galashiels Selkirkshire

First Published April 1972 in Hardback.

Text by STUART BARTON
Edited by R. A. CURTIS

Acknowledgements
Michael Gorton Design
Annette Hogg
Mary Hayman
Richard Munday

Paperback Edition June 1975

Printed in Great Britain by Apollo Press, Unit 5, Dominion Way, Worthing, Sussex.

PREFACE

William Hogarth — painter, engraver and above all, satirist.

Although Hogarth was born toward the end of the seventeenth century, his work, particularly his engravings, are as alive and as meaningful today as ever they were.

Using his tools sarcasm, sincerity and brutal truth, Hogarth ripped through the fashionably elegant veneer overlaying society and the Establishment, exposing the corruption, vice, degradation and social injustice which was threatening to destroy the very fabric of the British nation, more thoroughly than any foreign conqueror could ever hope to achieve by force of arms.

Strictly an individualist in his approach to his work, Hogarth had no time for the posturings and pomposities of his fashionable contemporaries, making a great many enemies with his penetrating vision and the unwavering accuracy of his comment. But his integrity and wit earned him a multitude of admirers — among them, Horace Walpole who was prompted to comment that Hogarth . . . 'observes the true end of comedy—namely, reformation.'

In this lies the key to the power of Hogarth's work and the endurance of his justly earned reputation; by exposing the follies, meannesses and outright brutality of eighteenth century society in so accurate and pointed a manner, he paved the way not only for many of the social reforms which were to follow, but also for the re-establishment of the great stature of English painting. For Hogarth's genius was not simply that of an illustrator, it was that of a commentator. His pictures do not simply delight the eye, they provoke the mind. In the words of the great English essayist, Charles Lamb 'Other prints, we look at. His prints were read.'

STUART BARTON

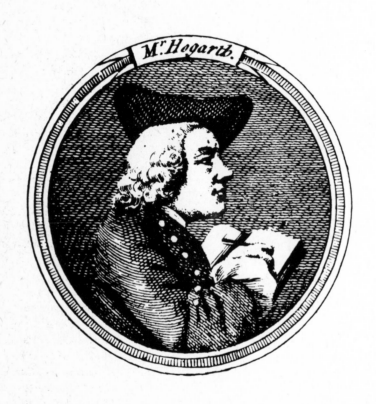

CONTENTS

WILLIAM HOGARTH

A Biographical Sketch

Seventeenth century England was a world of stark contrasts. The massive social, economic and ecological upheavals of the Industrial Revolution were still in the future and it is difficult for the twentieth century mind to fully comprehend the quality of life at that time. It was not, in fact, until the latter half of the eighteenth century that the changes were to occur which would alter a mode of living which had remained virtually static since the Reformation.

William Hogarth was born on November 10, 1697 and baptised eighteen days later in the parish of St. Bartholomew the Great. It is largely due to his genius that we can see some of the social conditions and fashionable idiosyncracies prevailing during his lifetime and begin to understand in some measure the zeal of the eighteenth century reformers.

Hogarth's father kept a school in the parish of St. Martin, at Ludgate: evidently more bookish than practical, he left his son, William, little beyond the ability to shift for himself. Accordingly, William Hogarth entered an apprenticeship under a silversmith named Gamble, learning the craft of engraving Coats of Arms and other inscriptions upon plate.

Being naturally adept with a pencil, Hogarth began drawing and painting and, on the expiry of his apprenticeship, he entered the Academy in St. Martin's Lane to study drawing from the life.

During this period of his career he supported himself mainly by engraving shop bills and Coats of Arms.

Despite his strong desire to paint in the classical manner, he made little or no impression on the art world and it is only fair to say that the mediocrity of much of his classical painting deserved no more recognition than it earned. However, from 1723 to about 1730 he obtained commissions to design the illustrations for a number of publications, including thirteen folio prints for Aubrey de la Mortraye's Travels, seven small prints for Apuleius and seventeen illustrations for a duodecimal edition of Hudi-

bras. It is in this latter work that the first signs can be seen of Hogarth's emerging genius - possibly the facetious satire of Butler's poem struck a response chord in the artist, inspiring him to shake off the shackles of conventionalism and give rein to his extraordinary ability to portray character and manners so graphically. 'It was character, passions and the soul that his genius was given him to copy'.

Although Hogarth had no success as a classical painter, his undoubted ability to capture a likeness enabled him to obtain a considerable number of portrait commissions. Flattery, however, was not his forte and he was, if anything, inclined to aggravate, rather than soften the harshness of nature. A certain nobleman who was extraordinarily ugly made the mistake of sitting for Hogarth, who painted him with his customary fidelity. Enraged by the result, the peer would not accept the picture and, despite repeated applications, refused to pay Hogarth's fee. Refused, that is, until he received the following communication:

'Mr. Hogarth's dutiful respects to Lord - -; finding that he does not mean to have the picture which was drawn for him, is informed again of Mr. Hogarth's pressing necessities for the money. If, therefore, his Lordship does not send for it in three days, it will be disposed of, with the addition of a tail and some other appendages to Mr. Hare, the famous wild beast man; Mr. H. having given that gentleman a conditional promise on his Lordship's refusal'. The picture was speedily paid for and burnt.

In 1730, at the age of thirty three, Hogarth married the only daughter of Sir James Thornhill, the painter. The marriage was conducted in secret and Sir James was not easily reconciled to his daughter's union with a relatively obscure artist. However, shortly after his marriage Hogarth began his first major series of moral paintings, the Harlot's Progress and, at Lady Thornhill's suggestion, some of these were shown by the new Mrs. Hogarth to her father. When he learned that they had been painted

by his son-in-law, Sir James observed that 'The man who can produce such representations as these can also maintain a wife without portion'. He soon relented, treating the young couple generously until his death in 1733, the year in which Hogarth truly rose to fame.

It was in 1733 that the third scene of the Harlot's Progress was printed and a copy of it shown by one of the Lords of The Treasury to a number of his colleagues. One of the figures portrayed is that of Sir John Gonson, a celebrated magistrate who was particularly harsh in his treatment of prostitutes: recognising the likeness, the Lords of the Treasury rose, almost as one man, went to the print shop and bought copies.

In some respects, this led to the eighteenth century version of 'pop mania'. Over twelve hundred subscribers entered their names for the plates which were copied and imitated on fan mounts and in a variety of other forms. Shortly afterwards the theme was used as the subject of a pantomime and other theatrical interpretations quickly followed, making Hogarth's name a household word.

Although gratified by the popularity of his works, Hogarth, not being a rich man, was considerably aggrieved by the number of copies made of his work - many of inferior quality - which, sold at a cheaper price than the genuine articles, milked off much of the profit which should have been his.

Accordingly, he enlisted the support of Vertue, Pine and others and petitioned Parliament to afford them some protection. In June 1735, the Statute was passed granting them copyright on their work for a period of fourteen years after publication.

At about this time, too, Hogarth who was living at South Lambeth, worked on designs for the improvement of Vauxhall Gardens and it was at his suggestion that the then owner, a Mr. Tyers, used paintings (including, of course, Hogarth's 'Four Parts of the Day' series) to embellish them.

Following the success of the Harlot's Progress, Hogarth produced several more series including the Rake's Progress, Marriage a la Mode, Industry and Idleness, and the Stages of Cruelty. Each of these was a lecture on morality - often rather heavy-handed and, perhaps naive-seeming to the twentieth century eye but, looking beneath the obvious reward-for-the-good-and-downfall-for-the-wicked themes, it becomes apparent that human nature has not undergone much of a change in the past two hundred-odd years.

Like Shakespeare, Hogarth had the ability to define universal characters and characteristics in a manner which sometimes amuses and sometimes horrifies, but never, never fails to convey its message.

Although he had firmly established himself in the society of his time on the merits of his own particular genius, Hogarth was still determined to gain recognition as a serious artist in the classical sense, Unfortunately he had developed a vast distrust for the critics of his day-Walpole explains why: 'From a contempt of the ignorant virtuosi of the age, and from indignation at the impudent tricks of the picture dealers, whom he saw continually commending and vending vile copies to bubble collectors, and from never having studied, or indeed having seen, good pictures of the great Italian masters, he persuaded himself that the praises bestowed on those glorious works were nothing but the effects of prejudice. He talked this language till he believed it: and having heard it often asserted (as is true) that time gives a mellowness to colours, and improves them, he not only denied the proposition, but maintained that pictures only grew black and worse by age - not distinguishing between the degrees by which the proposition might be true or false. He went farther: he determined to rival the ancients and unfortunately chose one of the finest pictures in England as the object of his competition. This was the celebrated Sigismunda of Sir Luke Schaub, said to be painted by Correggio, though probably by Furino . . . After many attempts Hogarth at last produced his Sigismunda - but no more like Sigismunda than I to Hercules.

Beside trying to produce works to rival the great painters, Hogarth attempted (as many have before and since) to discover a formula for beauty. In the year 1753 he published his Analysis of Beauty - a single volume whose chief principle was the proposition that beauty fundamentally consists in the union of uniformity found in a curved or waving line and that round, swelling figures are most pleasing to the eye.

In 1757, Hogarth obtained both an honorary title, that of Counsellor and Honorary Member of the Imperial Academy at Augsburg, and an emolument on his appointment to the post of Serjeant Painter to the King, an office which carried an income of £200 per annum. The latter post having been resigned by his brother-in-law, John Thornhill.

From this time, Hogarth failed to produce, with one or two exceptions, any works of great merit, though two years later (1759) he completed his Sigismunda.

In 1762, Hogarth, for the first time, entered the field of political caricature by launching an attack on his former friends, John Wilkes and, later, Churchill.

The wrangling contest that followed reflected no credit on any of the parties involved and was held by many to have injured his health.

Toward the end of that year, the artist complained of an internal disorder and his general condition visibly deteriorated.

Despite this, Hogarth continued working, mainly on retouching his old plates, which he continued, with the help of several engravers for the next two years.

On October 25, 1764, he was removed from his villa at Chiswick to his house at Leicester Square where, on the same night, he died in the arms of his wife.

Hogarth was buried in Chiswick Churchyard where a monument was erected to his memory, with an inscription by his friend, Garrick.

the genius of
WILLIAM HOGARTH

An Explanation of the Plates

PORTRAIT OF HOGARTH WITH HIS DOG TRUMP

The earliest portrait, of Hogarth in a cap, suggests his high opinion of himself, the portrait medallion standing as it does upon three books lettered Shakespeare, Swift, and Milton's Paradise Lost. His palette bears the line of Beauty and Grace. The pug dog, Trump, was Hogarth's favourite companion.

This plate was later totally altered in 1763, to represent Churchill as a Russian Bear during the course of Hogarth's battles with John Wilkes and his adherants.

PORTRAIT OF HOGARTH PAINTING THE COMIC MUSE

The later portrait, published in 1758, shows Hogarth painting the Comic Muse. The original inscription read 'W. Hogarth, Serjeant Painter to His Majesty. Engraved by W. Hogarth'. There were several other alterations made before the present print was made - All inscription has been removed apart from the artist's name. The face of Comedy and the mask show signs of alteration and the title engraved on the pillar dated the last of the alterations as 1764.

INDUSTRY AND IDLENESS

The story line of this series of twelve prints is easy to follow with the aid of the descriptive title above each and the biblical quotation appended below.

Of this series Hogarth is reported as saying:

'These twelve prints were calculated for the instruction of young people and everything addressed to them is fully described in words as well as figures, yet to foreigners, a translation of the mottoes, the intention of the story and some little description of each print may be necessary . . . These prints I have found to sell much more rapidly at Christmas than at any other season'.

TIMES OF THE DAY

These four popular prints are amongst the most ageless of all Hogarth's works. Although they contain some portraits and allusions to contemporary events, these are of decidedly secondary importance to the atmosphere of the pictures themselves.

MARRIAGE A LA MODE

This series of prints has been widely acknowledged to be the greatest of all Hogarth's works - an opinion which the artist himself is believed to have endorsed.

The six prints were published in April 1745 and announced as 'invented, painted and published by W. Hogarth, and engraved by the best masters'. (Scotin, Baron and Ravenet).

PLATE 1

We see the two lovers pushed to a position of no significance by the financial transaction taking place between the two families - the noble earl, indicating his family tree, remains aloof while the wealthy citizen, who is paying dear for the privilege of marrying his daughter into the nobility, scans the marriage settlement.

The two pointers, leashed together, symbolise that the actual marriage partners are to be joined, not of their own free will, but at the inclination of their respective families.

PLATE 2

Shows the household of the now married couple at one fifteen in the afternoon.

The young Lord has not yet been to bed after a night of riotous behaviour (suggested by his broken sword and the cap and ribbon hanging from his coat pocket), while his wife has only lately risen, having just finished her breakfast.

11

She, too, has been entertaining as we see from the state of the rooms, and the yawning figure of the servant in the background.

The old steward, who has obviously tried to bring a pile of bills to the attention of his employers, is a picture of disapproval and manages to convey his opinion that ruin is soon to overtake the household.

PLATE 3

Having indulged his fleshly lusts among the brothels of the town, the young Lord is here shown complaining to a quack doctor that his pills have failed to cure the disease for which they were prescribed. On our hero's right is the young girl to whom he has transmitted the infection and we may assume that the woman with the knife is the prostitute from whom he, in his turn contracted the disease.

PLATE 4

The heroine of the piece - infatuated with her new found position of rank - entertains all the fashionable excesses of her time, sitting at her toilette and dallying with the lawyer who paid her some attention in Plate 1. An Italian singer gives voice, accompanied by a flautist, being received with mixed feelings by the other members of his audience.

PLATE 5

Suspecting the fidelity of his wife, the young Lord follows her to a masquerade and from thence to a bagnio where he discovers her in *flagrante delicto* with Lawyer Silvertongue.

Enraged, he attacks the lawyer who, by luck or judgment, inflicts a mortal wound in retaliation, making his escape through the window just as a constable and watchman are called to the room.

It may be of interest to note that the background of this picture, more finely finished than most, is the work of Ravenet's eldest daughter, who used to assist her father before she married.

PLATE 6

The young widow, filled with remorse at the result of her amorous adventures, takes her own life by drinking laudanum bought at her request by the simple-looking servant who is receiving a tongue lashing from the doctor.

The old nurse tries to pull the child from her dying mother while the merchant coolly removes a diamond ring from her dying finger, determined to regain some percentage of the money he spent in marrying his daughter into the aristocracy.

THE HARLOT'S PROGRESS

This series, directly responsible for Hogarth's rise to fame was published in 1733. There were over twelve hundred subscribers to the original prints which were later widely pirated.

PLATE 1

The story opens at the Bell Inn, Wood Street and the Heroine, daughter of the elderly clergyman is approached by a famous procuress, one Mrs. Needham, a pious woman whose prayer was that she might make enough money from her profession in time to retire and make her peace with God. This ambition was never fulfilled, her days ending following some particularly rough usage in the pillory. The other two gentlemen represented in the first plate are the Notorious Colonel Chartres and behind him, John Gourlay, a well known pimp and Chartres' regular companion.

PLATE 2

In this plate, the young heroine is shown as diverting the attention of her wealthy patron in order that one of her gallants can beat his retreat unobserved. Nice touches are those that suggest careless high-living: the black servant boy, the monkey playing with its mistress' hat and indeed, the diversionary tactics of the girl herself.

PLATE 3

Having fallen from the favour of her wealthy benefactor, the harlot is obviously having a hard time - gin measures and pewter pots suggest the standing of her clientele, the candle in a bottle and the basin resting on a chair, the broken window, bare boards, torn drapes and lumpy companion all indicate poverty, the medicines on the window all suggest that she has fallen prey to the medical hazards inherent in her choice of profession.

The wig box above the bed is that of James Dalton, a street robber who was later executed. The gentleman leading the constables into the room is a magistrate, Sir John Gonson, well known for the severity of his treatment of prostitutes.

PLATE 4

The wages of sin . . . a house of correction, where the heroine is sent to mend her ways and learn that virtue is its own reward. Here she must either beat hemp or stand locked in the 'corrector' like the unfortunate behind her, or have a heavy log chained to her leg or even submit to chastisement at the whipping post which is felicitously inscribed 'the wages of idleness". The torn card was probably dropped by the well dressed young man whose downfall was brought about by a love of gambling.

PLATE 5

Released from Bridewell, the heroine breathes her last in some wretched attic room. Two well-known quacks of the day are more concerned for the merits of their respective potions than for their dying patient and the nurse takes advantage of the uproar to steal what she can.

PLATE 6

The plate on the coffin lid confirms that M. Hackabout died Sept. 1731, aged 23. Her remains are surrounded by her professional sisters, one of whom is seducing the undertaker while stealing his handkerchief. The gin is flowing and the rather heavyhanded moral of the story is driven home.

THE ELECTION

Like many of Hogarth's more 'journalistic' prints, these four contain sufficient action, allusion and humour to justify many pages of descriptive and explanatory text.

Suffice it here to say that each print represents a stage in the election of a Member to Parliament, from An Election Entertainment, at which the Candidate seeks to gain the favour of his guests, through the Canvassing and Polling stages to the climactic Chairing of the Members.

BEER STREET AND GIN LANE

These two prints, although each complete in itself, should be viewed as a pair to fully appreciate the moral Hogarth intended.

Under each of the prints are twelve appropriate lines from the pen of the Reverend James Townley and in the advertisement announcing them, Hogarth says 'As the subjects of these prints are calculated to reform some reigning vices peculiar to the lower class of people, in hopes to render them of more extensive use, the author has published them in the cheapest manner possible'.

THE RAKE'S PROGRESS

One of the best known of Hogarth's series, these eight plates follow the fortunes of a young man from the day he receives his inheritance to his eventual incarceration in Bedlam.

As usual, Hogarth has managed to introduce into his moral tale a great number of details of contemporary significance, including portraits of well known personages and characters besides some biting comment on the manners and morals of the times.

PLATE 1

The hero is measured for his father's mourning by a humble, country tailor while trying to buy his way out of a betrothal entered upon when his prospects were less bright. All around are signs of miserliness (the shoe-sole cut from the family Bible, the coins falling from a hole above the fireplace, etc.) and it is not to be wondered at that his new found wealth turns the young man's head.

PLATE 2

Here, the hero is shown as the young Rake, surrounded by poets, milliners, jockeys, barbers, French tailors and the whole retinue of a Fashionable Young Man. Many of the figures are portraits of well known characters of the period, including Bridgeman, a garden designer, Figg, the Prizefighter and Dubois a Master of Defence, who was later killed in a Duel.

PLATE 3

The young man, accompanied by his friends to a brothel, sinks deeper into depravity as he awaits the forthcoming entertainment by the 'Posture Woman' who is shown undressing preparatory to performing her somewhat indelicate dances and other activities.

PLATE 4

Here we see the young man, dressed to pay his compliments at Court, being accosted by a Bailiff. The young woman who he scorned to marry in the first plate is in the process of persuading the Bailiff to release him.

PLATE 5

His fortune squandered, our hero is compelled to marry a woman whose only attraction can be her wealth.

Commenting on the condition of the church at Marylebone, Hogarth shows the roof propped up, the poor box covered with cobwebs and the commandments broken. (The church was pulled down and rebuilt some six years after the print was published). Suggestive of the unnatural union taking place, Hogarth has introduced his dog, Trump, paying his respects to a sick-looking, one-eyed female of the same species, while, at the door of the church, we see again the hero's spurned love being refused admission.

PLATE 6

Determined to free himself from the distasteful marriage he has been forced into the Rake tries, and fails, to win back his lost fortune at cards.

The fire breaking out alludes to an incident at White's in 1733.

PLATE 7

Thrown into Debtor's Prison, the Rake is followed even here by his faithful young woman, shown fainting.

PLATE 8

The final scene shows the Rake in the madhouse, Bedlam, again accompanied and succoured by the young woman he has spurned for so long.

The other inmates are typical Hogarth touches, as is the halfpenny, reversed and fixed against the wall to suggest that Britannia was only fit for the mad house, as the artist asserted several times during his life.

THE FOUR STAGES OF CRUELTY

Once again the Reverend Townley provides some spiritual lines of support of Hogarth's moral prints and once again we have a record of Hogarth's own words relating to his work.

'The leading points in these, as well as the two preceding prints (Beer Street & Gin Lane) were made as obvious as possible in the hope that their tendency might be seen by men of the lowest rank.

Neither minute accuracy of design, nor fine engraving were deemed necessary: as the latter would render them too expensive for the persons to whom they were intended to be useful. And the fact is that the passions may be more forcibly expressed by a strong, bold stroke than by the most delicate engraving'.

The series of prints shows the history of Tom Nero - in the first plate as a schoolboy with an unpleasant way with dogs - in the second as a brutal coachman who has graduated to the ill treatment of his horse.

The third plate shows Nero having reached the summit of his ill starred career with the vicious murder of a serving girl pregnant with his child.

Finally, at the hands of Justice, Nero's body is, after execution, placed in the hands of the dissector, who appears to be no more equipped with humane feelings than was Tom Nero himself.

FRANCE AND ENGLAND

There can be no doubt, after seeing these two prints of Hogarth's love of England and contempt of France, at that time her enemy.

In the first print, France, he has allowed himself to stray from the realm of depicting nature, plunging deep into caricature. As always, he shows the French as a nation of undernourished cowards contrasted, in the second print (England) with the robust, jolly patriots who inhabited his own motherland.

ILLUSTRATIONS FOR DON QUIXOTE

Hogarth was but one of a number of artists employed to submit designs for an edition of Don Quixote published in 1738 by Lord Carteret.

The six plates included here were submitted to his Lordship and, although paid for, were rejected as unsatisfactory.

Unpublished, the plates remained for some years in private hands until, upon the death of Mr. Tonson, their owner, they were sold to a Mr. Dodsley. He, after having the chapter and page numbers of Jervis's translation inscribed beneath the plates sold them to Messrs. Boydell, the publishers.

ILLUSTRATIONS FOR HUDIBRAS

The first series of prints in which Hogarth displayed signs of his own particular genius, though Walpole commented that 'His Hudibras was the first of his works that marked him as a man above the common; yet, what made him then noticed now surprises us, to find so little humour in an undertaking so congenial to his talents'.

Despite Mr. Walpole's somewhat grudging praise, the series displays some excellent touches, particularly when taken in the context of Butler's ludicrous poem.

PORTRAIT OF THE RIGHT HONOURABLE JAMES CAULFIELD, EARL OF CHARLEMOUNT

This portrait was engraved by Joshua Haynes (who also engraved the following plate of Lord Holland) and published in 1782.

PORTRAIT OF THE RIGHT HONOURABLE HENRY FOX, LORD HOLLAND

This is a serious portrait, from a drawing executed by Hogarth in 1757, of Henry Fox, Lord Holland.

The plate was engraved and published in 1782.

PORTRAIT OF SIMON, LORD LOVAT

This must surely have been the fastest-selling print Hogarth ever produced, demand exceeding the supply for some weeks despite the day and night use of a rolling-press in an effort to print enough copies for all intending purchasers.

The subject of the print, the 23rd Lord Lovat was convicted of treason, for which crime he paid with his life.

Hogarth made this portrait at St. Albans where his Lordship rested for a few days on his way to London, arrest and trial. Commenting on the picture, the artist explained that ' . . . this portrait was taken in the attitude of relating on his fingers the numbers of the rebel forces - Such a general had so many men etc'. He also remarked: 'The muscles of Lord Lovat's neck appeared of unusual strength, more so than I had ever seen'.

PORTRAIT OF JOHN WILKES ESQ.

At the time this print was published, John Wilkes was at the zenith of his popularity and Hogarth sold over 4,000 copies almost overnight.

The portrait has been described by a contemporary commentator as a 'caricature of what nature has already caricatured'.

PORTRAIT OF DR. BENJAMIN HOADLEY, LORD BISHOP OF WINCHESTER

This is a fine portrait in the grand style which was engraved by Baron.

PORTRAIT OF MARTIN FOLKES ESQ.

Martin Folkes, the subject of this portrait was a noted mathematician and antiquary. Elected a fellow of the Royal Society in 1713 at the early age of 24 he was elected President in 1741.

He was also a member of the Society of Antiquaries, being elected President of that august body in June 1754.

PORTRAIT OF CAPTAIN THOMAS CORAM

This print is from Hogarth's portrait of the founder of the Foundling Hospital. An indefatigable Philanthropist, Captain Coram spent so much of his time, energy and wealth in the service of others that he was forced to live the later years of his life on a pension provided for him by well-wishers.

THE SHRIMP GIRL

This portrait from life was first published in 1782. Many critics consider that it would have benefitted from different treatment in the engraving, suggesting that the then fashionable dotted manner of its execution has lost much of the life and spirit of the original oil sketch.

THE POLITICIAN

This print is a gentle jibe at one Mr. Tilson, a laceman in the Strand who, in Hogarth's opinion, concerned himself too much with the political columns of the newspapers and not enough with his own affairs.

Mr. Tilson's sword suggests that, although not engraved until 1775, the picture was probably painted around 1730, when street robberies were so common that tradesmen frequently carried arms with which to defend their pockets.

THE BRUISER CHARLES CHURCHILL

In defence of his friend Wilkes, Churchill published his 'Epistle to William Hogarth' in which he vigourously attacked the artist under the motto 'Ut Pictura Poesis'.

Without delay, Hogarth retaliated with this print in which Churchill (who was a rough and lusty man) is portrayed as a Russian Bear.

The engraving was done as an alteration to the plate of his self portrait which Hogarth had produced some years earlier and Trump, his dog, remains.

The palette has been partly obscured by a small drawing referring to Pitt, Wilkes and others of whom Hogarth disapproved.

PORTRAIT OF SARAH MALCOLM

This innocuous looking print has a somewhat macabre story behind it - Sarah Malcolm was a char woman who was convicted of the murders of Mrs. Lydia Duncombe, aged eighty, her sixty year old companion, Elizabeth Harrison and Anne Price, her seventeen year old maid. She had strangled the two older ladies and cut the throat of the maid and, for these crimes, was executed on March 7, 1732 -3. Two days prior to her execution she sat, dressed in red, for Hogarth to paint the portrait from which this print was made.

THE PIEMAN
THE MILK MAID

These two prints, together with that of the Shrimp Girl offer an interesting glimpse of certain sections of the working class community of Hogarth's time.

THE INDIAN EMPEROR

This print represents Act Four, Scene Four, of 'The Indian Emperor' as performed for the Duke of Cumberland. Although this picture has received wide praise, a number of the figures are rather woodenly composed and poorly constructed, emphasising the point that Hogarth's genius lay in his ability to recognise and illustrate the more robust, flesh and blood facets of his time - generally through the medium of satire.

BEGGARS OPERA ACT III

This fine picture shows the third act of Gay's well known work.

Apart from being, we are told, a collection of genuine portraits of actors of the period, it is the only known illustration of the inside of the Lincoln's Inn Fields Theatre.

GARRICK IN THE CHARACTER OF RICHARD III

A good, if rather pedestrian portrait of Garrick, one of the great tragedians of the English stage and a close friend of Hogarth.

SIGISMUNDA

This picture, Hogarth's great attempt at overcoming the prejudice which he felt the connoisseurs to exercise against him, earned him much abuse and caused him a great deal of distress.

Painted at a time when he had determined to leave off painting partly for the sake of ease and retirement, but more particularly because he had found it to be less profitable than his engraving, Hogarth was unable to sell the original and met with no more success when he tried to have it engraved.

Ravenet began work on the plate, but he was under an agreement to work for no-one but Boydell for three years, so he was obliged to stop.

Grignion next attempted a plate, but Hogarth pronounced it unsatisfactory.

Basire was next employed, working under Hogarth's personal guidance, but again the work was unsatisfactory and remained unfinished.

In 1764, Hogarth attempted the task himself but died before completing it and the plate here reproduced was finally engraved by Benjamin Smith under instruction from Boydell who bought the original picture at the sale of effects of Hogarth's widow in 1790.

THE BEGGARS' OPERA BURLESQUE

The interpretation of this plate is somewhat obscure, but it appears to represent the conflict between English and Italian Theatre.

The characters of the Beggars' Opera are drawn with animal heads and Harmony is seen to be deserting their performance, flying towards the Italian stage behind. This is further suggested by the makeshift instruments being played by the musicians.

Apollo and the Muse are dozing beneath the stage and, in the background a gentleman is making rather indelicate use of one of the ballads which hang on the wall behind him.

A JUST VIEW OF THE BRITISH STAGE

Walpole describes this plate as 'Booth, Wilkes and Cibber contriving a Pantomime, a Satire on Farces'.

Apart from the persons represented, the plate, with the inscription below, is self explanatory.

MASQUERADE TICKET

A strongly satirical commentary on the vices and follies of his time, Hogarth engraved this allegorical plate in 1772, not long before his death.

The bacchanalian picture on the far wall of the room sets the scene - the suggestion being that this masquerade is, or will soon be, little short of an orgy.

Provocatives are offered on the supper table and the two barometer-like devices on either side of the room are to indicate the amorous reactions of those who stand near.

The antlers and goats' heads suggest wickedness and, while cupid fires his arrow at random into the crowd, the masked venus looks, by her posture, to be somewhat startled at the liberties being taken in her name.

Note the pictorial pun on the left hand side - a bishop killing time at the masquerade.

MASQUERADES AND OPERAS, BURLINGTON GATE

Considered to be the first plate published by Hogarth on his own account and a strong satire on the tastes and follies of the times. This print is said to have been designed by Hogarth as a favour to his father in law, Sir James Thornhill.

Lord Burlington had championed Mr. Kent over Sir James to paint for George II at his Kensington Palace. The grotesque leader of the figures hurrying to the masquerade crowned with cap and bells is a representation of the King. All the show signs are for opera and other amusements considered flippant at the time, while the works of great English dramatic writers are trundled through the streets on a salvage barrow.

The figure of Kent is shown brandishing his palette and brushes on the top of Burlington Gate, above those of Michaelangelo and Raphael.

Lord Burlington and other fashionable figures form the central group.

THE MYSTERY OF MASONRY

One of Hogarth's earlier works, this print makes up in enthusiasm what it lacks in polish. Beneath is printed its explanatory inscription.

THE POLITICAL CLYSTER

For a description of this print, see Gulliver's speech to the honourable house of Vulgaria in Lilliput.

ALTAR PIECE OF ST. CLEMENTS

This print was considered by many to have been a parody of the actual Altar piece.

According to Hogarth (who held a very low opinion of Kent, the author of the original) the engraving was a very fair copy of a contemptible painting. His notes and explanation are printed beneath the plate.

THE PRINCIPAL INHABITANTS OF THE MOON

Almost a surrealist satire on Royalty, the Church and the Law who are shown seated on a platform in the clouds.

The King's face is shown as a coin and his figure is an empty robe adorned with sash, chain and star. The Bishop - his face a Jew's harp is pulling on a string which works a pump shaped like a church spire and which spews money into his own coffer.

Justice like the King, is without bodily substance. Having a wooden mallet for a head, he sits beside an oversized sword to indicate severity with no signs representative of mercy or just impartiality.

On either side are non-beings representing drawing-room soldiers, empty headed courtiers and the 'enlightenment'of penal restraint.

RICH'S TRIUMPHANT ENTRY

This plate represents Rich's removal from Lincoln's Inn Fields to the new Theatre in Covent Garden.

Rich, shown riding with his mistress in a chariot, is accompanied by his entire theatrical staff.

Once again, Hogarth has taken the opportunity to ridicule Pope, representing him in the right foreground as making indelicate use of the Beggar's Opera. - The reason for this may have been Pope's doubts that the Beggar's Opera would succeed, or it may simply have been an extension of the old war between Sir James Thornhill (Hogarth's father-in-law) and the Earl of Burlington and his friends.

FRONTISPIECE TO DR. BROOK TAYLOR'S PERSPECTIVE

Not content to confine his creative abilities to pure, non functional picture making, Hogarth gave, in 1761, a design for an attempt at a new order of architecture.

In his 'Analysis', published some eight years earlier, Hogarth wrote, 'I am thoroughly convinced in myself however it may startle some, that a completely new and harmonious order of architecture in all its parts might be produced'. This statement must have been regarded as bordering on the heretical at the time it was written, the firm belief being that architecture had reached its zenith with the productions of the Ancient Greeks.

Undaunted, however, Hogarth created the design shown in this print, being a capital composed of the Star of St. George, the Prince of Wales' Feather and a regal Coronet.

Finely engraved by Woolett, the print was used as a frontispiece to 'Dr. Brook Taylor's Perspective of Architecture'.

ANALYSIS OF BEAUTY

To amplify the statements made in these two prints, Hogarth published a separate quarto volume explaining his theory on the beauty of the curved line.

In his usual manner, Hogarth has, in these two plates, relied strongly on ridicule to carry his point across. As an example Essex (Fig. 7) in the first plate, 'A celebrated dancing master, is shown trying to alter the graceful pose of Antinous into one of fashionable stiffness.

PAUL BEFORE FELIX
PLATE 1

This plate was described at the time of its publication as being 'designed and etched in the ridiculous manner of Rembrandt'. Some indication of the contempt in which all but the Italian Classical style of painting was held in the eighteenth century.

PLATE 2

This plate was engraved by Hogarth and was intended as a serious representation of the scene burlesqued in the previous print.

Despite this, in the opinion of Walpole, 'there is much less dignity in this than wit in the preceding', and, finding that his burlesque print was generally more admired than this serious study, Hogarth set the plate aside, declaring it 'insufficient'.

PLATE 3

This plate was engraved from the same design as the former but by Luke Sullivan instead of Hogarth himself.

Several alterations will be noticed, however, not least of these being the omission of the wife of Felix because, again in the words of Walpole 'Paul's hand was very improperly placed before her'.

The fact that the third plate is seen to be a reversal (right to left) of the second is undoubtedly due to the fact that Hogarth himself frequently engraved his plates without the use of a mirror, considering such details to be unimportant.

MOSES BROUGHT BEFORE PHARAOH'S DAUGHTER

The original painting from which this print was taken was presented by Hogarth to, appropriately enough, the Foundling Hospital where it was the subject of mixed critical attention.

THE POOL OF BETHESDA
THE GOOD SAMARITAN

These prints were made from paintings completed by Hogarth in 1737, a small copy of the Pool of Bethesda, engraved by Ravenet, being used as a frontispiece to Stockhouse's Family Bible.

The picture illustrates the artist's decision to break away from the painting of traditional 'Conversation pieces' and explore fresh ground. He decided that there should be a market for paintings and engravings of (to use his own words) ' . . . modern moral subjects, a field not broken up in any country or any age'.

It is, perhaps, worthy of note that the plump nude is said, on good authority, to be a portrait of one Nell Robinson, a celebrated courtesan of whom Hogarth had more than a passing knowledge.

THE TIMES
PLATE 1

This crowded print is a rather involved allegory on the practical state of Europe in 1761-2.

France, Germany and Spain are in flames, with the fire threatening to engulf England.

Pitt is shown on stilts, fanning the blaze with a pair of bellows and wearing a cheese hanging from his neck (alluding to a speech in which he claimed that he 'would sooner live on a Cheshire cheese and a shoulder of mutton than submit to the enemies of Great Britain').

Lord Bute, with the aid of Highlanders and English soldiers and sailors, is attempting to put out the blaze, but is impeded by the Duke of Newcastle who is adding fuel to the fire in the form of copies of the 'North Briton' and 'Monitor'.

PLATE 2

This plate was not published until 1790 - after the death of Hogarth's widow.

Its allusions, being even more obscure than those in Plate 1, will be of interest only to a few political historians, representing, as they do for the most part, minor personal and political wrangles of little general interest.

THE SOUTH SEA BUBBLE

A cartoon depicting the madness which overtook London during the short life of the ill-fated South Sea Bubble. Among the figures represented are Pope (the short, misshapen man) who profited from the venture and Gay (having his pocket picked by the former) who lost.

The engraving was accompanied by an explanatory verse.

See here of causes why in London
So many men are made and undone
That Arts and honest trading drop
To swarm about ye Devil's Shop (A)
Who cuts out (B) Fortune's Golden Haunches
Trapping their souls with lots and chances
Sharing 'em from Blue Garters down
To all blue aprons in the town.
Here all religions flock together,
Like tame and wild fowl of a feather
Leaving their strife, Religious bustle
Kneel down to play at pitch and Hustle (C)
Thus, when the Shepherds are at play
Their flocks must surely go astray.
The woeful cause yet in these times
(E) Honour, & (D) honesty are crimes.
That publickly are punished by
(G) Self interest and (F) Vilany;
So much for monys magick power
Guess at the rest, you find out more.

THE LOTTERY

The following inscription was placed beneath the engraving:

1 Upon the pedestal National Credit, leaning on a pillar, supported by Justice.
2 Apollo showing Britannia a picture representing the Earth receiving enriching showers drawn from herself (an emblem of State Lotteries).
3 Fortune drawing the blanks and prizes.
4 Wantonness drawing ye numbers.
5 Before the pedestal, Suspence turned to and fro by Hope and Fear.
6 On one hand Good Luck, being elevated, is seized by Pleasure and Folly - Fame persuading him to raise sinking Virtue, Arts &c.
7 On the other hand Misfortune, opprest by Grief - Minerva, supporting him, points to the sweets of Industry.
8 Sloth hiding his head in ye curtain.
9 On the other side, Avarice hugging his money.
10 Fraud tempting Despair with money at a trap-door in the pedestal.

THE LECTURE

This print offers another of the collections of heads so beloved of Hogarth.

Representing a University Lecture, the print shows the Rev. Henry Fisher, M.A. of Jesus College, Oxford, Registrar of the University, who freely gave his consent to the publication of the portrait.

The Students' faces are a study in the various degrees of idiocy and it seems somewhat unusual that the Rev. Fisher should have consented to having himself represented in such company unless he wished to publish his low opinion of the students he was obliged to suffer.

THE COMPANY OF UNDERTAKERS

The three things which distinguished a physician in the eighteenth century were his cane, his wig and his gravity.

This print humourously entitled the Company of Undertakers is composed of caricatures of a number of prominent physicians of Hogarth's day.

The inscription beneath the plate parodies the language of heraldry and reads:

Beareth Sable, an URINAL proper, between 12 QUACK - HEADS of the second & 12 CANE-HEADS or, CONSULTANT. On a Chief Nebulae, Ermine, one Compleat DOCTOR issuant, checkie sustaining in his Right Hand a Baton of the Second. On his Dexter and Sinister sides two DEMI-DOCTORS, issuant of the second, & two CANE-HEADS issuant of the third; The first having One Eye couchant, towards the Dexter Side of the Escocheon; the second FACED per pale proper and Gules, Guardent - with this motto - ET PLURIMA MORTIS IMAGO.

CHARACTERS AND CARICATURA

This plate was the receipt for the Marriage a la Mode series and in it Hogarth has tried to differentiate, for the sake of the 'illiterate', between Character and Caricatura.

The lower row of figures, copied (rather badly) from the masters, shows *Character* in three heads from Raphael Cartoons and *Caricatura* from works by Ghezzi, Caracci and Da Vinci.

The heads above (over a hundred of them) are all, says Hogarth himself, drawn without exaggeration and, therefore, examples of Character.

Exaggerated or not, the variety and originality of the large group bear the mark of the undisputed master.

THE FIVE ORDERS OF PERRIWIGS

In this print, Hogarth was said to be attacking, in particular, the architect-designer 'Athenian' Stuart who published 'Antiquities of Athens' in which he set out in minute detail the measurements of all the principal surviving examples of Greek Architecture.

' . . . There is no great difficulty' said the artist 'in measuring the length, breadth or height of any figures, where the parts are made up of plain lines. It requires no more skill to take the dimensions of a pillar or cornice than to measure a square box; and yet the man who does the latter is neglected and he who accomplishes the former is considered a miracle of genius: but I suppose he receives his honours for the distance he has travelled to do his business'.

A CHORUS OF SINGERS

This plate given as the receipt for 'A Modern Midnight Conversation' represents a rehearsal of an Oratorio, 'Judith' which was a monumental failure. (Hence the sarcastic choice of the line 'The World Shall Bow to the Assyrian Thrones' showing on the song sheets.

In it Hogarth has given full rein to his talent for caricature and the faces portrayed have a timelessness which marks pure genius.

THE LAUGHING AUDIENCE

Another example of Hogarth's genius for extracting every ounce of humour from a small everyday scene, this plate was used as a receipt for half a guinea, the down payment on nine prints (including the series of eight showing the Rakes Progress). The remainder of the purchase price (a further one guinea) was payable prior to receipt of the prints.

THE BENCH

This print is one of several in which Hogarth attempted to define, by example, character and caricature.

In his own words 'it has ever been allowed that, when a *Character* is strongly marked in the living face, it may be considered as an index of the mind, to express which with any degree of justness in painting, requires the utmost efforts of a great master. Now that which has of late years got the name of *Caricatura* is, or ought to be, totally divested of every stroke that hath a tendency to good drawing: it may be said to be a species of lines that are produced rather by the hand of chance than of skill; for the early scrawlings of a child, which do but barely hint an idea of a human face, will always be found to be like some person or other, and will often form such a comical resemblance as in all probability the most eminent *Caricaturers* of these times will not be able to equal with design . . .'.

The unfinished row of heads above the main picture which were intended to have illustrated both *caricature* and *outre*, were worked upon by the artist on the day before his death in October 1764.

FOUR HEADS FROM THE CARTOONS AT HAMPTON COURT

It has been suggested that Hogarth engraved this plate from drawings made by his father-in-law, Sir James Thornhill, who, in turn, copied them from cartoons at Hampton Court.

BOYS PEEPING AT NATURE

The original plate of Boys Peeping at Nature was engraved in 1733 as a subscription receipt for a set of prints of the Harlot's Progress.

Four years later it was used again, this time as a subscription ticket for a Strolling Company of Actresses Dressing Themselves in a Barn together with the series of prints depicting Morning, Noon, Evening and Night.

In 1744, the plate was again used as a subscription ticket; this time for the Paul Before Felix print.

For this occasion, however, Hogarth was persuaded to make some alterations to his plate - removing the satyr (surely one of the most interesting characters of the group) who might be construed to be, indeed, peeping at nature, and substituting the boy pointing to a portrait.

This alteration may have been made in the cause of good taste or it may have been a comment on Hogarth's view that the contemporary art world preferred to substitute charm for the true study of nature.

THE WEIGHING HOUSE

Carrying its own explanation, this print was given by Hogarth to the Rev. John Clubbe who used it as a frontispiece to his 'Essay on Physiognomy'

FRONTISPIECE TO TRISTRAM SHANDY

Here are two prints given to Lawrence Sterne as frontispieces for volumes two and four of his popular Tristram Shandy.

FRONTISPIECE AND TAILPIECE TO THE ARTIST'S CATALOGUE

These two prints, forming the frontispiece and tailpiece to the Catalogue of the 'Artist's Exhibition in Spring Gardens, 1761' proved so popular that, before the demand was met, the original plates wore out, fresh ones being engraved by Grignion.

The first print represents Royal patronage of the arts of sculpture, architecture and painting, but it is evident from the distribution of this patronage (the water sprinkled by Britannia) that Architecture is favoured above the others.

The second print represents the Connoisseur (in the form of a monkey in full dress) lavishing care upon old, decayed arts, (the dead plants) while inspecting them through a magnifying-glass to reveal beauties hidden from all but his discriminating eye.

THE ENRAGED MUSICIAN

Mr. John Festin was a prominent musician and music teacher, besides being a friend of Hogarth's.

It is reported that, one day, he called to give a lesson to Mr. Vernon (later Lord Vernon) and, sitting by the open window, he observed a man playing tunes on the hautboy in return for onions given him by an itinerant onion-seller. Enraged at this debasement of his high profession, Festin is said to have mentioned the incident to Hogarth, who translated it into the print entitled the Enraged Musician.

If this story were true, it is perhaps curious that the picture shows not the slightest sign of an onion. It is, therefore, more probable that the picture is no more or less than a product of the artist's fertile imagination resulting from a desire to convey the cacophony of the eighteenth century London streets.

THE DISTRESSED POET

This portrait of Lewis Theobald, author and scholar, is believed to have been an attempt by Hogarth to make peace with Pope, the 'Waspish Bard of Twickenham', who had been ousted by Theobald as **the** commentator on the works of Shakespeare.

Theobald is shown, surrounded by all the signs of abject poverty, attempting to write a Poem upon Riches - obviously not a subject with which he was well acquainted, despite the map of the 'Gold Mines of Peru' above his head.

Under the original print, later altered, was the following quotation from Pope:

Studious he sate, with all his books around,
Sinking from thought to thought, a vast profound:
Plunged for his sense, but found no bottom there,
Then wrote and floundered on in mere despair.

BAMBRIDGE ON TRIAL FOR MURDER BY A COMMITTEE OF THE HOUSE OF COMMONS

The Event represented is the examination, by a select committee, of Thomas Bambridge, warden of the Fleet Prison and John Huggins, his predecessor. They were charged and found guilty of 'great breaches of trust, extortions, cruelties and other high crimes and misdemeanors'.

The picture was painted in 1729 for Sir Archibald Grant, one of the members of the committee. Each head is a genuine portrait and, although the names of the thirty members of the committee are still available, no indications can be found to identify those portrayed by Hogarth in this picture.

The plate shows the committee questioning one of the prisoners of the Fleet Prison, who kneels in the foreground, under restraint. Several instruments of torture are displayed and the accused, Bambridge, fiddling with his button holes looks as though he wished he had stayed in bed that morning.

ROYAL MASQUERADE, SOMERSET HOUSE

This print represents a scene at the great ball described in the Gentleman's Magazine thus;

'Feb 6. The Russian ambassador gave a most magnificent ball at Somerset House. His Majesty came a little after eight, dressed in a black domino, tie-wig, and gold laced hat. Her Royal Highness, the Princess of Wales was in a blue and silver robe and her head greatly ornamented with jewels. The Prince of Wales was in a pink and silver dress, Prince Edward in a pink satin waistcoat, with a belt adorned with diamonds.

Princess Augusta was in a rich gold stuff, The Duke (of Cumberland) was in a Turkish Dress, with a large bunch of diamonds in his turban...'

TASTE IN HIGH LIFE

This satire upon the fashions reigning in the year 1742 was commissioned by the wealthy Miss Edwards of Kensington at a fee of sixty guineas. Having incurred some criticism by her own fashionable excesses, she wished, with Hogarth's help, to recriminate on the public.

The print offers a superb insight into the fashionable tastes and preoccupations of the time, though Hogarth himself is said to have thought so little of the picture that he would not consent to its reproduction, this being eventually contrived through the connivance of one of Miss Edwards' servants.

CHARITY IN THE CELLAR

The original painting from which this print was engraved was painted for Lord Boyne and contains portraits of several members of the notorious 'Hell Fire Club'.

The grouping of the four central figures is in imitation of a statue representing Charity seen on the right of the picture.

WOMAN SWEARING A CHILD

This plate, one of Hogarth's productions, carries the following accompanying verse:

'Here Justice triumphs in his elbow chair
And makes his Market of the trading Fair
His office shelves with Parish laws are grac'd
But spelling books and Guides between 'em placed.
Here pregnant Madam screens the real Sire
And falsely swears her Bastard child for hire
Upon a rich old Letcher who denies
The fact, and vows the naughty hussif lies;
His wife, enrag'd, exclaims against her spouse
And swears she'll be reveng'd upon his Brows
The Jade, the Justice and the Church Ward'ns agree
And force him to provide security.

SANCHO AT THE FEAST STARVED BY HIS PHYSICIAN

This splendid print was published at an early period of Hogarth's life and shows how well the artist was able to illustrate the works of a writer (in this case Cervantes) with whom he felt himself in tune.

THE ROAST BEEF OF OLD ENGLAND

'After the March to Finchley' says Hogarth 'The next print that I engraved was the Roast Beef of Old England, which took its rise from a visit I paid to France the preceding year'.

Hogarth detested the French and everything about them and this feeling could only have been heightened by the fact that he was arrested one day while sketching the gates of Calais. Although, on examining his sketch books, the French Authorities were satisfied that he was not a spy drawing maps of their fortifications but merely an artist drawing for his own purposes, they confined him to his lodgings and shipped him back to England with the first favourable wind.

To continue in Hogarth's own words: 'I no sooner arrived than I set about the picture: made the gate my background and in one corner introduced my own portrait, which has generally been thought a correct likeness, with the soldier's hand upon my shoulder.

By the fat friar who stops the lean cook that is sinking under the weight of a vast sirloin of beef, and two of the military bearing off a great kettle of *soup maigre*, I meant to display to my own countrymen the striking difference between the food, priests, soldiers etc., of two nations so contiguous . . . The melancholy and miserable Highlander, browsing on his scanty fare, consisting of a bit of bread and an onion, is intended for one of the many that fled from their country after the rebellion in 1745'.

COLUMBUS BREAKING THE EGG

It was almost inevitable that this incident, which has earned Columbus almost as much praise as his voyage of discovery should have become a subject for Hogarth's burin.

Certainly Hogarth recognised the fact that Columbus, like himself, had been subjected to scorn and abuse over which he had triumphed to the confusion of his detractors. It is, therefore, significant that Hogarth engraved this plate as the receipt for his 'Analysis of Beauty' which he considered his own discovery and a major contribution to the world of Art.

COUNTRY INN YARD

The scene represented is an election procession in 'the Yard of the old Angel Inn Kept by Tom Bates from London'.

The words on the placard carried by one of the members of the procession ('No old baby') was the slogan adopted by the opponents of the Hon. John Child Tylney when he stood as a candidate for the county of Essex at the age of twenty years.

Despite the importance of the main occasion, it is the foreground commotion which most captures the imagination - Hogarth's wonderful imagination coupled with his almost incredible powers of observation have created a comic masterpiece where lesser men might have simply recorded a rather mundane scene.

STROLLING ACTRESSES DRESSING IN A BARN

Overflowing with humour and incident, this is another of Hogarth's most popular pictures for the simple reason that it requires little or no explanation in terms of historical reference.

Attention should be drawn, however, to the play-bill on the cot which declares the company to be preparing for a performance of 'The Devil to Pay in Heaven' this 'Being the last time of acting before the Act commences'.

Near this, upon the crown, is a copy of The Act Against Strolling Players.

A MIDNIGHT MODERN CONVERSATION

Possibly Hogarth's most popular single print, Midnight Modern Conversation carries the inscription:
'Think not to find one meant resemblance there
He lash the vices but the persons spare,
Prints should be prized as authors should be read
Who sharply smile prevailing folly dead.
So Rabilaes taught and so Cervantes thought
So nature dictated what art has taught.

Despite this disclaimer, most, if not all the figures are thought to have been real portraits, and habituees of St. John's Coffee House, Shire Lane.

The Parson and the Lawyer in the centre of the picture were considered by some to represent Parson Ford (an uncle of Dr. Johnson) and Lord Northington. Generally however, they were held to be portrayals of Orator Henley and Kettleby, a notoriously vociferous lawyer.

The figure leaning over the Parson was a drinking companion of Hogarth's, a tobacconist named John Harrison and a local book binder called Chandler is shown smoking and wearing his night cap.

It is evident that the artist thoroughly enjoyed the production of this picture and, from the many authentic touches and characterisations, we may deduce that, like his subjects here, Hogarth was no stranger to the four a.m. drinking sessions so beloved by many of his contemporaries.

THE COCKPIT

All of the clamour and excitement of the cock-fights are wonderfully depicted in this print which represents a scene at the King's Arms, Newcastle. ·

Apart from the liveliness of the characters - many of whom bore resemblance to notable sports of the day, it is interesting to note the curiously shaped shadow on the floor of the cockpit. It represents a man, suspended in a basket over the pit, this being the usual punishment meted out to those who were unable to honour their losing bets. Since the inclusion of this unfortunate in the picture would have detracted from the composition and moved the focus of attention out of the arena, Hogarth hit upon this ingenious method of indicating the practice in a manner which is both dramatic yet unobtrusive.

THE MARCH TO FINCHLEY

This print, originally priced at 7/6d shows, in the words of Hogarth's friend, Saunders Welch esq., ' . . . a view of a military march and the humours and disorders consequent there upon'.

King George II, hearing that Hogarth had painted this picture and hoped to dedicate the print engraved from it to His Majesty, demanded to see a proof print.

Just what kind of picture the King expected to see is not recorded but his reaction to Hogarth's print was far from favourable: 'Does this fellow mean to laugh at **My Guards**?' he exclaimed.

It was explained that the picture was intended as a Burlesque.

'What! a painter burlesque a soldier? - he deserves to be picketed for his insolence'.

The print was returned to Hogarth who promptly altered the inscription to read, instead of the King of England, 'the King of Prussia, an encourager of the arts'.

SOUTHWARK FAIR

Southwark Fair is one of Hogarth's magnificent hurly-burly prints, every inch of which is packed with interest and humour, conveying a superb impression of the atmosphere of an eighteenth century fair.

Apart from the generalities so skilfully pictured, many of the characters and incidents owe their appearance in the print to actual characters and events of the day.

DEBATES IN PALMISTRY

This print appears to represent a group of Physicians and surgeons debating how best to receive large fees and more or less oblivious of the lame woman.

THE STAY MAKER

Not one of Hogarth's better drawings, either in content or execution, the print shows a staymaker, apparently taking liberties with his customer while her husband sits in the same room, his attention distracted by the foul nurse and his youngest child.

KING HENRY VIII AND ANNE BULLEN

This plate, said to be from a painting in the old Portico of the old Great Room in Vauxhall Gardens, owned by Hogarth's friend Mr. Tyers. Not, perhaps, one of Hogarth's better works.

THE SLEEPING CONGREGATION

First published in 1736 priced one shilling this print is one of the artist's delicious flights of satirical fancy: Every face, every posture tells its own story so well that the viewer can almost feel the drowsiness in the air and hear the dull monotony of the preacher's monologue.

There has been some dispute as to which of two churches, at Whitchurch, Middlesex or Much Munden, Herts, the print refers, since both fell under the pastoral care of the Divine, John Theophilus Desaguliers. Authorities are agreed, however, as to the identity of the above mentioned Pastor, who was a tireless experimental philosopher.

THE HOUSE OF COMMONS

This print, published in 1803 was engraved from a painting executed jointly by Hogarth and Sir James Thornhill, his father-in-law.

Representing a scene inside the House of Commons, it contains portraits including those of Rt. Hon. Arthur Onslow (Speaker), Sir Robert Walpole (Prime Minister), Sidney Godolphin esq., (Father of the House), Colonel Onslow, Sir James Thornhill, Sir Joseph Jekyll, Edward Stables esq., (Clerk of the House) and Mr. Askew (Clerk Assistant).

CREDULITY, SUPERSTITION AND FANATICISM, A MEDLEY

This print was intended as a parody on the imagery which painters of religious pictures had become accustomed to using in their attempts at portraying Saints, the Trinity, Angels and the like.

Witches, ghosts, demons and historical figures are shown in a church, implying criticism of some of the superstitions perpetuated in the name of religion.

The woman lying on the floor with rabbits issuing from her skirts is taken for one Mrs. Tofts, a well known witch of her time, and her 'familiars'.

TIME SMOKING A PICTURE

Part of his lifelong campaign against art connoisseurs, this plate was used by Hogarth as a subscription ticket for his ill-starred Sigismunda.

It represents Hogarth's view that the Art Establishment considered age to be the greatest merit an object or painting could possess.

THE FARMERS RETURN

The original drawing from which this plate was taken was given to Garrick by Hogarth, and it illustrates a scene from a play which Garrick wrote.

Later, the play was published in book form, this print being used as a frontispiece.

THE MAN OF TASTE

In 1731, Alexander Pope published a poem entitled 'False Taste' in which he roundly criticises 'Timon', a man of great wealth and little taste. The Timon of Pope's satire was intended to be the Duke of Chandos, a man who, despite his love of pomp and ceremony, was of a kind and generous nature.

As a result of the poem, Pope came in for considerable abuse, particularly since he was said, in the words of Dr. Johnson 'to have been indebted to the patronage of Chandos for a present of a thousand pounds, and who gained the opportunity of insulting him by the kindness of his invitation'.

Pope made various excuses and apologies, claiming that he had not intended Timon for the Duke of Chandos and, anyway, he had never received a thousand pounds from his patronage.

Soon after publication of the poem alluded to, Hogarth designed this plate. It represents a view of Burlington Gate (Pope's poem had been addressed to the Earl of Burlington) and shows the poet, in the guise of a plasterer, brandishing his brush and spraying whitewash over the Duke of Chandos who tries to shelter beneath his hat.

The Earl of Burlington is represented as the plasterer's labourer, carrying fresh plaster for the poet to use for the dual purpose of beautifying Burlington Gate and defiling any passer-by.

Once again, Hogarth mounts Kent atop Burlington Gate, armed, as before, with palette and brushes and again placed above Raphael and Michaelangelo.

The print from which this plate was copied was originally prefixed to;
'A Miscellany on Taste, by Mr. Pope & c; viz 1. of Taste in Architecture, an Epistle to the Earl of Burlington with *Notes Variorum*, and a complete Key: 2. Of Mr. Pope's taste in Divinity; viz the Fall of Man and the first Psalm translated for the use of a Young Lady: 3. Of Mr. Pope's Taste of Shakespeare: 4. His Satire on Mr. P(ultene)y; 5. Mr. Congreve's fine Epistle on Retirement & Taste, addressed to Lord Cobham'.

The pamphlet soon became a rarity since the publisher was immediately prosecuted and sale prohibited.

FALSE PERSPECTIVE

In 1753, Hogarth drew this piece of whimsy and presented it to his friend Joshua Kirby.

It is said that Hogarth designed the plate as a jibe at Sir Edward Walpole, who was learning to draw without being taught perspective.

BATTLE OF THE PICTURES

'The bearer hereof is entitled (if he thinks proper) to be a bidder for Mr. HOGARTH'S PICTURES which are to be sold on the last day of this month'.

So runs the somewhat sarcastic inscription above this print which, as the title suggests, is drawn to represent a Battle of the Pictures.

The intended meaning behind this print becomes quite clear when it is remembered how Hogarth despised the establishment's slavish adherence to the Italian Classical Schools.

To show his distaste, Hogarth has represented the classical paintings, reproduced ad nauseam, blocking access to the saleroom and actively engaged in attacking his own pictures.

DISTANT VIEW OF MR. RANBY'S HOUSE AT CHISWICK

This view, etched by Hogarth in 1748 was published in 1781 by his widow.

THE MATCHMAKER

There is a nice touch of humour in the evident reluctance of the young man (unseen) to take the hand of the ageing spinster.

The Matchmaker himself is well characterised, though the woman is rather awkwardly constructed.

HYMEN AND CUPID

Originally engraved as a ticket for the Masque of Alfred, this plate was afterwards intended as a receipt for Sigismunda. Although this is a fairly neat picture, it lacks the strength which is so much a characteristic of Hogarth's work.

RECEIPT FOR THE ELECTION PRINTS

'After having had my prints pirated in almost all sizes, I applied to Parliament for redress, and obtained it in so liberal a manner, as hath not only answered my own purpose, but made Prints a considerable article in the commerce of this country, there being now more business of that kind done here than at Paris, or anywhere else, and as well'.

These words were recorded by Hogarth in the year 1735 after the passing of the Act for the Encouragement of the Arts of Designing, Engraving, etc., which was designed to protect the rights of Artists in their work by forbidding reproductions and copies.

This print, later used as a receipt for subscriptions to his 'Election' series, was designed in gratitude to Parliament for the passing of the Act and shows the Royal Crown darting its rays on the Chancellor's great seal, the speakers hat etc., etc.

RECEIPT FOR MARCH TO FINCHLEY

This is a receipt to the subscribers for the 'March to Finchley' representing a stand of various weapons and a pair of scissors cutting the Arms of Scotland.

SIX TICKETS

Each in itself a work of art, these small engravings show the ease with which Hogarth was able to tackle minor subjects on a small scale without any lowering of his standards.

THE BATHOS

Apparently aware of his imminent death, Hogarth spent the last few months of his life at Chiswick, retouching his plates.

On March 3, 1764 he published this, the last of his works, entitled 'Finis or the Tailpiece; the Bathos or manner of sinking in Sublime Painting; inscribed to the dealers in dark pictures.

The imagery is self explanatory.

BEFORE AND AFTER

These two prints are best described by the terse inscription which originally accompanied them.

'The first shows how precarious it is for Frailty to strive with Opportunity: and the second, how useless it is for Importunity to solicit Impossibility.

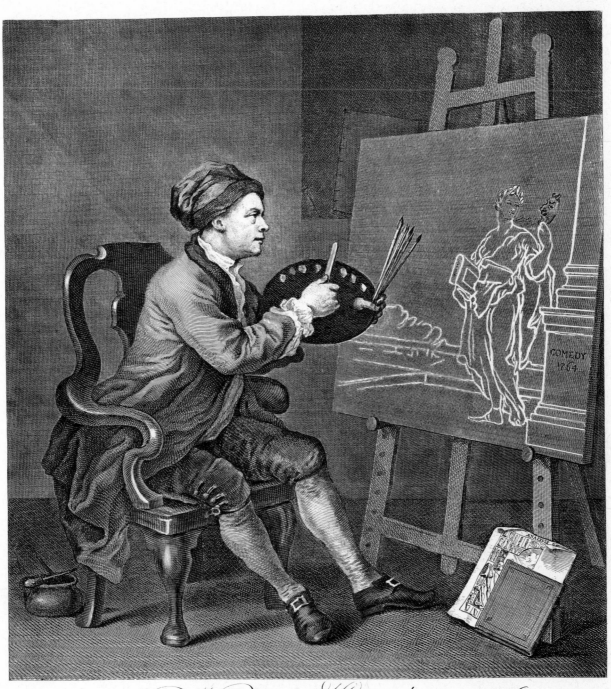

William Hogarth. 1764

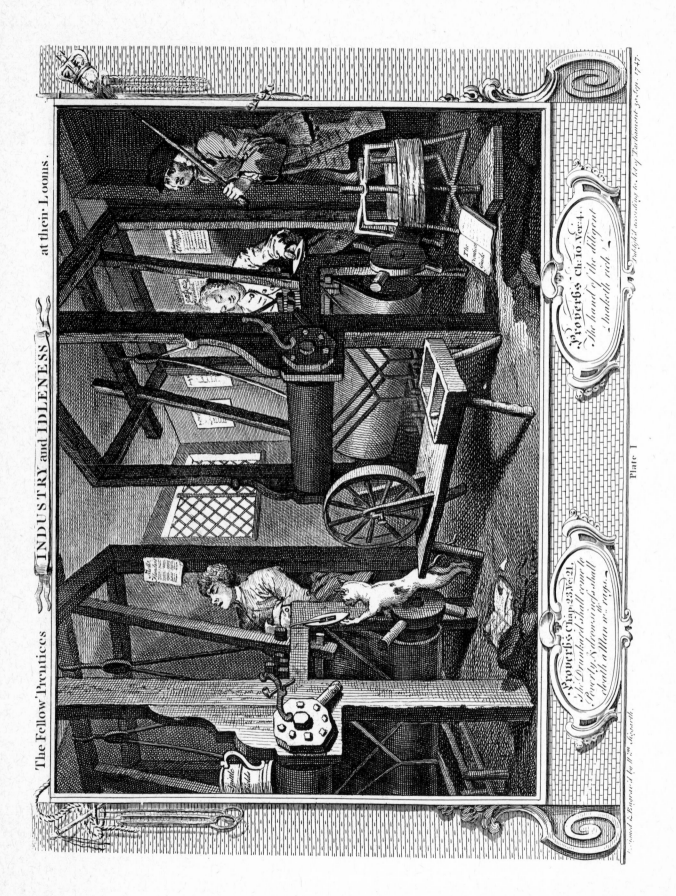

The Fellow 'Prentices INDUSTRY and IDLENESS at their Looms.

Proverbs Chap: 23 & c. 21.
The Drunkard shall come to
Poverty: & drowsiness shall
cloath a Man with rags.

Proverbs Ch: 10. Ver. 4.
The hand of the diligent
maketh rich.

Plate 1

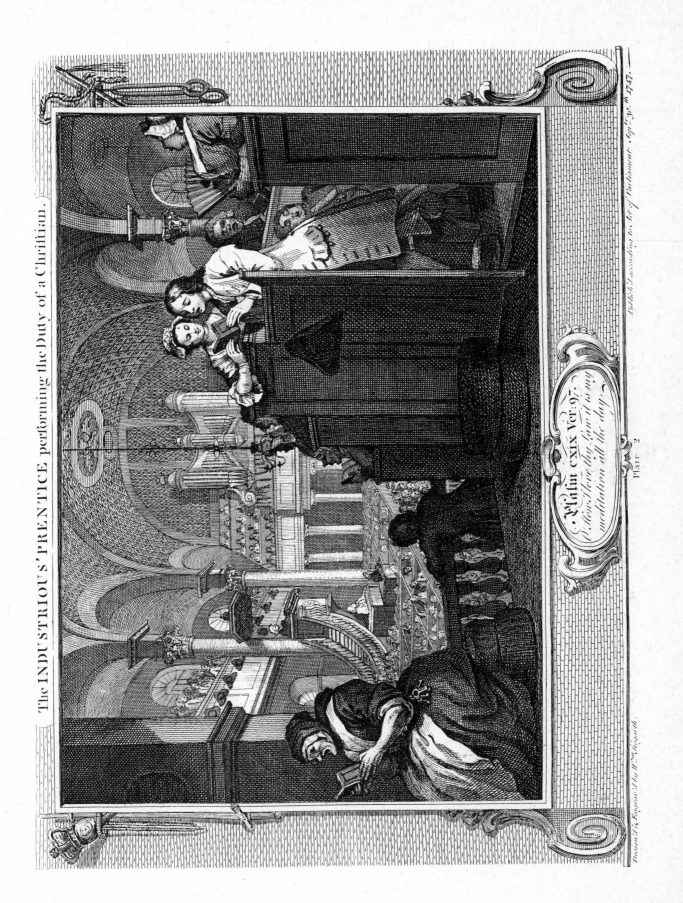

The INDUSTRIOUS 'PRENTICE performing the Duty of a Christian.

Psalm CXIX Ver: 97.
O how I love thy Law it is my meditation all the day.

Plate 2.

Design'd & Engrav'd by Wm. Hogarth.

Publish'd according to Act of Parliament . Sep. tr 30. th 1747.

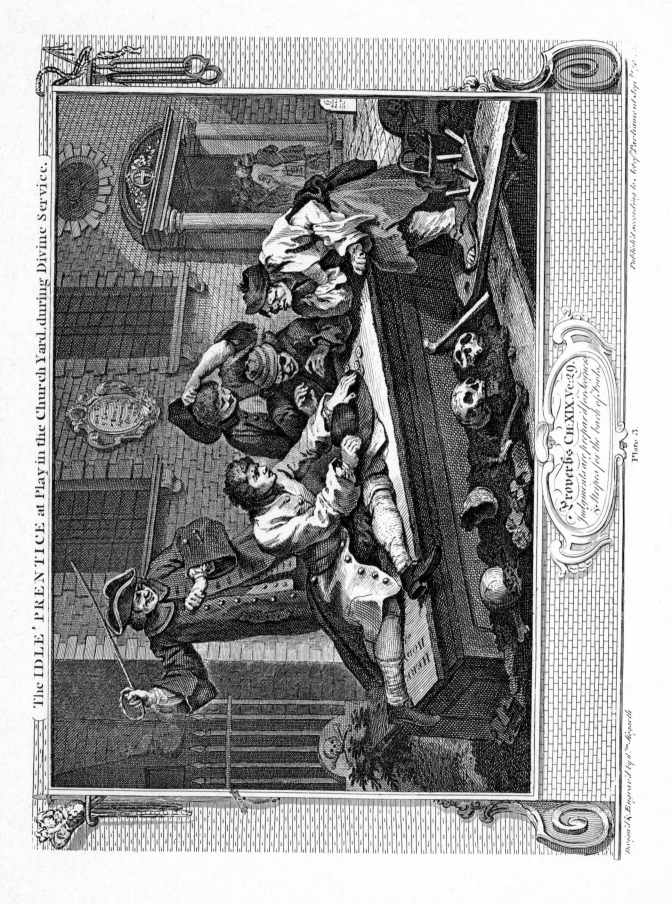

The IDLE ' PRENTICE at Play in the Church Yard, during Divine Service.

Proverbs Ch:XIX Ve:29.
Judgments are prepared for scorners
& Stripes for the back of fools.

Plate 3.

Desin'd & Engrav'd by W.m Hogarth

Publish'd According to Act of Parliament Sep.t 30.17—

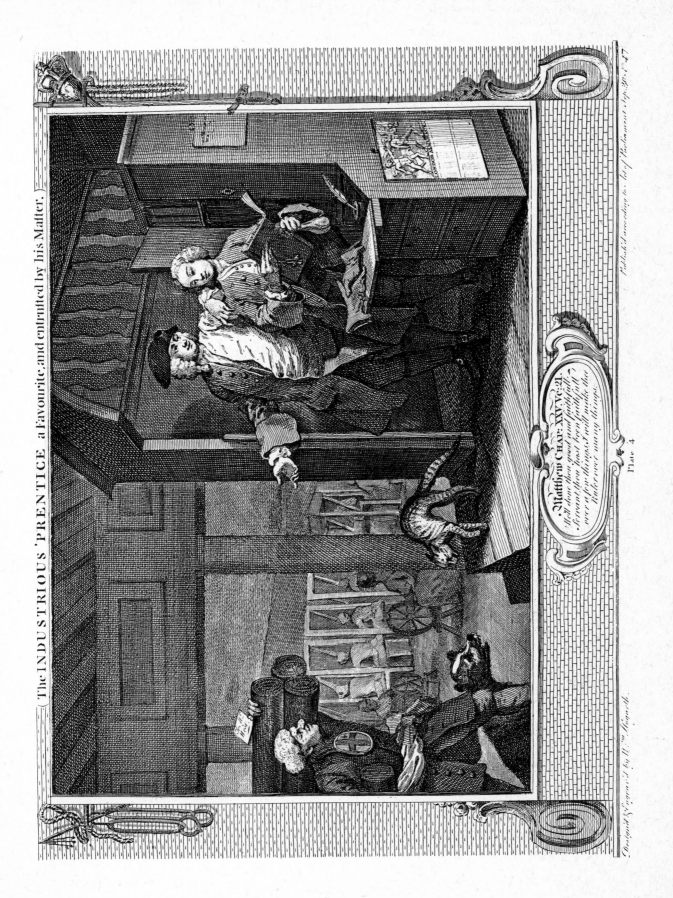

The INDUSTRIOUS 'PRENTICE a Favourite, and entrusted by his Matter.

Matthew Chap: XXV. Ve: 21.
Well done thou good and faithfull
Servant thou hast been faithfull
over a few things, I will make thee
Ruler over many things.

Plate 4

Designed & Engrav'd by W.m Hogarth.

Publish'd according to Act of Parliament Sep.t 30.th 1747

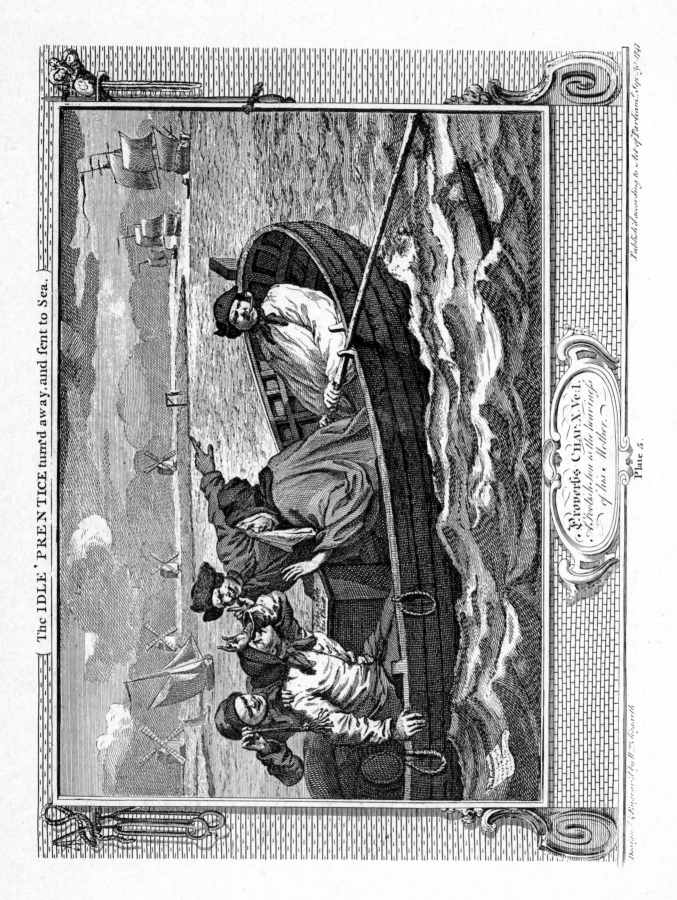

The IDLE 'PRENTICE turn'd away, and sent to Sea.

Proverb 6, Chap: X. Ve: 1.
A foolish Son is the heaviness of his Mother.

Plate 5.

Design'd & Engrav'd by Wm Hogarth

Publish'd according to Act of Parliamt Sepr 30 1747

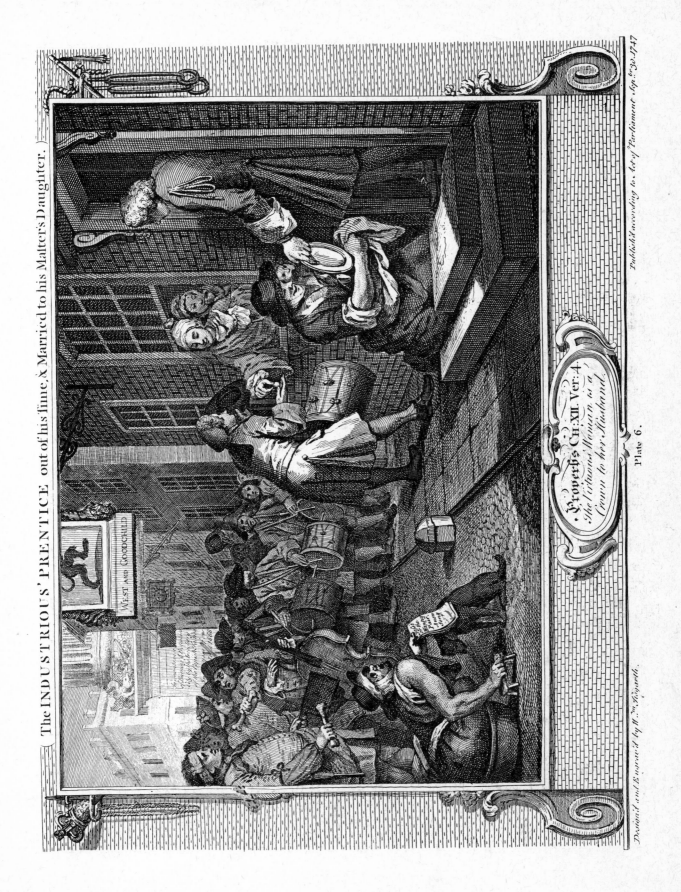

The INDUSTRIOUS' PRENTICE out of his Time, & Married to his Master's Daughter.

Proverbs Ch: XII Ver: 4.
She that is a Virtuous Woman is a
Crown to her Husband.

Plate 6.

Design'd and Engrav'd by W.m Hogarth.

Publish'd according to Act of Parliament Sep.br 30. 1747.

31

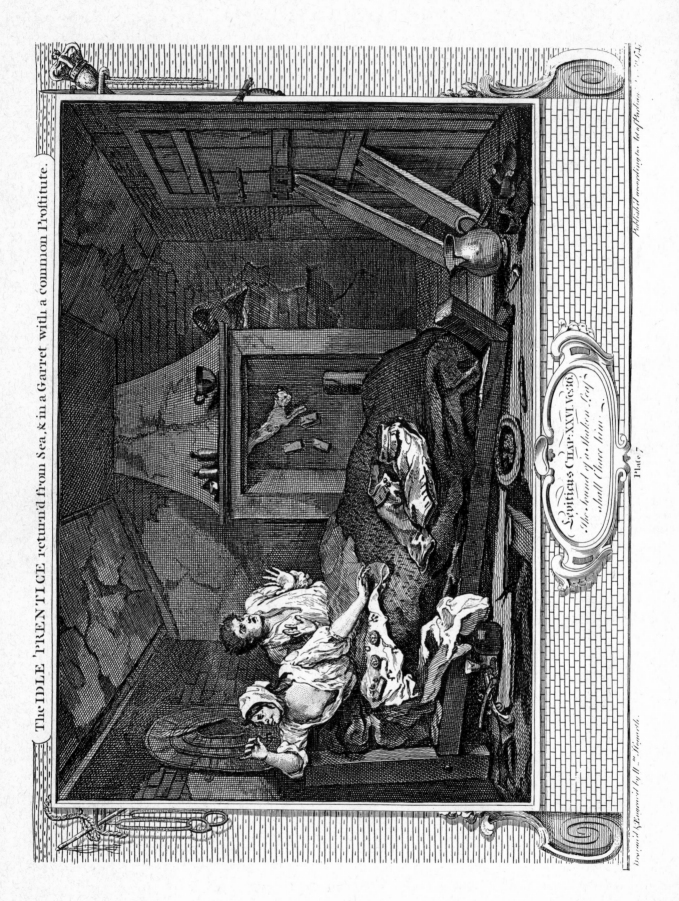

The IDLE 'PRENTICE return'd from Sea, & in a Garret with a common Proftitute.

Leviticus Chap: XXVI. Ve:36.
The Sound of a shaken Leaf
shall Chace him.

Plate 7.

Designd & Engraved by W.m Hogarth.

Published according to Act of Parliam.n 1747.

32

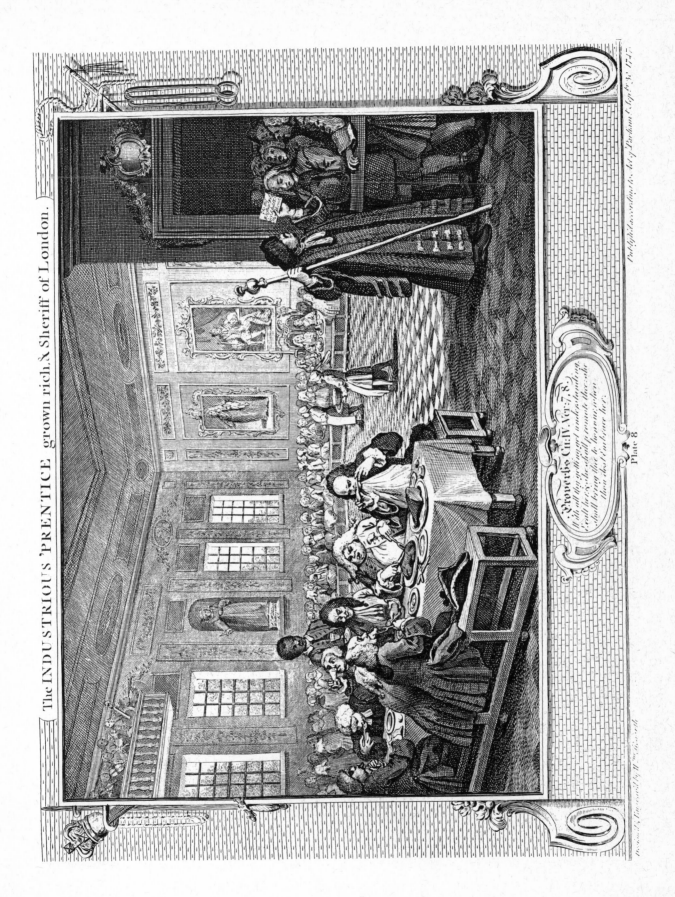

The INDUSTRIOUS 'PRENTICE grown rich, & Sheriff of London.

Proverbs Ch:IV. Ver:7, 8.
With all thy getting get understanding.
Exalt her & she shall promote thee, she
shall bring thee to honour, when
thou dost embrace her.

Plate 8

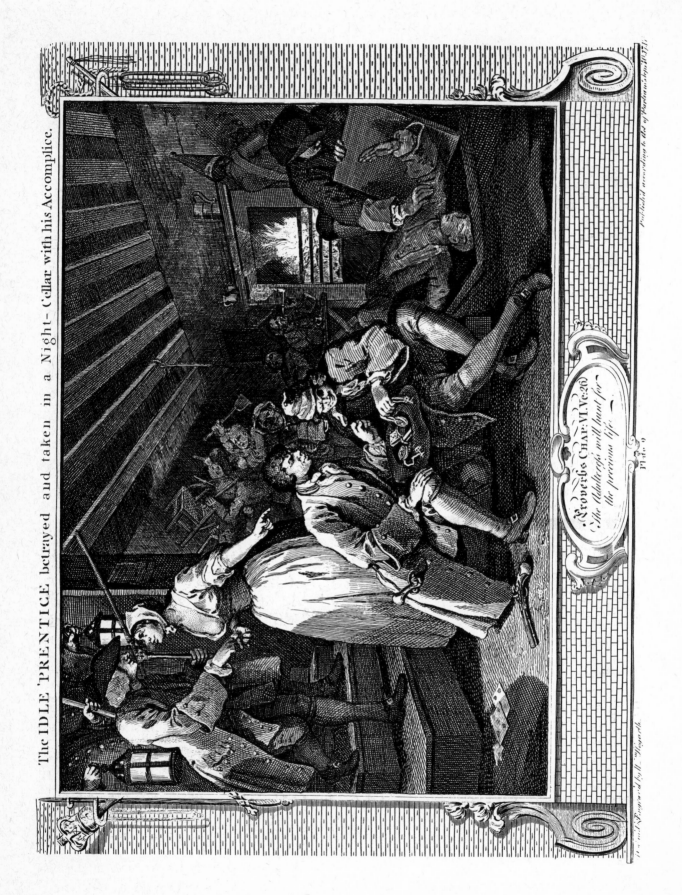

The IDLE PRENTICE betrayed and taken in a Night-Cellar with his Accomplice.

Proverbs Chap: VI. Ve. 26.
The Adulteress will hunt for the precious life.

Plate 9.

34

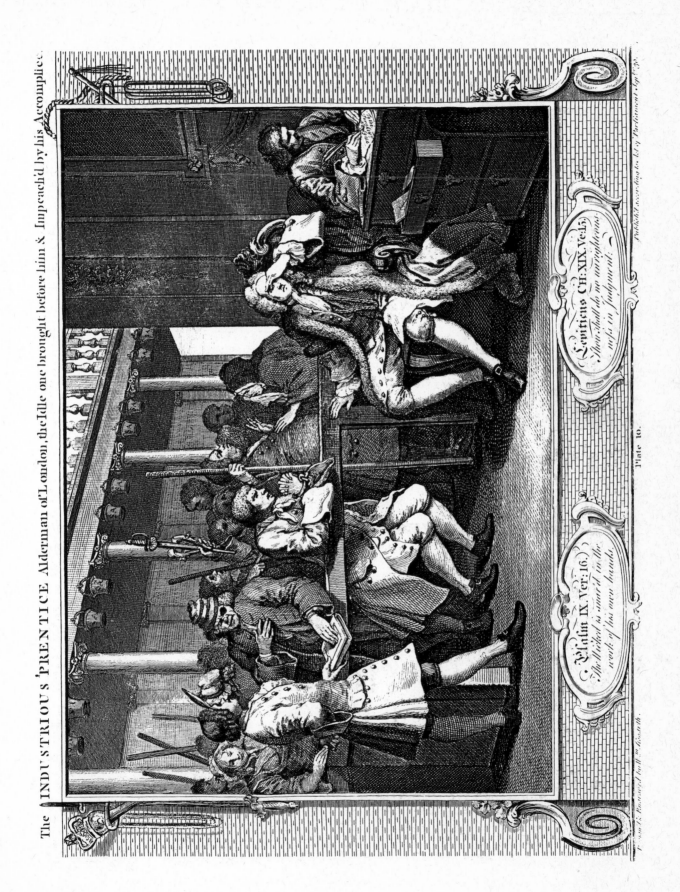

The INDUSTRIOUS 'PRENTICE Alderman of London, the Idle one brought before him & Impeach'd by his Accomplice.

Leviticus Ch:XIX.Ve:15.
Thou shalt do no unrighteousness in Judgment.

Psalm IX.Ver:16.
The wicked is snared in the work of his own hands.

Plate 10.

35

The IDLE PRENTICE Executed at Tyburn.

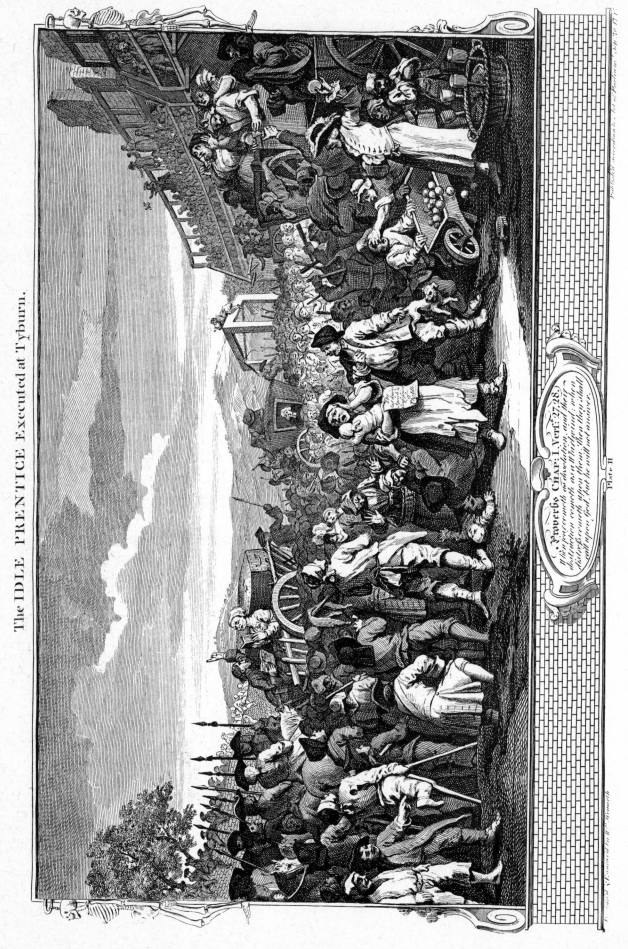

Proverbs Chap: I. Verſ: 27,28.
When fear cometh as desolation, and their
destruction cometh as a Whirlwind; when
distress cometh upon them; then they shall
call upon God, but he will not answer.

Plate 11

The INDUSTRIOUS 'PRENTICE Lord-Mayor of London.

Proverbs CHAP: III Ver: 16.
length of days is in her right hand, and
in her left hand Riches and Honour.

Plate 12

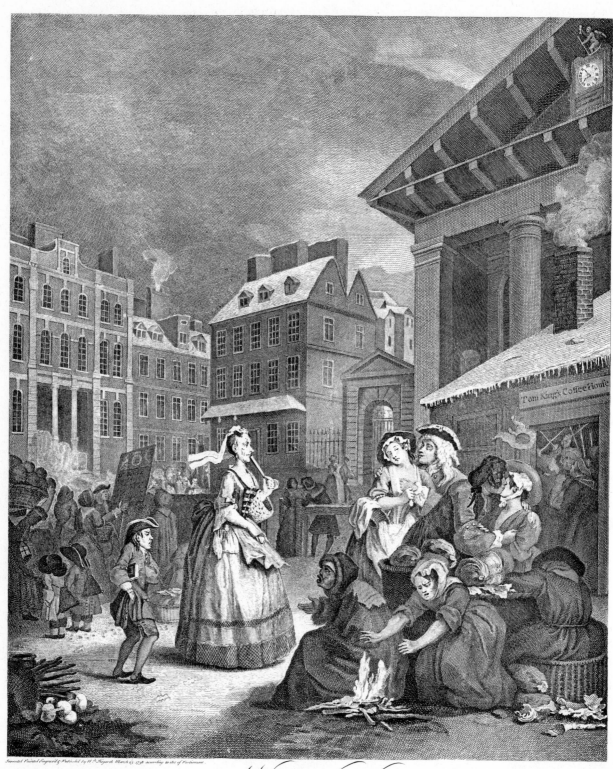

Invented Painted Engraved & Published by W.d Hogarth March 25 1738 according to Act of Parliament.

MORNING

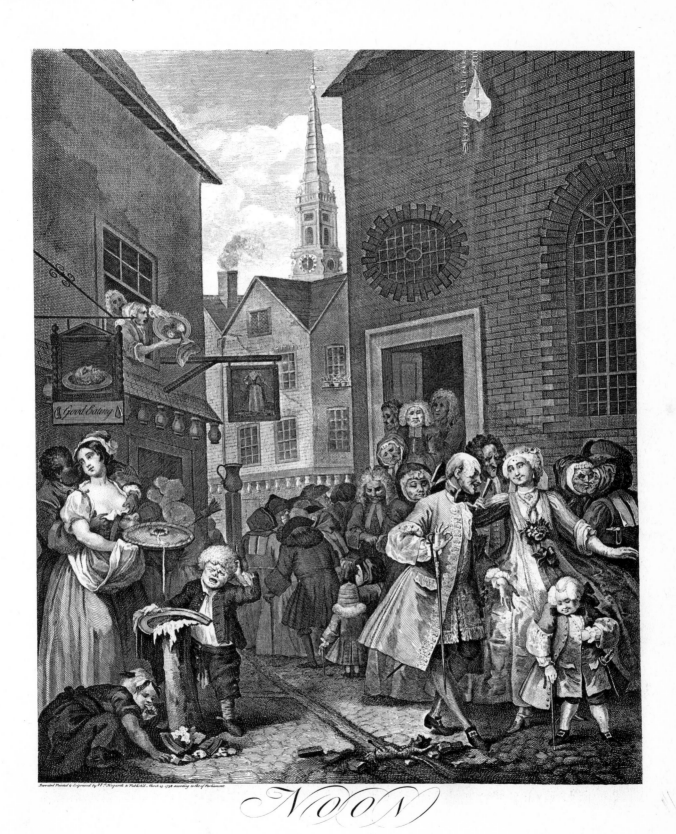

Invented Painted & Engraved by Wm. Hogarth & Publish'd, March 25 1738 according to the Act of Parliament.

NOON

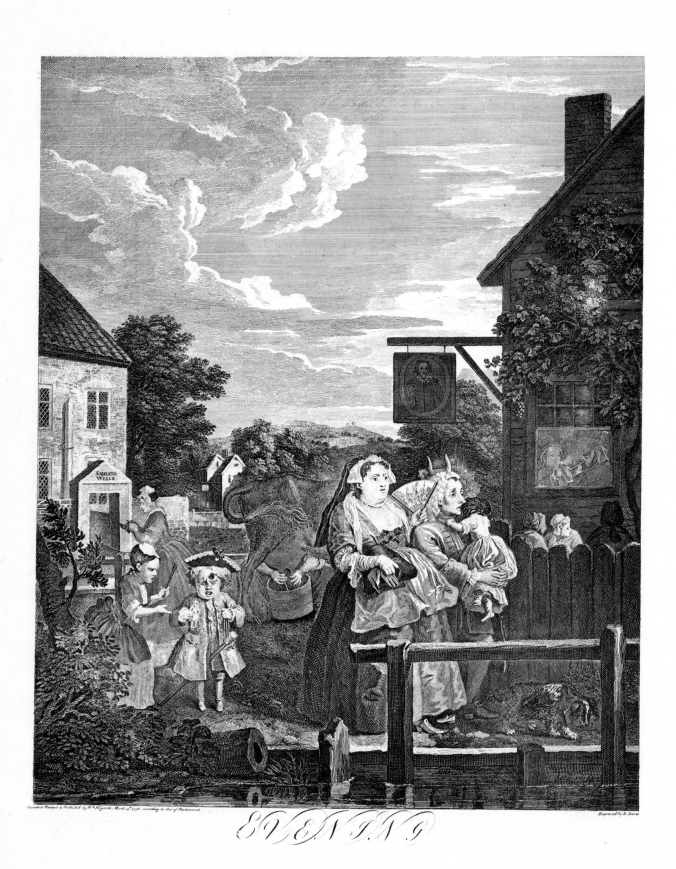

Invented Painted & Publish'd by Wm Hogarth, March 25th 1738, according to Act of Parliament

Engraved by B. Baron

EVENING

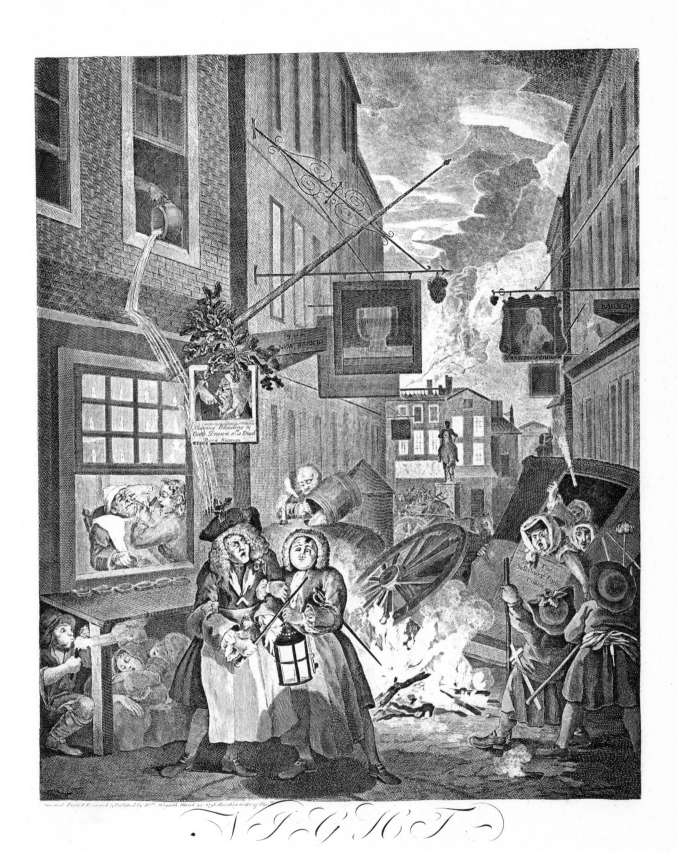

NIGHT

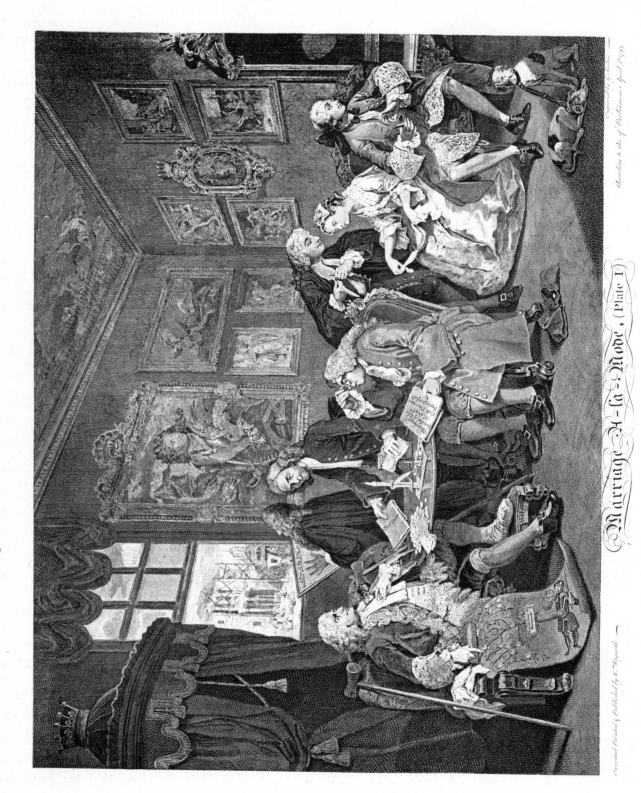

Marriage A - la - Mode, (Plate I)

Invented Painted & Published by W.^m Hogarth —

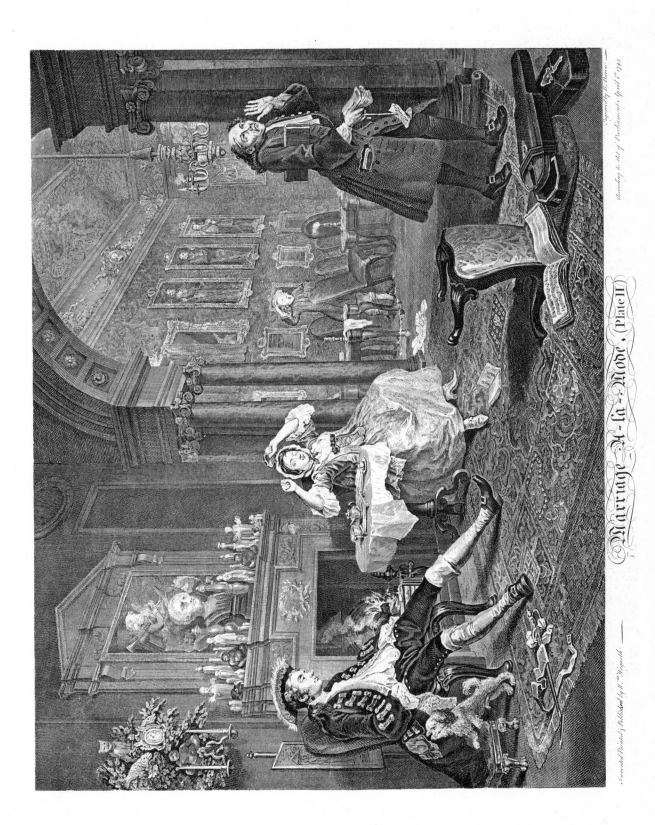

Invented Painted & Published by W.^m Hogarth —

Marriage A-la-Mode. (Plate II)

Engraved by B. Baron

According to Act of Parliament, April 1.st 1745

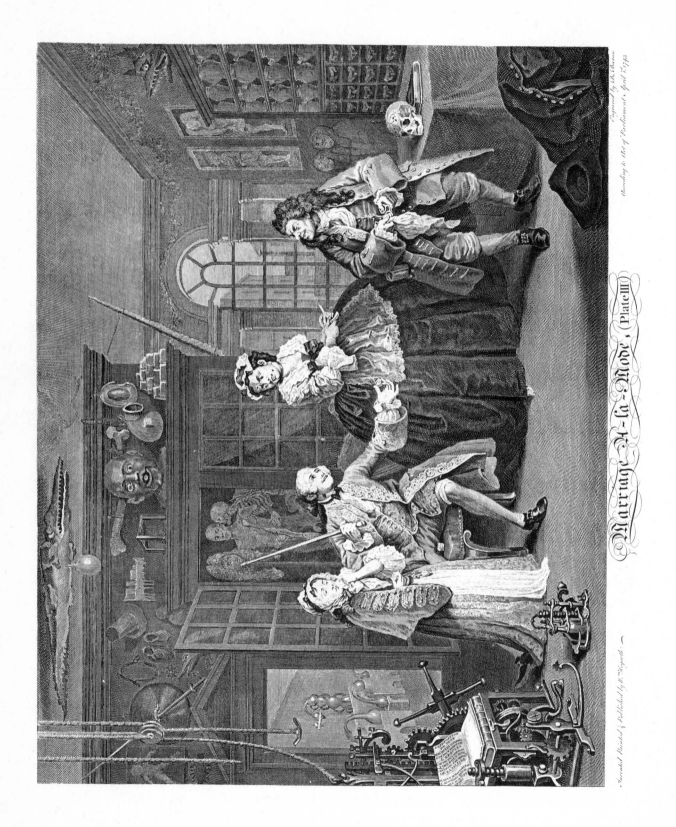

Invented, Painted, & Published by W.ᵐ Hogarth

Marriage A-la-Mode, (Plate III)

According to Act of Parliament, April 1.ˢᵗ 1745

Engraved by R. Baron

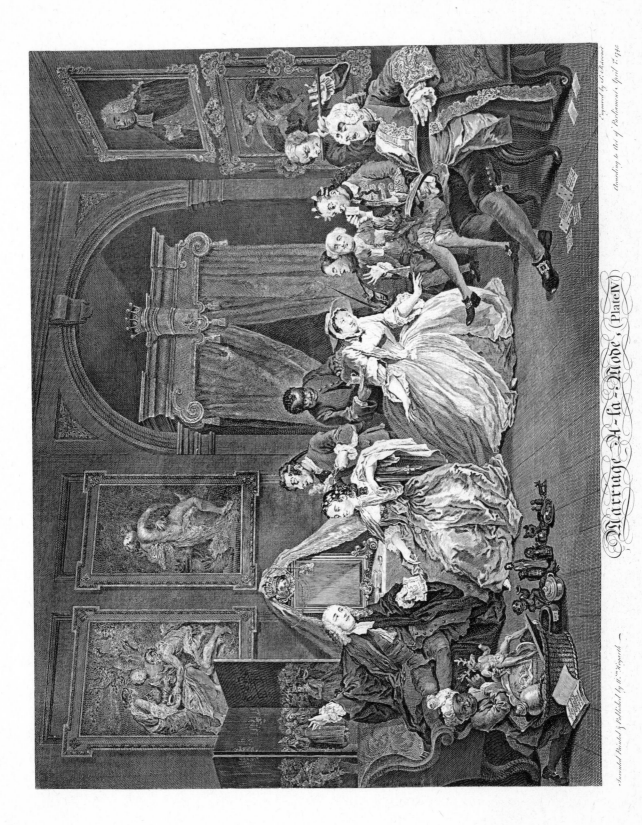

Marriage A–la–Mode. (Plate IV)

Invented Printed & Published by W.ᵐ Hogarth —

According to Act of Parliament, April 1ˢᵗ 1745

Engraved by S. Ravenet

45

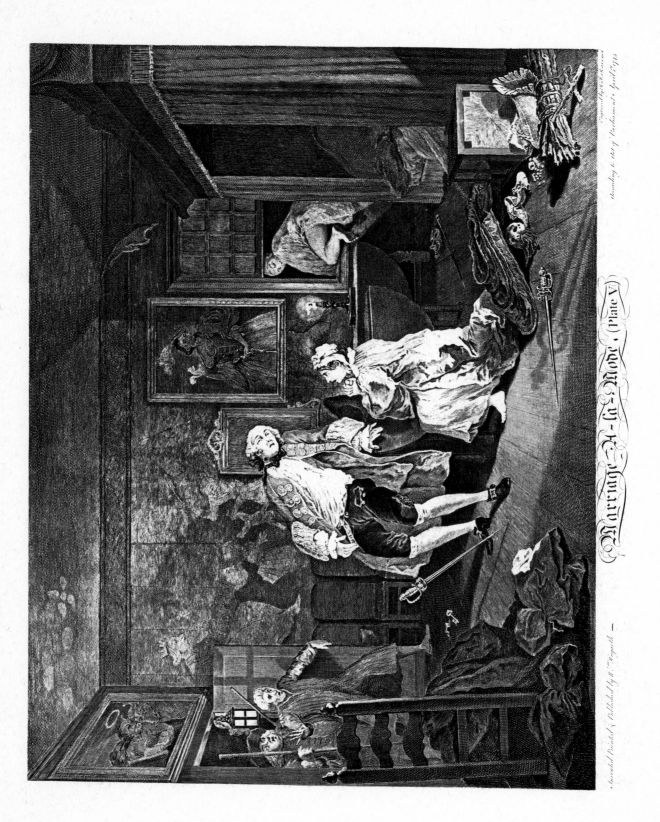

Marriage-À-la-Mode. Plate V

Invented Painted & Published by W.ᵐ Hogarth — According to Act of Parliam.ᵗ April 1745. Engraved by G. Scotin Paris.

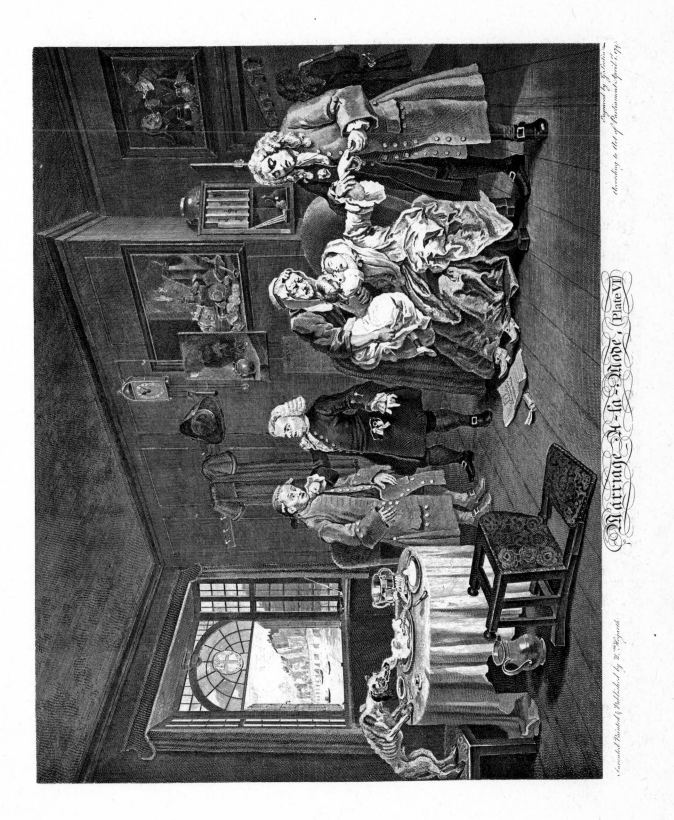

Marriage A-la-Mode. (Plate VI)

Invented Painted & Published by W.m Hogarth

Engraved by G. Scotin
According to Act of Parliament April 1. 1745

47

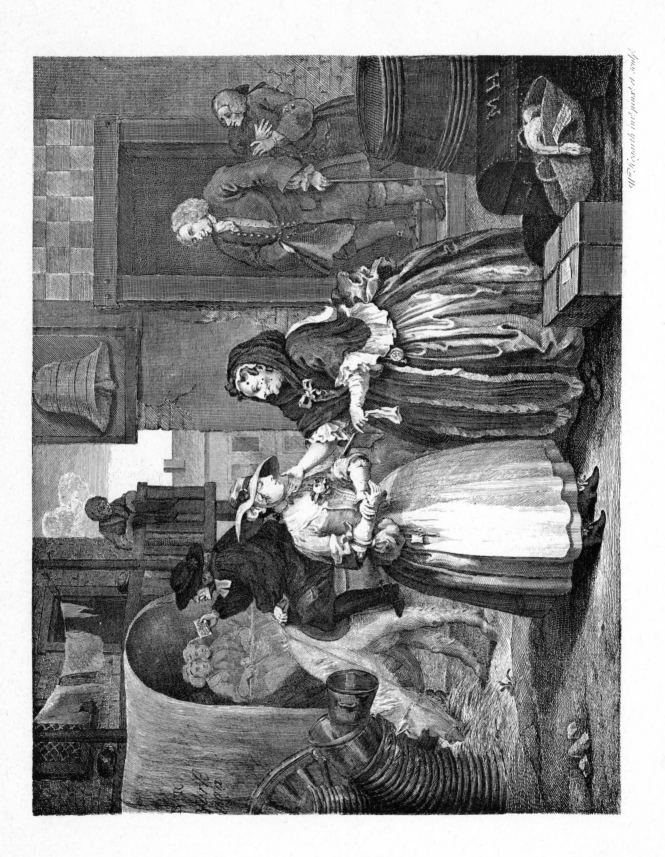

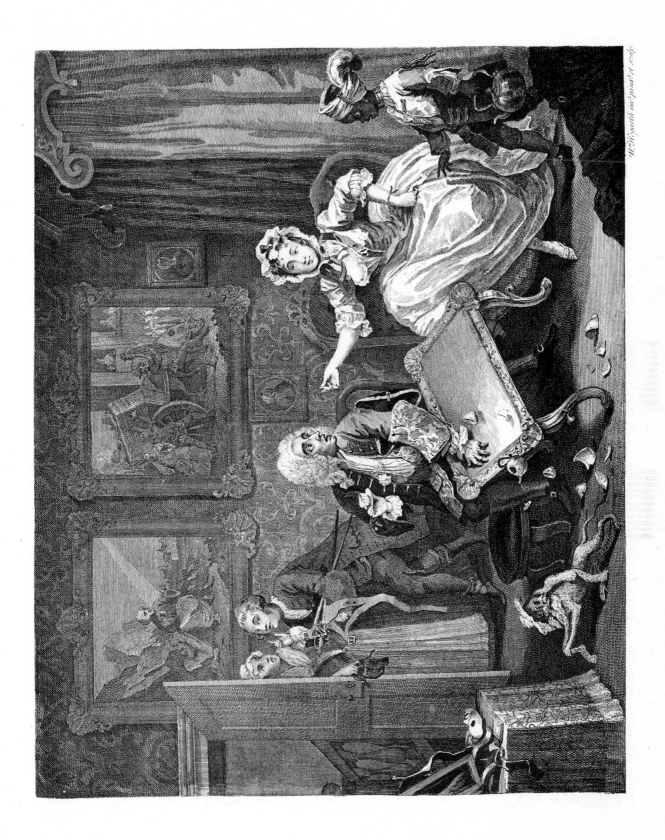

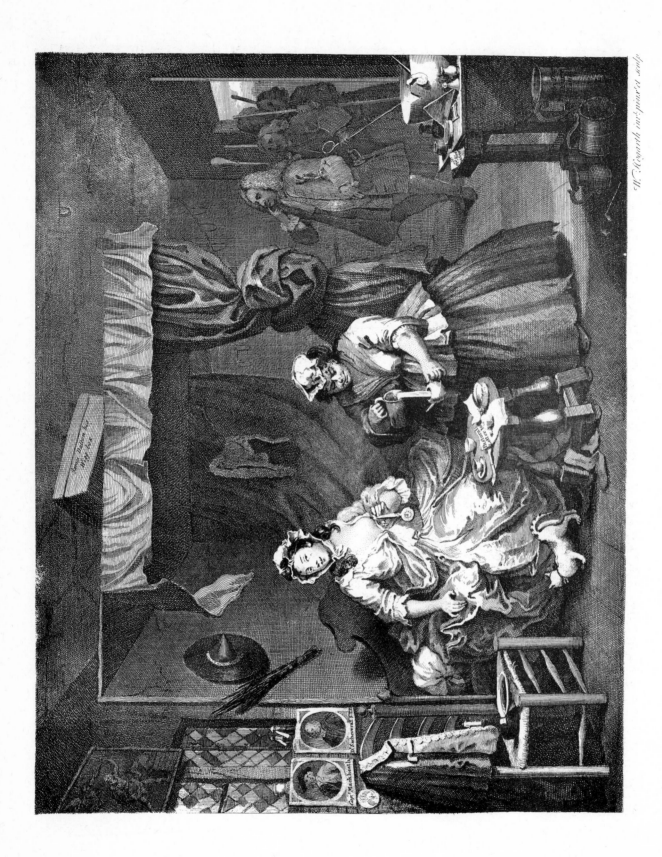

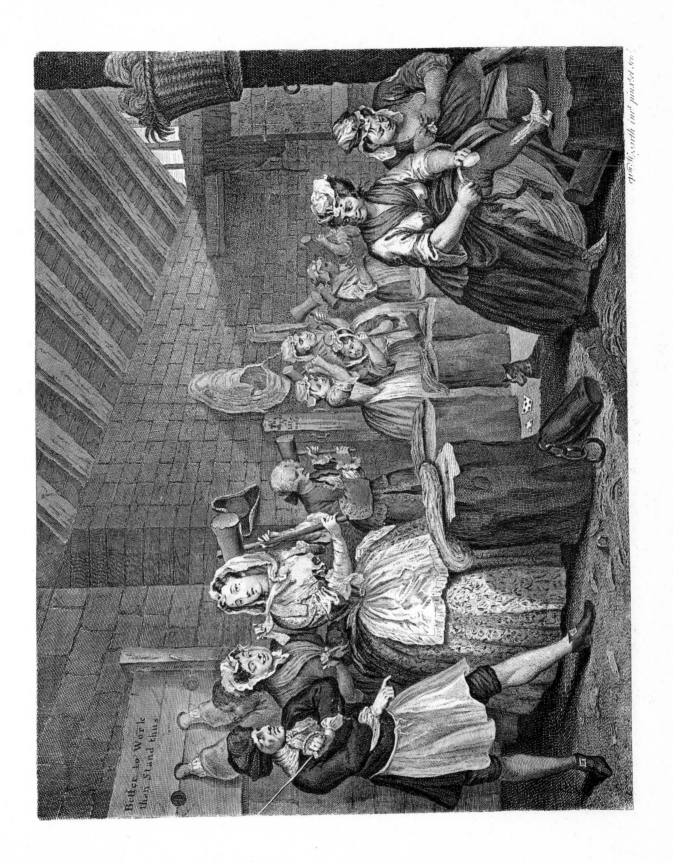

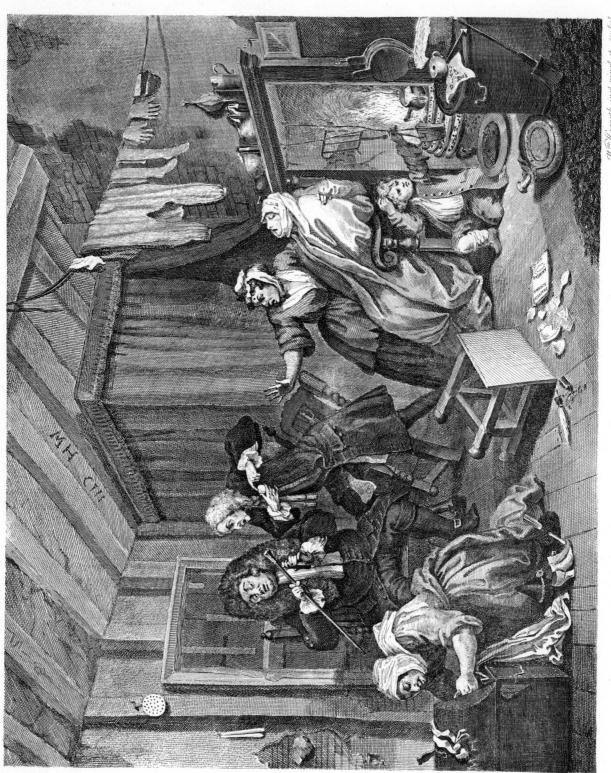

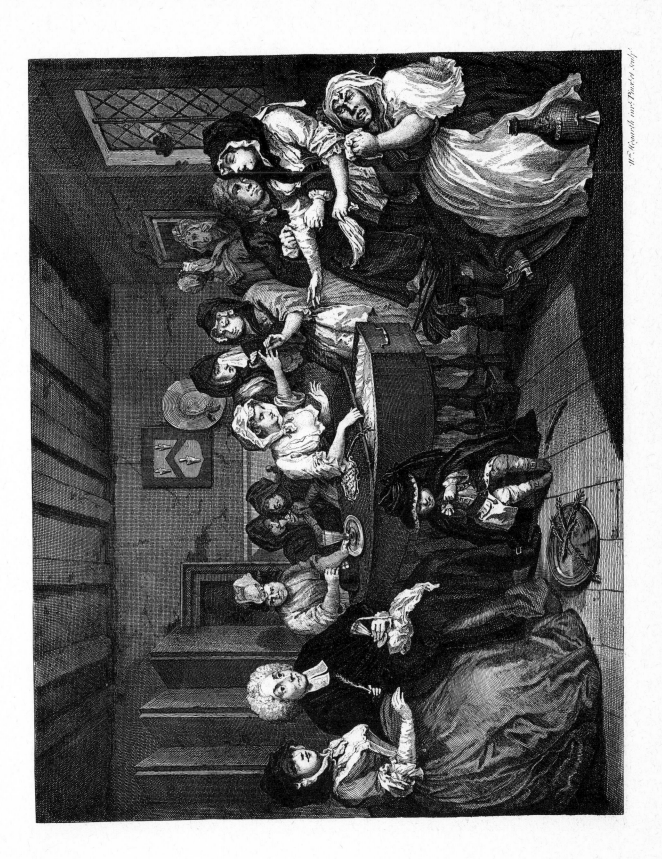

Wᵐ Hogarth inv Pinxit sculp.

53

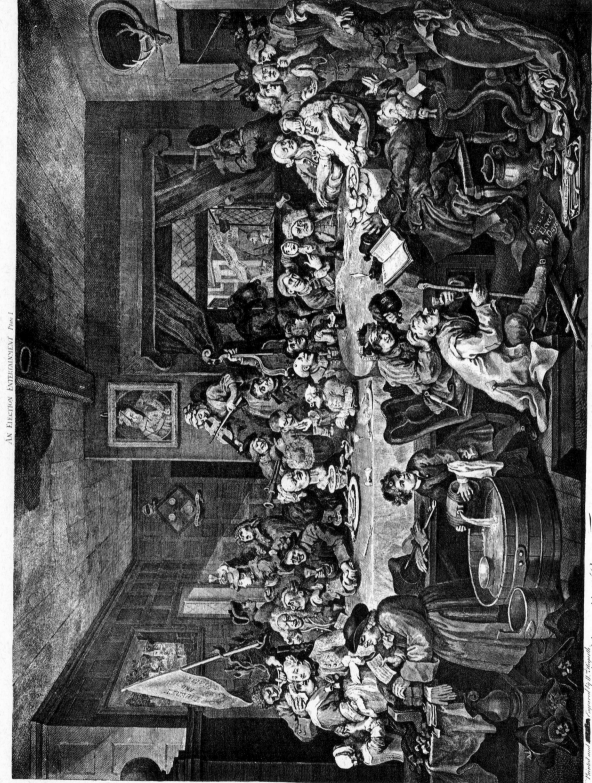

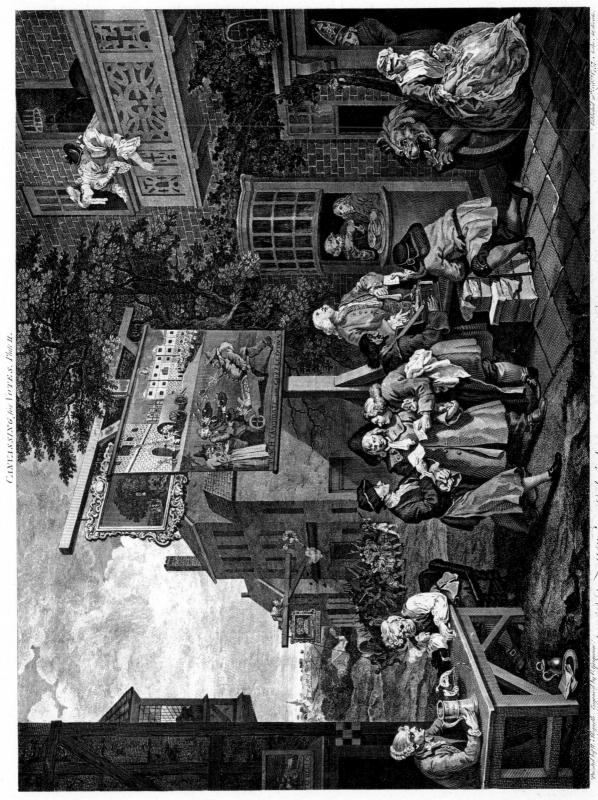

CANVASSING for VOTES. Plate II.

Painted by W. Hogarth. Engraved by C. Grignion.

To His Excellency. Ce Chevalier. Hanbury Williams Envoy Extraordinary to the Court of RUSSIA. This Plate is most humbly Inscribed. By his most Obedient humble Servant — W. Hogarth.

55

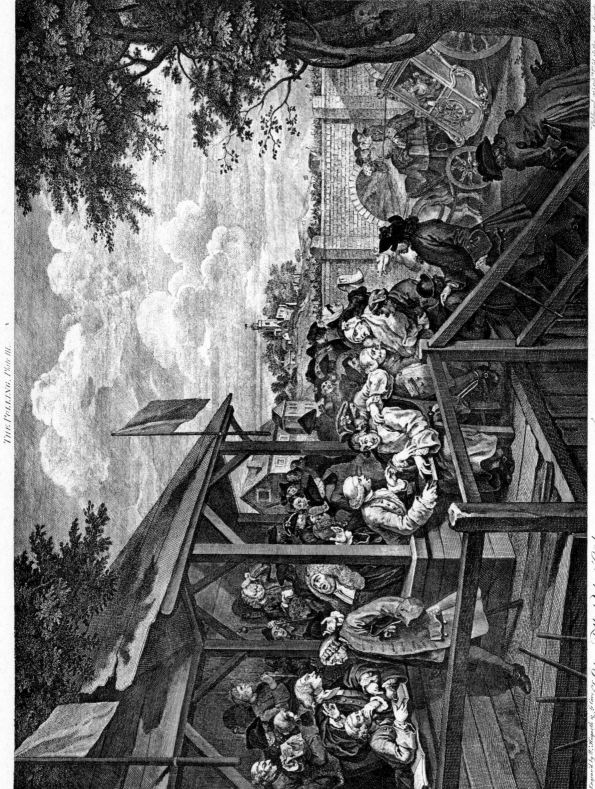

THE POLLING. Plate III.

Engraved by W. Hogarth & Grignion &c. Published with the Act of Parliament 1758. as the Act directs.

To the Right Hon.ble S.r Edward Walpole. Knight of the BATH.— This Plate is most humbly Inscribed. By— his most Obedient humble Servant. Will.m Hogarth

56

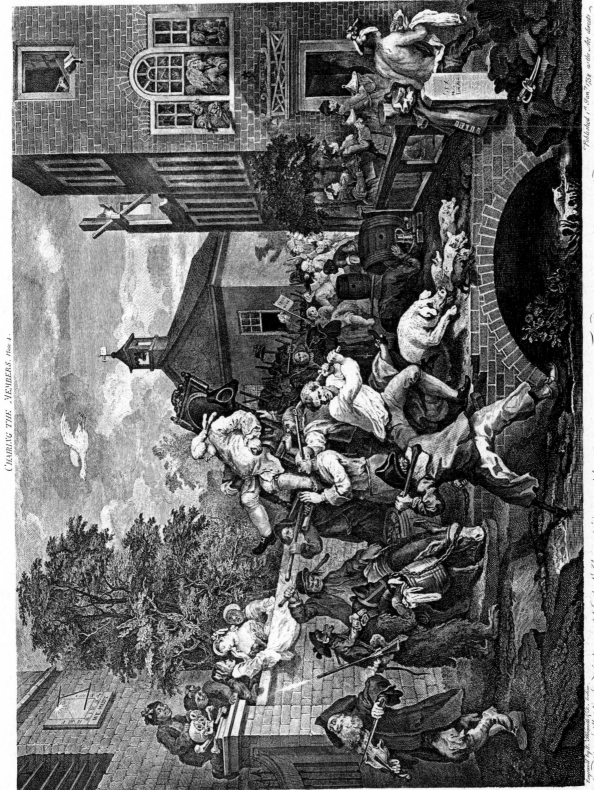

CHAIRING THE MEMBERS. *Plate 4.*

Engraved by W. Sharp...

Published 1.st Jan.y 1758 as the Act directs

To the Hon.ble George Hay one of the Lords Commissioners of the ADMIRALTY, &c. &c. ~ This Plate is most humbly Inscrib'd ~ By his most Obedient, humble Servant ~ Will.m Hogarth

Beer, happy Produce of our Isle
Can sinewy Strength impart,
And wearied with Fatigue and Toil
Can chear each manly Heart.

Labour and Art upheld by Thee
Successfully advance,
We quaff Thy balmy Juice with Glee
And Water leave to France.

Genius of Health, thy grateful Taste
Rivals the Cup of Jove,
And warms each English generous Breast
With Liberty and Love.

Design'd by W. Hogarth Published according to Act of Parliament Feb. 1. 1751.

GIN LANE.

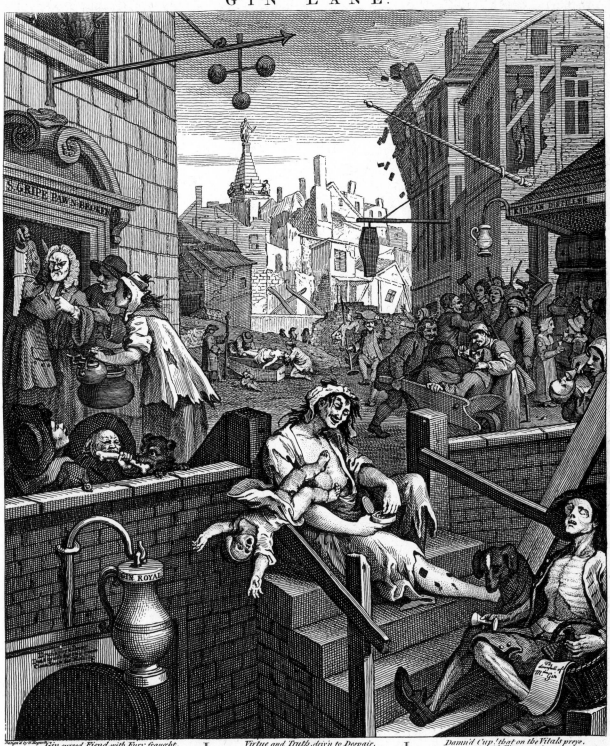

Gin cursed Fiend, with Fury fraught,
Makes human Race a Prey;
It enters by a deadly Draught,
And steals our Life away.

Virtue and Truth, driv'n to Despair,
It's Rage compells to fly,
But cherishes with hellish Care,
Theft, Murder, Perjury.

Damn'd Cup! that on the Vitals preys,
That liquid Fire contains,
Which Madness to the Heart conveys,
And rolls it thro' the Veins.

59

60

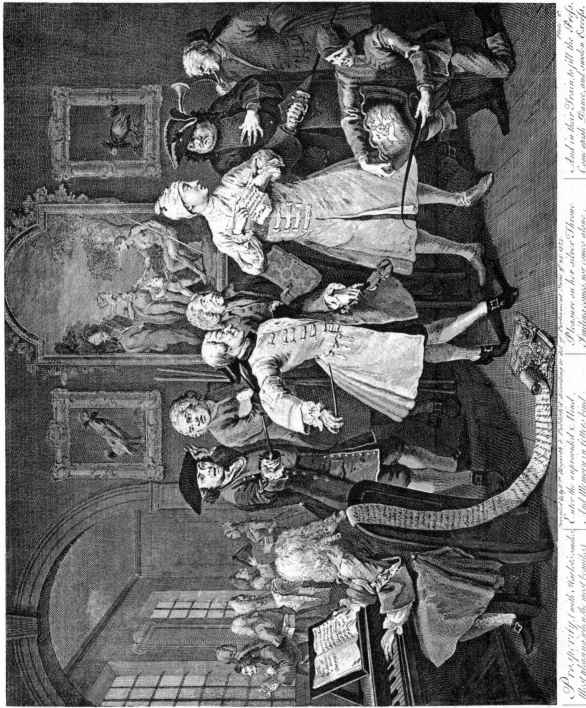

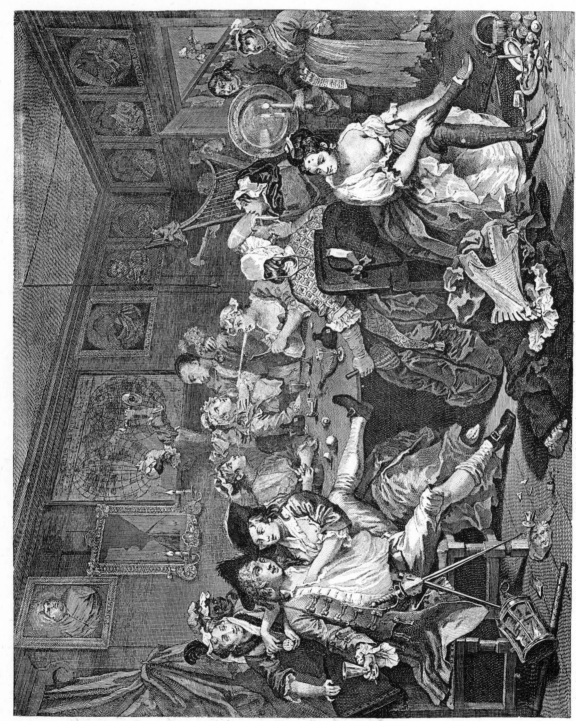

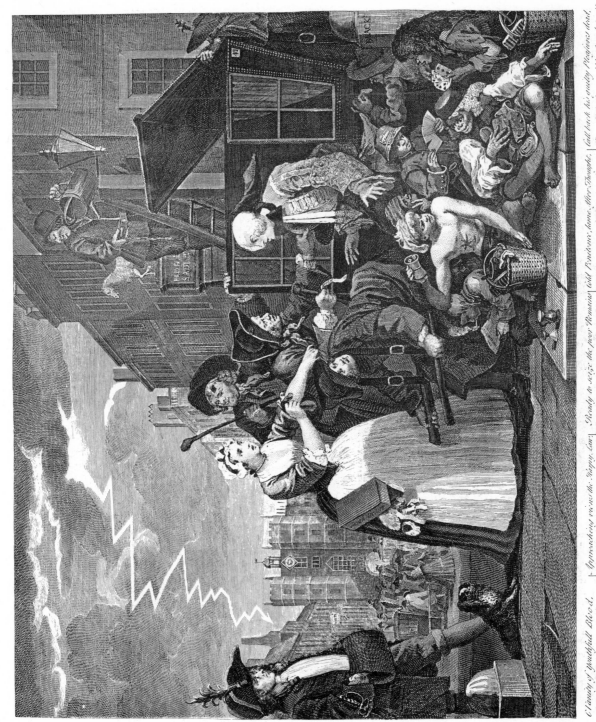

O Vanity of youthfull Blood,
So by Misuse to poison Good:
Reason awakes, & views unbarr'd
The sacred gates he watch'd to guard.

Approaching in his crimson Robe,
Alarms his Heart, his utter Thought:
And Pow'ry with a Train
...

Already to obey the new Romantic wild Pandora's dame:
That Vice hath kept of all this Gains:
With Vices Desparir &c.

(all back his mantica Pleasures stand,
When he hath revived's whom homit.

Invented Designd Engraved by Wm Hogarth & Publishd —————
June ye 25. 1735. According to ye Act of Parliament.

Plate. 4.

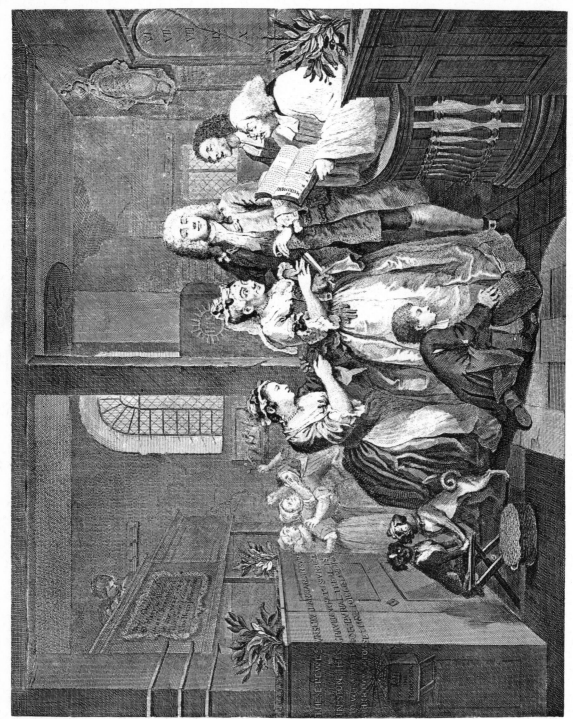

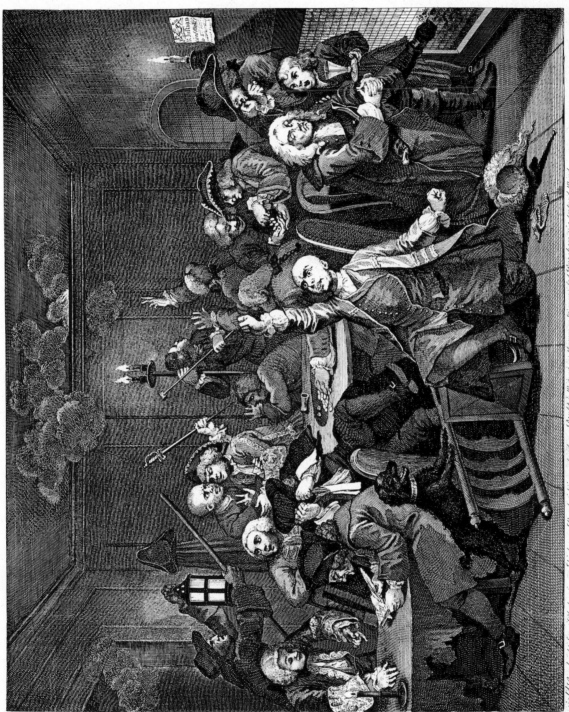

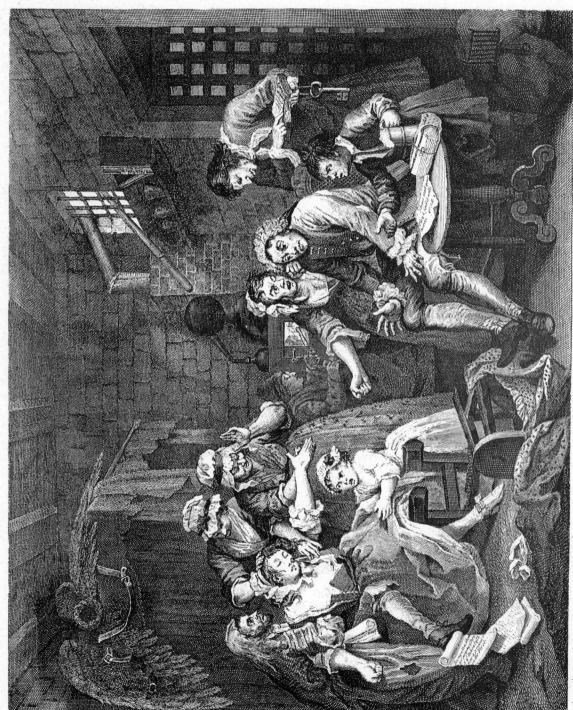

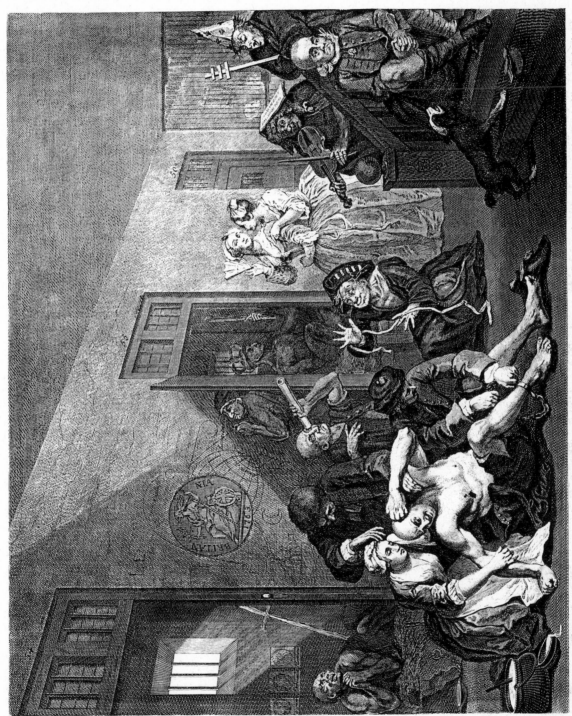

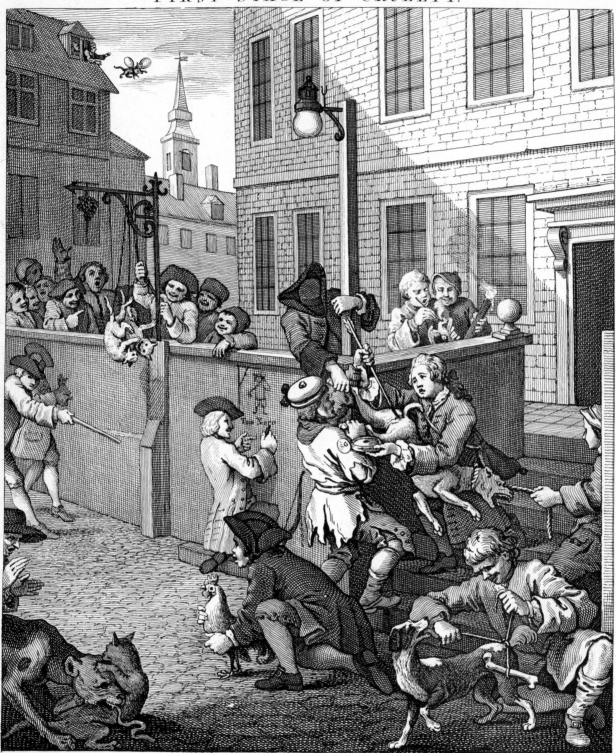

While various Scenes of sportive Woe
The Infant Race employ,
And tortur'd Victims bleeding shew
The Tyrant in the Boy.

Bebold!a Youth of gentler Heart,
To spare the Creature's pain,
O take, he cries—take all my Tart,
But Tears and Tart are vain.

Learn from this fair Example—You
Whom savage Sports delight,
How Cruelty disgusts the view
While Pity charms the sight.

Designd by W.Hogarth. Published according to Act of Parliament Feb.1.1751.

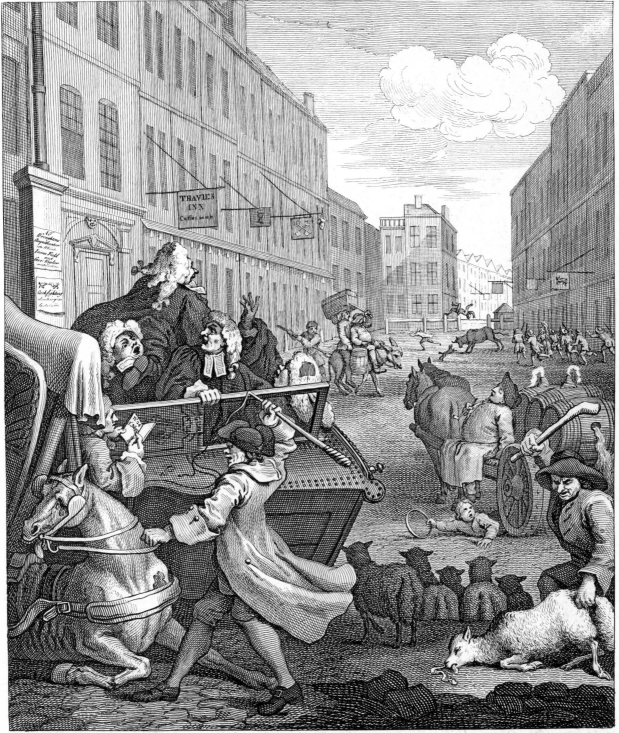

The generous Steed in hoary Age
Subdu'd by Labour lies;
And mourns a cruel Master's rage,
While Nature Strength denies.

The tender Lamb o'er drove and faint,
Amidst expiring Throws;
Bleats forth its innocent complaint
And dies beneath the Blows.

Inhuman Wretch! say whence proceeds
This coward Cruelty?
What Intrest springs from barbrous deeds?
What Joy from Misery?

Designed by W. Hogarth Published according to Act of Parliament Feb.i.1751.

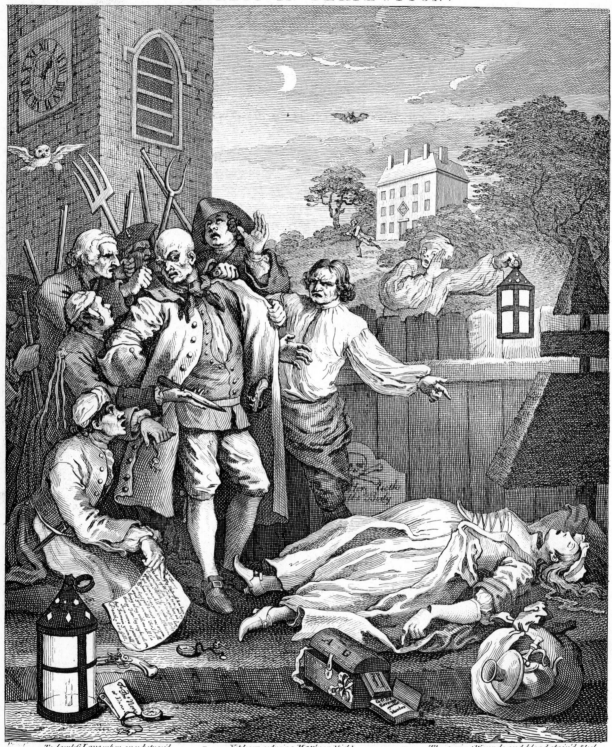

To lawless Love when once betray'd,
 Soon Crime to Crime succeeds:
At length beguil'd to Theft, the Maid
 By her Beguiler bleeds.

Yet learn, seducing Man! nor Night,
 With all its sable cloud,
Can screen the guilty Deed from Sight;
 Foul Murder cries aloud.

The gaping Wounds, and blood-stain'd Steel,
 Now shock his trembling Soul:
But Oh! what Pangs his Breast must feel,
 When Death his Knell shall toll.

Published according to Act of Parliament Feb.r 1.1751.

Design'd by W.Hogarth

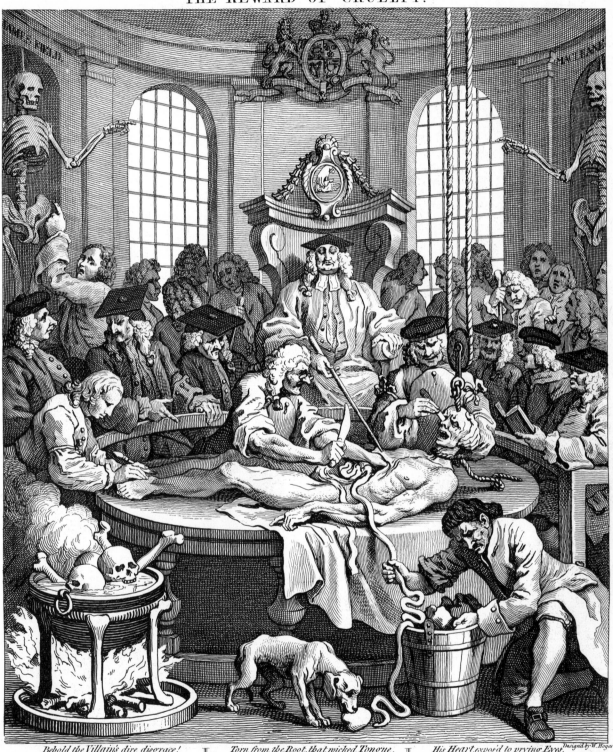

Behold the Villain's dire disgrace!
Not Death itself can end.
He finds no peaceful Burial Place;
His breathless Corse, no friend.

Torn from the Root, that wicked Tongue,
Which daily swore and curst!
Those Eyeballs, from their Sockets wrung,
That glow'd with lawless Lust!

His Heart, expos'd to prying Eyes,
To Pity has no Claim:
But, dreadful! from his Bones shall rise,
His Monument of Shame.

Designd by W. Hogarth.

Published according to Act of Parliament Feb.1.1751.

71

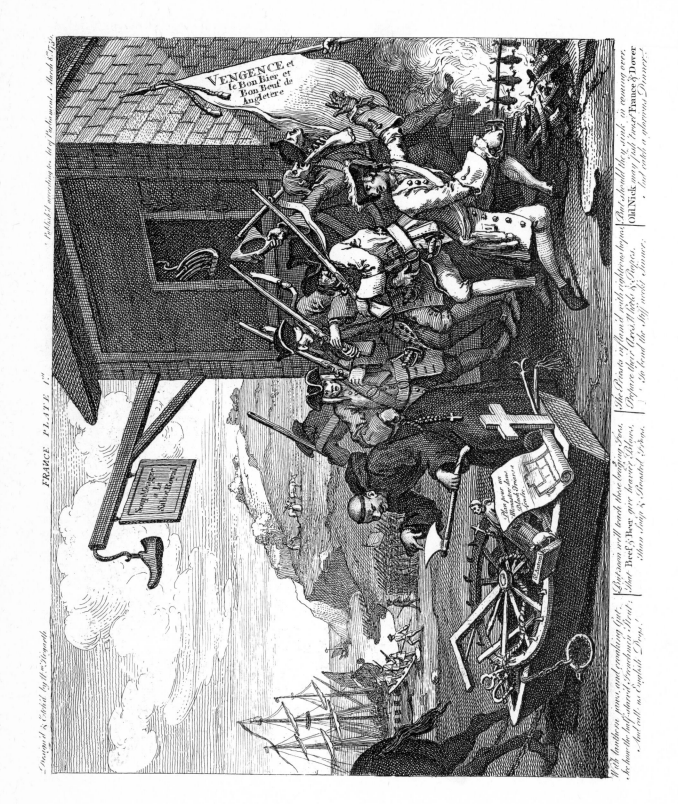

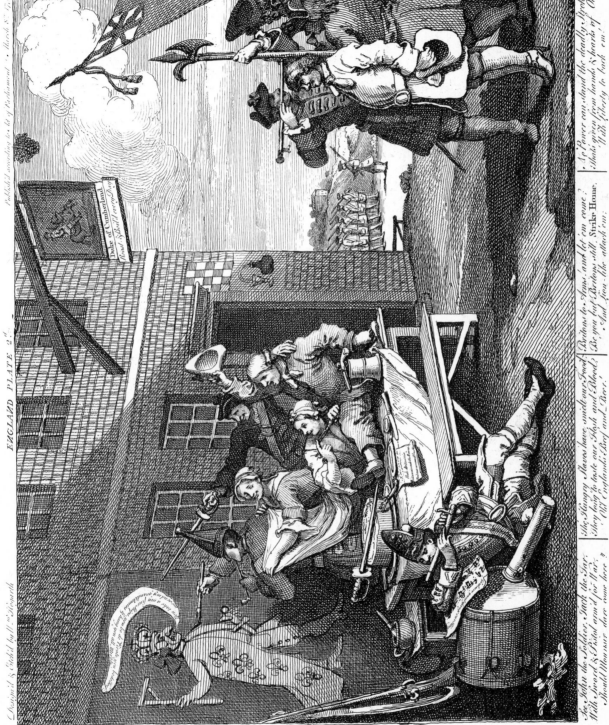

73

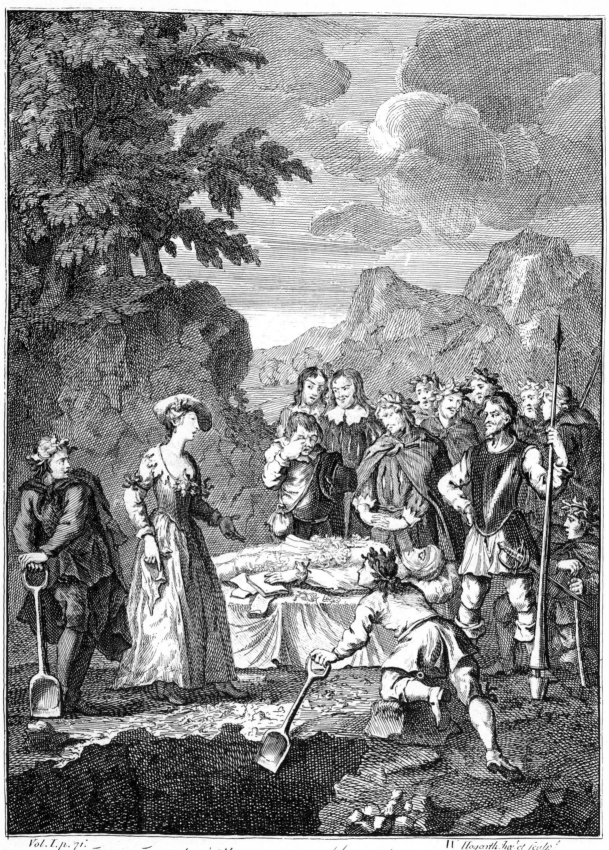

Vol. I. p. 71. W. Hogarth Inv.t et Sculp.t

The Funeral of Chrystom & Marcella vindicating herself.

Book 2nd Ch. 5th

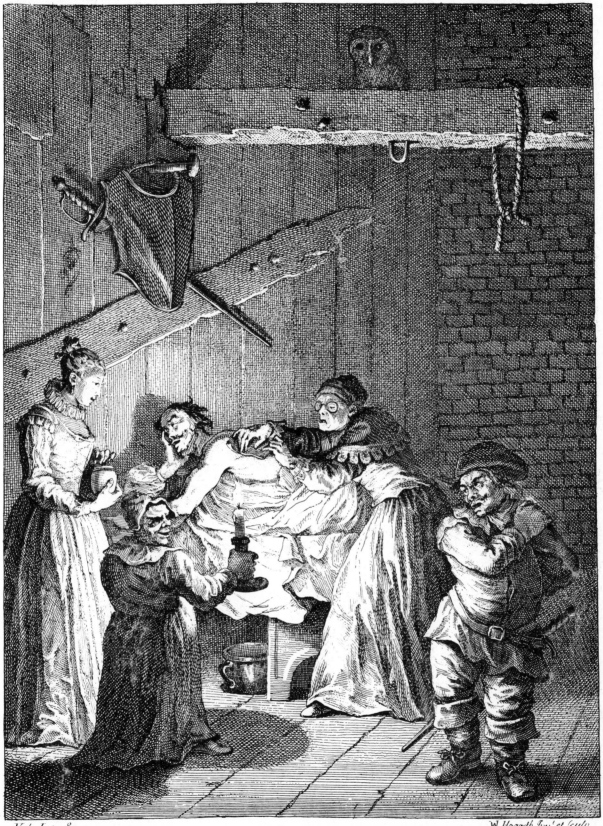

Vol. I. p. 80.

W Hogarth Inv.t et Sculp

The Innkeeper's Wife & Daughter taking Care of y.e Don after being beaten & bruised.
Book 3.rd Ch: 2.nd

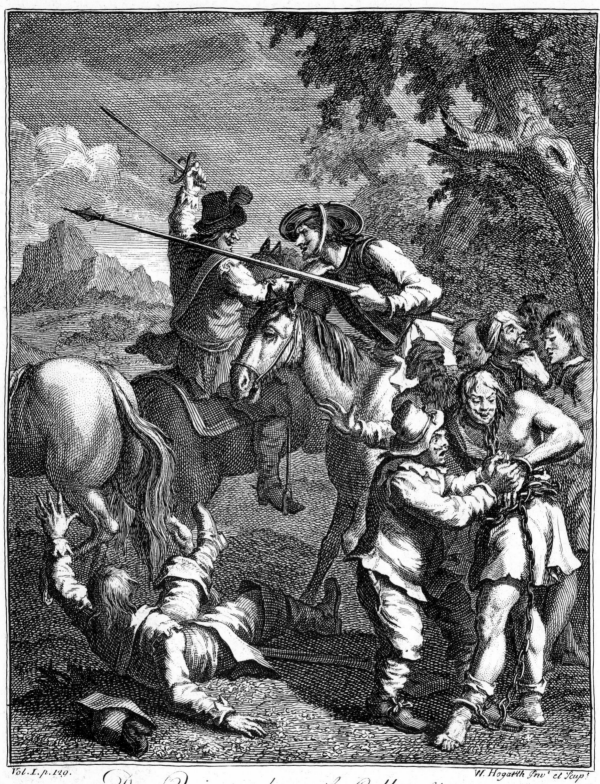

W. Hogarth Inv.t et Sculp.t

Don Quixote releases the Galley Slaves.

Book 3.rd Ch: 8.th

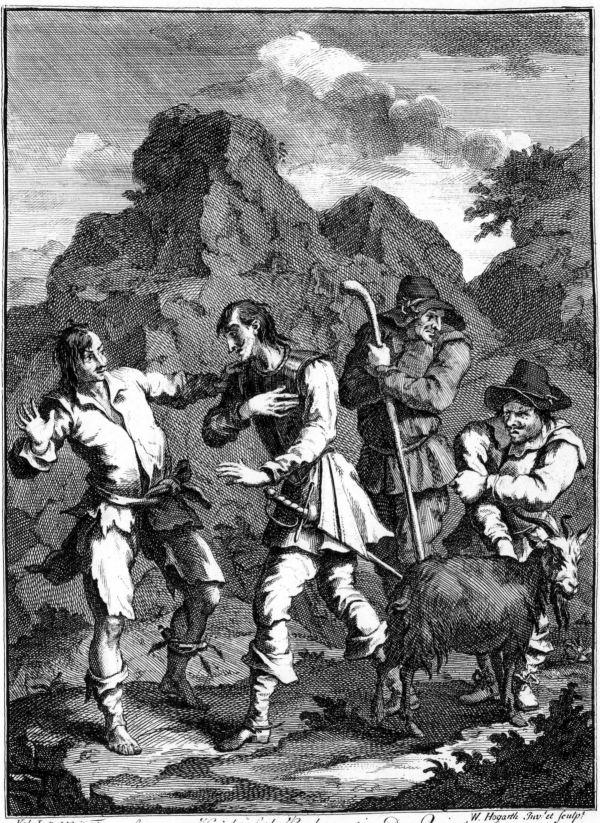

Vol. I. p. 140. *The unfortunate Knight of the Rock meeting Don Quixote.*
W. Hogarth Inv.t et sculp.t
Book 3.rd Ch: 9.th

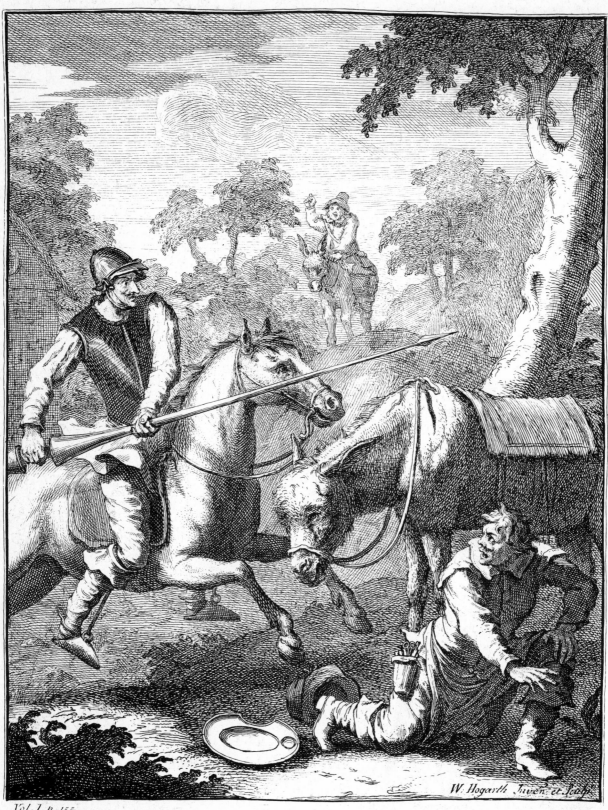

Vol. I. p. 155.

W. Hogarth *Inven. et Sculp.*

Don Quixote seizes the Barber's Bason for Mambrino's Helmet.
Book 3ʳᵈ Ch: 7ᵗʰ

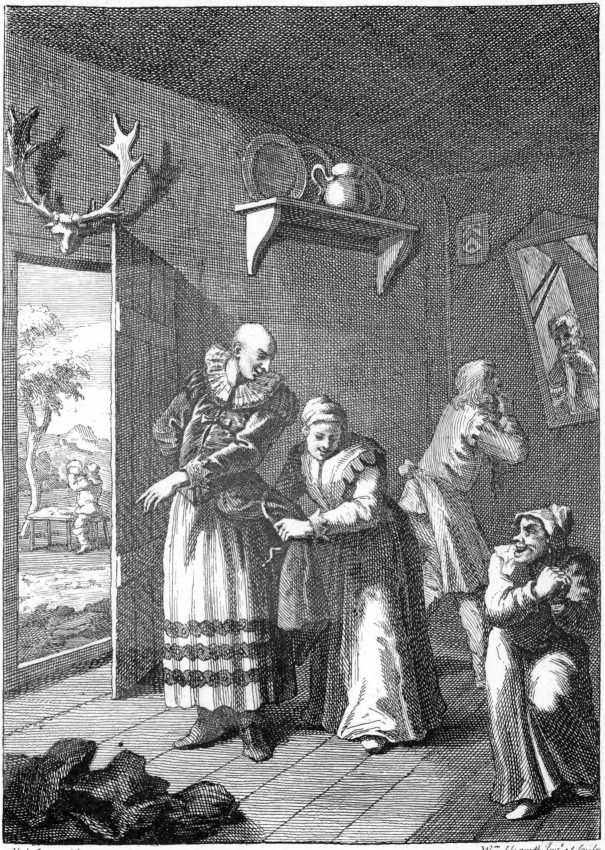

W.ᵐ Hogarth Inv.ᵗ et ſculp.

The Curate & Barber disguising themselves to convey D. Quixote home.
Book 3.ʳᵈ Ch: 13.ᵗʰ

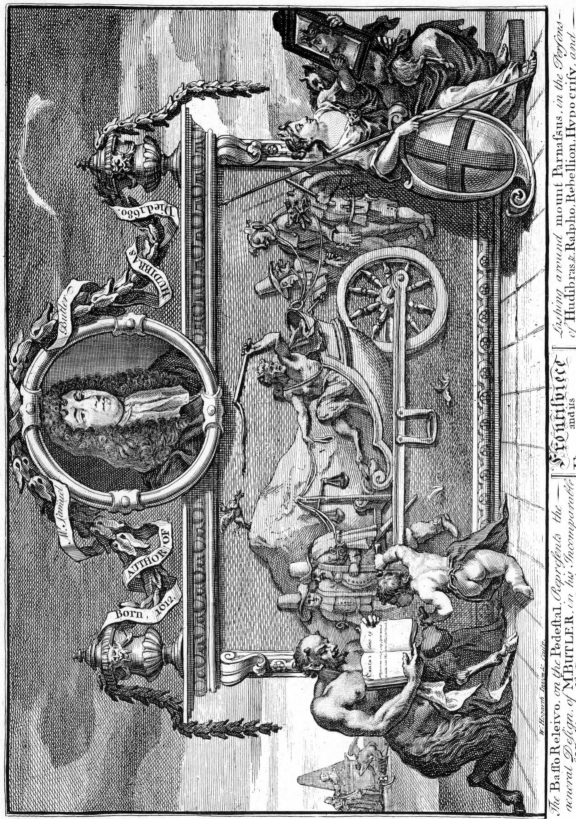

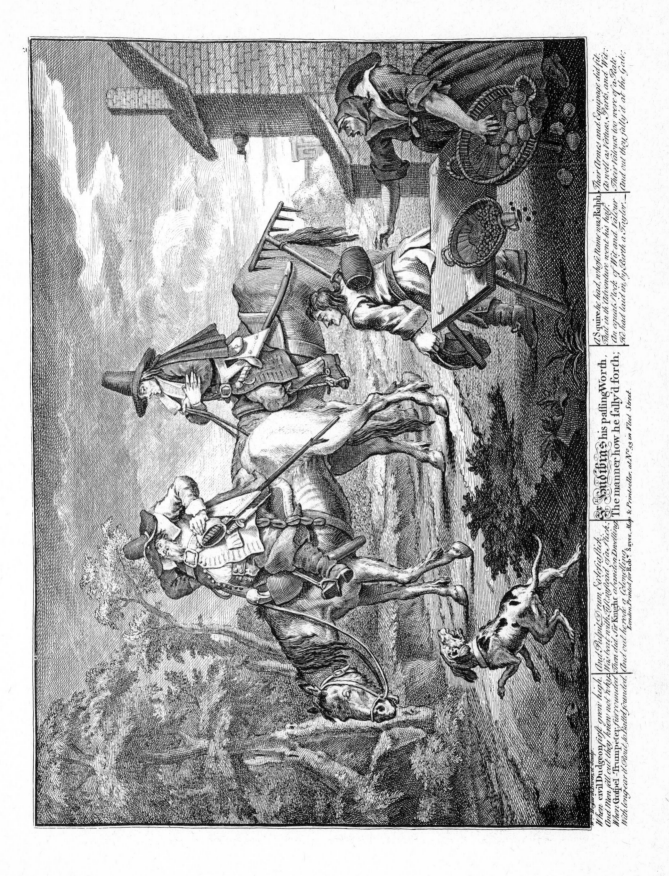

When crst Dudgeon grew so high.
And Men fell out they knew not why:
When Gospel-Trumpeter furrounded
With long-ear'd Rout, to Battle founded:

And Pulpit Drum Ecclesiastick.
Was beat with Fist instead of a Stick:
Then did Sir Knight abandon Dwelling.
And out he rode a Colonelling:

A Squire he had, whose name was Ralph.
That in th' Adventure went his half:
An equal Stock of Wit and Valour.
He had laid in, by Birth a Taylor—

Their Arms and Equipage did fit.
As well as Virtues, Parts, and Wit:
Their valours too were of a Rate.
And out they fally'd at the Gate.

HUDIBRAS his passing Worth.
The manner how he sally'd forth;

London Printed for Rob.t Sayer, Map & Printseller, at N.o 53 in Fleet Street.

81

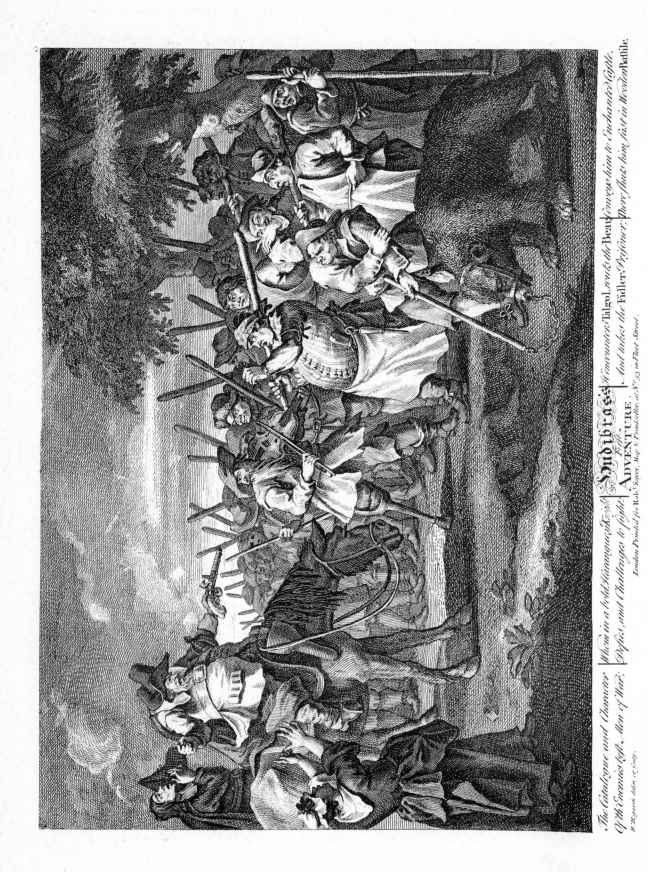

The Catalogue and Character | Whom in a bold Harmonious Knight | Incounters Talgol, routs the Bear, conveys him to Enchanted Castle,
Of th' Enemies leßt Men of War: | Defaći, and Chellenges to fight: | And takes the Fidler Pris'ner: there shuts him fast in Wooden Battile.

Hudibras

The ADVENTURE.

London Printed for Rob.ᵗ Sayer, Map. & Printseller, at Nᵒ 53 in Fleet Street.

W. Hogarth delin. et sculp.

82

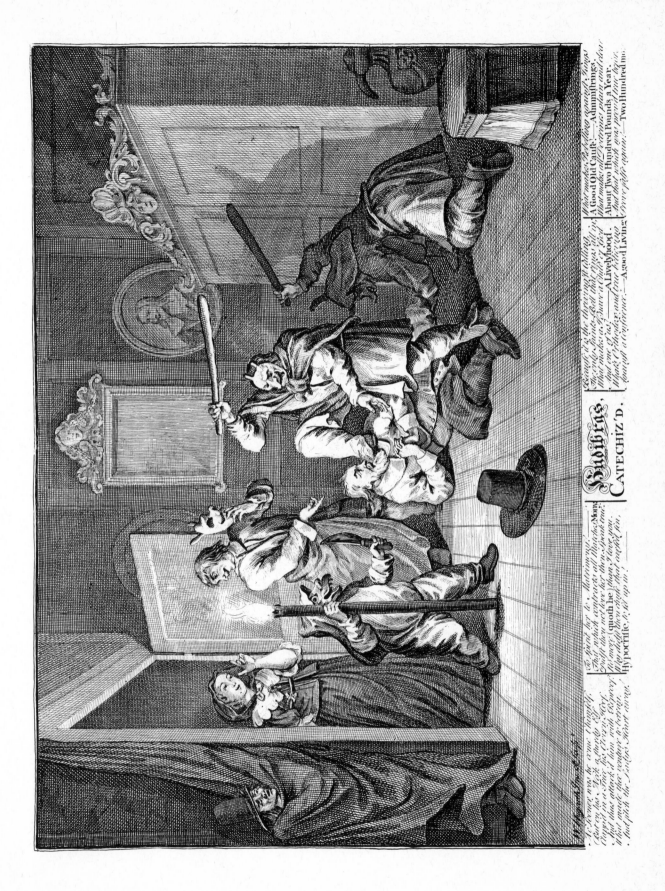

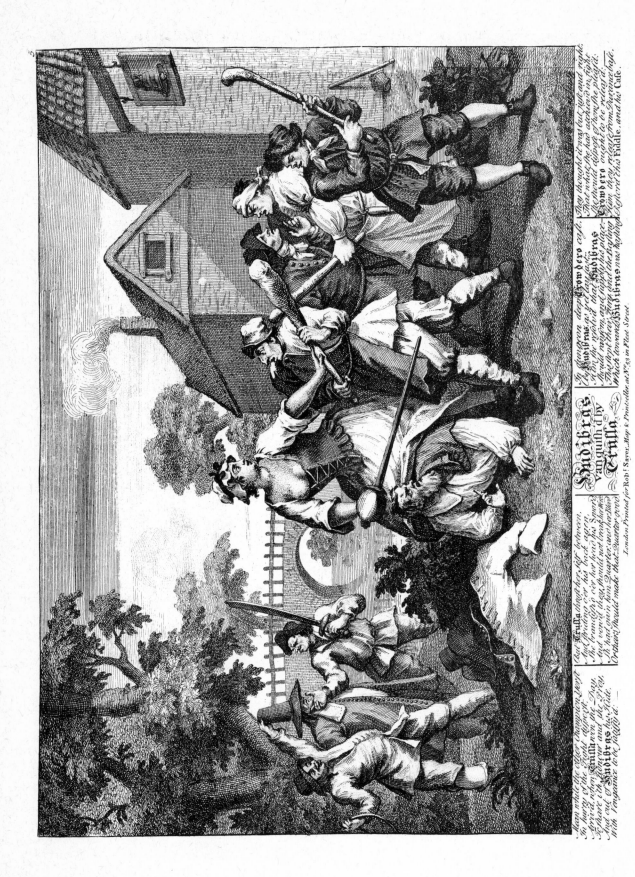

Now while the Knight Champian flept,
To hunt of the Fight slipped between.
stirr'd when Trulliwas their Day,
To place the Conquerer and the Slew,
And out of Hudibras his Hide.

But Trulla draught her staff between.
The finding o'er his back again,
she frantical'd o'er her breech his Squire,
And view'd them should not break wonder
He had own him Quarter: and her Blow
Orthain should make that Quarter-zeal

They thought it was but just and right,
That what she had acken on fight,
she should dispole of her the plagd:
Hudibras ought to be releas'd
Whom they releast from Durance bafe.
Which lowered Hudibras was having Refor'd this Fiddle. and his Cafe.

London Printed for Rob.t Saver. Map & Printseller. at N.°53 in Fleet Street.

Hudibras
vanquith'd by
Trulla.

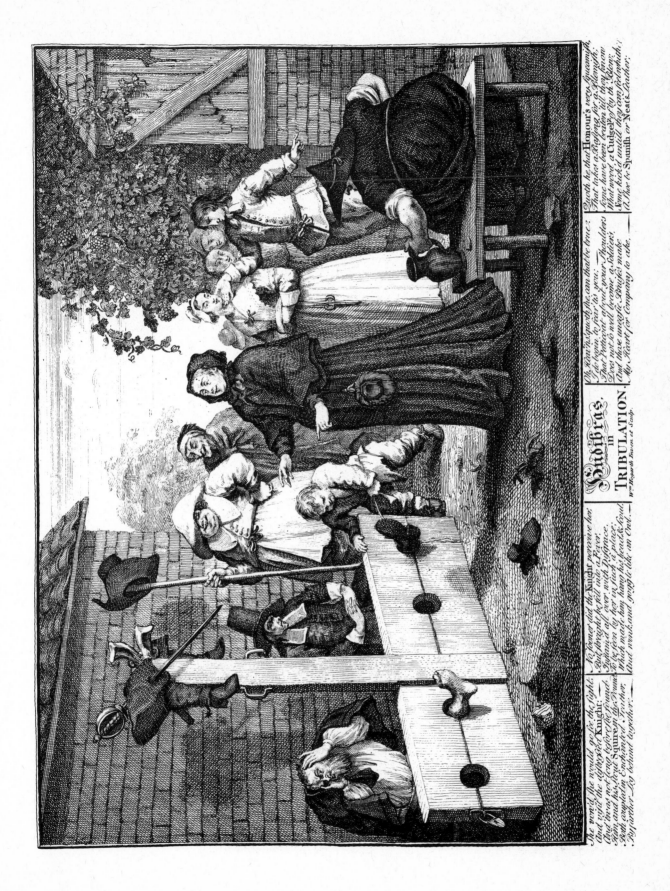

Hudibras
in
TRIBULATION.

She would go see the fight;
And rais'd the ditipted Knight:
Out bawling out cry'd and roar'd,
Stay, and his first Squire the Round
With exaltation Cudgel'd : Trather,
By partner, Lay behind together:

No sooner did the Knight perceive her,
But dreught he fell into a Fever;
Within a call now with Distance,
She given by her in such a place,
Which many tiny hand his frantic lighd,
That roused and jogg'd take an Oue.

Uy How'ts quietly she, can that be true,
I de began to fear 'tis grew;
That Petticoat of your your Shoulders
Does not to well berome a Soldier;
And those unlucke Bricks make
My Heart for Company to ake.

Quoth he, that Homour's very squeamish,
That takes a Reffrep for a Blemysh;
Some have been beaten till they know
What never a Cudgel by the Blow;
Now kick't antill they one forbidh :
(A due to Spanish or Neats Leather;

W^m. Hogarth Inven. et Sculp.

85

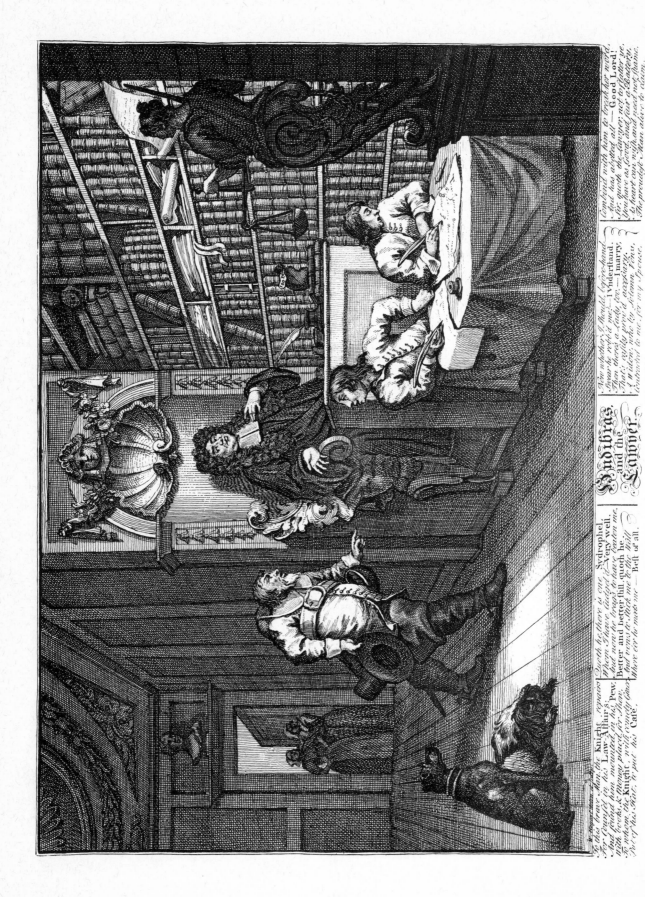

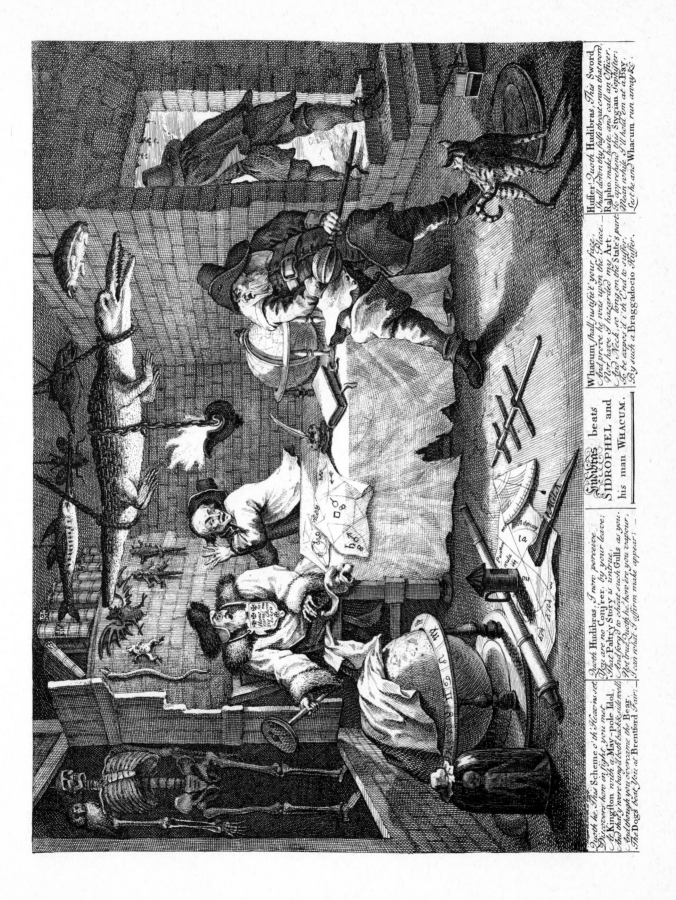

Quoth he, This Scheme o' th' Heav'ns set,
Discovers how in sight you met;
At Kingston, with a May-pole Idol,
And that ye were hang'd both back to back side well,
But although you o'ercame the Bear,
The Dogs beat You at Brentford Fair: —

Quoth Hudibras, I now perceive
You are no Conj'rer, by your leave;
That Paltry Story is untrue,
And forg'd to cheat such Gulls as you.
Not true, Quoth he, hen ére you vapour,
I can what I affirm make appear: —

Whacum shall justifie't your face,
And prove he was upon the Place.
Not hast I hazarded my Art,
And Neck, so long on the State's part,
To be expos'd i' th' End to suffer:
By such a Braggadocio Huffer.

Huffer! Quoth Hudibras, This Sword
Shall down thy false throat cram that word.
Ralpho, make haste, and call an Officer,
To apprehend this Stygian Sophister;
Mean while I'll hold 'em on at Bay,
Lest he and Whacum run away.

Hudibras beats **SIDROPHEL, and his man WHACUM.**

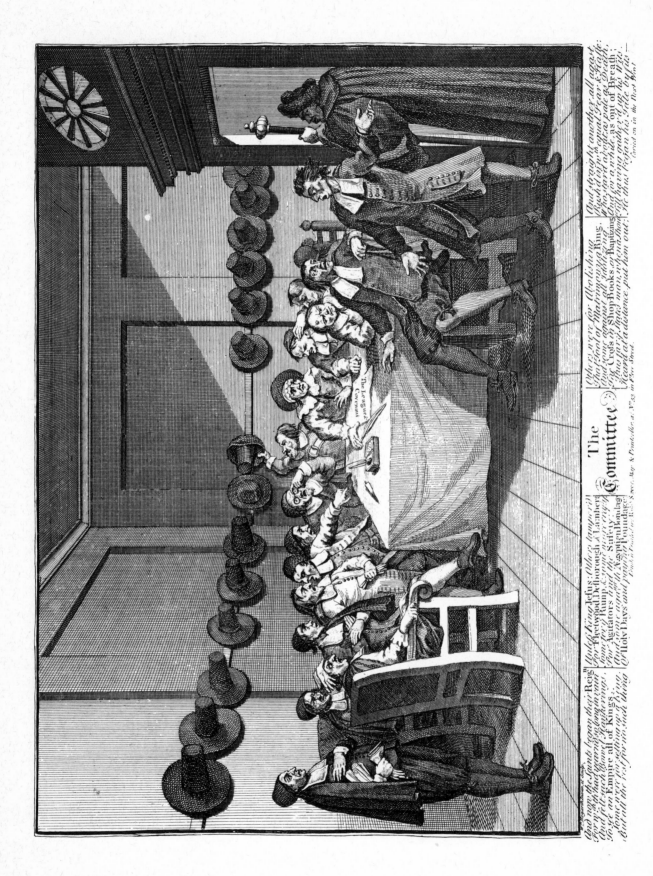

The
Committee

88

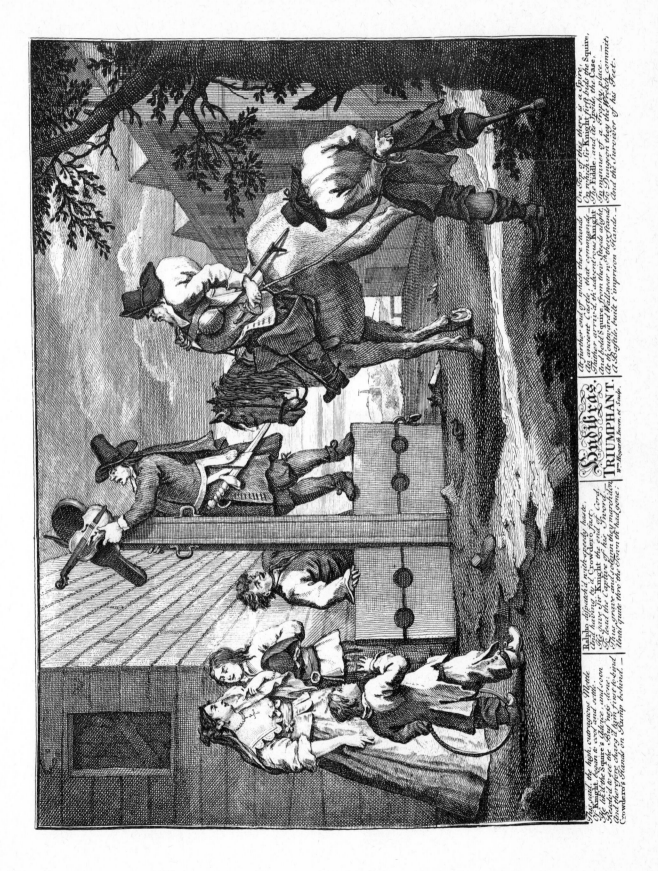

Hudibras.

TRIUMPHANT.

Wm Hogarth invent et Sculp.

89

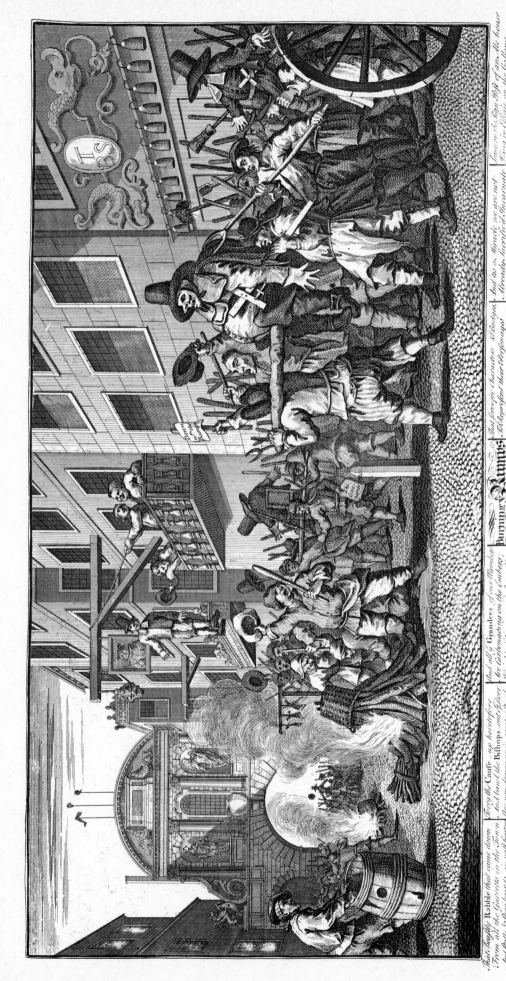

90

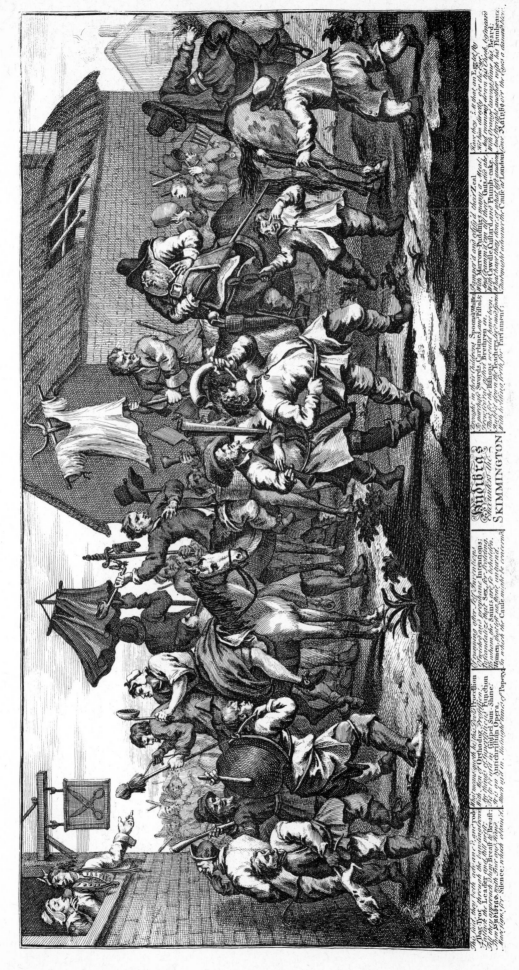

91

The Right Hon. *Ja.* *Caulfield Earl of Charlemount*
of the Kingdom of Ireland Head of the Volunteers
From an original Portrait by Hogarth in the Possession of M. *Sam.* *Ireland*
etched by Jos. *Haynes Pupil to the late M*. *Mortimer*
Pub.^d as the Act directs Mar. 19.th 1782

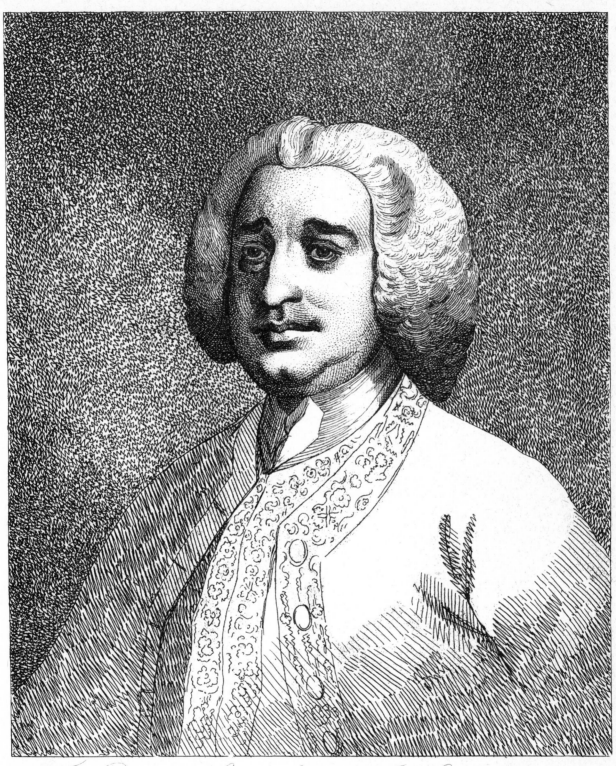

The Right Hon.ᵇˡᵉ Henry Fox, Lord Holland.

From an original Portrait in Oil by Hogarth, in the Possession of Mr. Saml. Ireland, etched by J. Haynes Pupil to the late Mr. Mortimer.

Pubᵈ as the Act directs Mar. 19ᵗʰ 1782

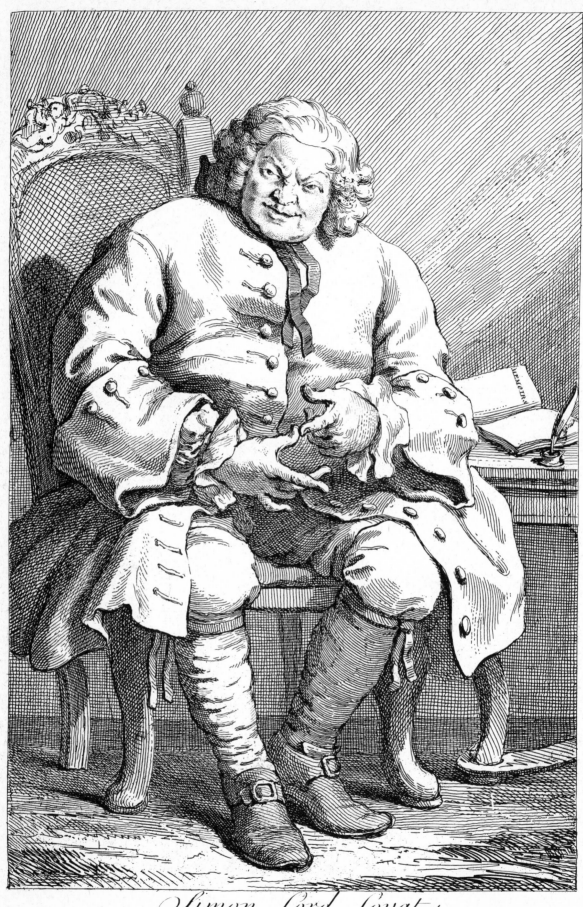

Simon Lord Lovat

Drawn from the Life and Etch'd in Aquafortis by Will.ᵐ Hogarth.

Publish'd according to Act of Parliament. August.25.ᵗʰ 1746.

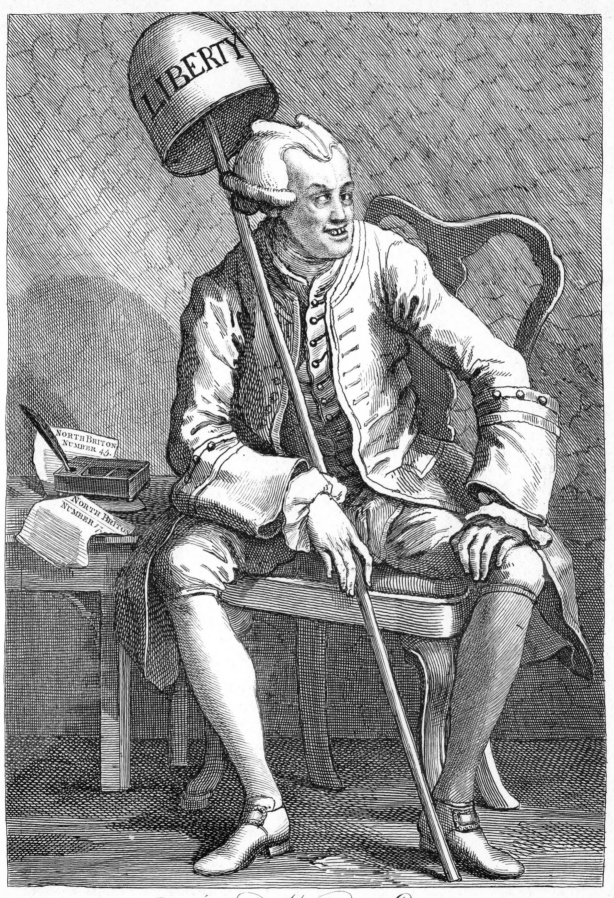

John Wilkes Esq.ʳ

Drawn from the Life and Etch'd in Aquafortis by Willᵐ Hogarth.

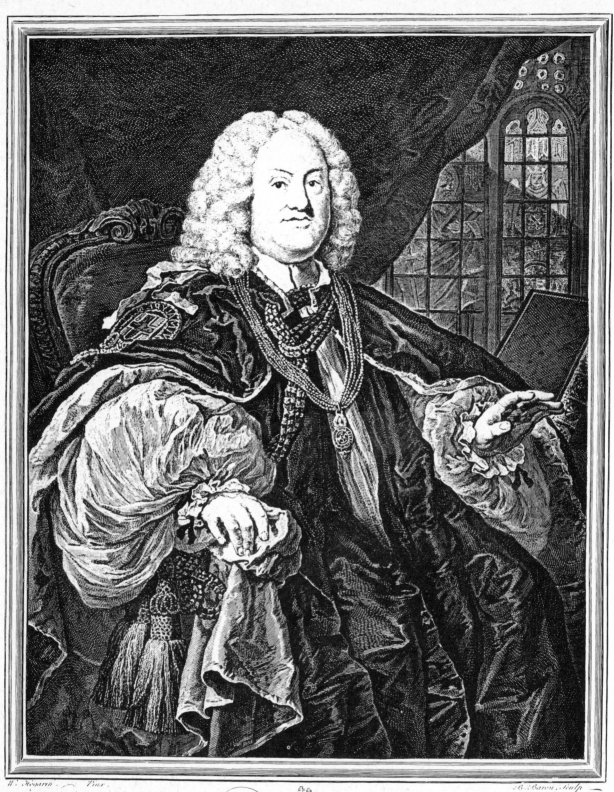

W.^m Hogarth. Pinx. *R. Baron Sculp.*

The Right Reverend Father in GOD,
D.^r BENJAMIN HOADLY, LORD BISHOP of WINCHESTER
Prelate of the Most Noble Order of the Garter,
Æ.^t 67. A.D. 1743.

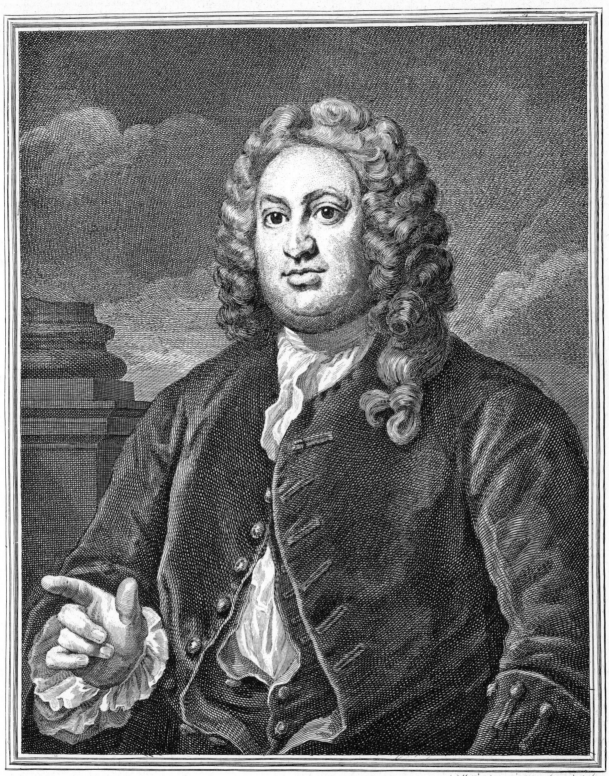

W.^m Hogarth Pinx.^t et Sculp.^t

Martin Folkes Esq.^r

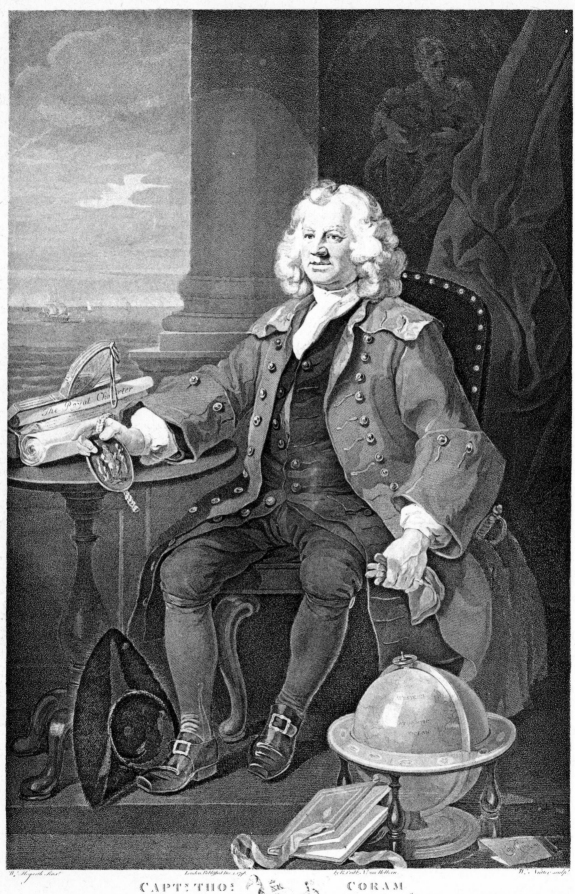

CAPT? THO? CORAM
who after 17 Years unwearied application, obtained *the CHARTER of the FOUNDLING HOSPITAL.*
To the GOVERNORS & GUARDIANS of the *Hospital, this Print is humbly dedicated*
 by their obedient humble Serv?, R. Cribb.

98

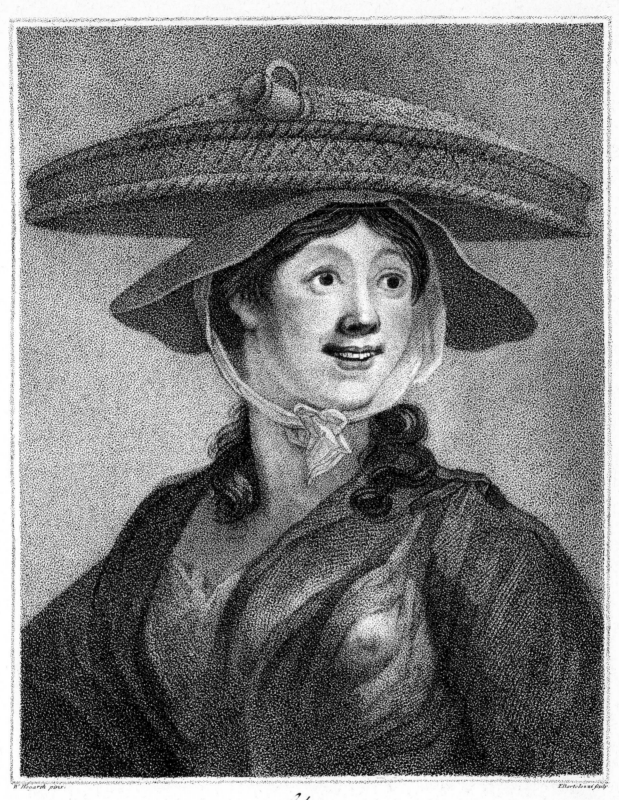

Shrimps!

Engraved from an Original Sketch in Oil by Hogarth, in the possession of M.rs Hogarth.

Publish'd March 2.d 1782 by Jane Hogarth Leicester Fields.

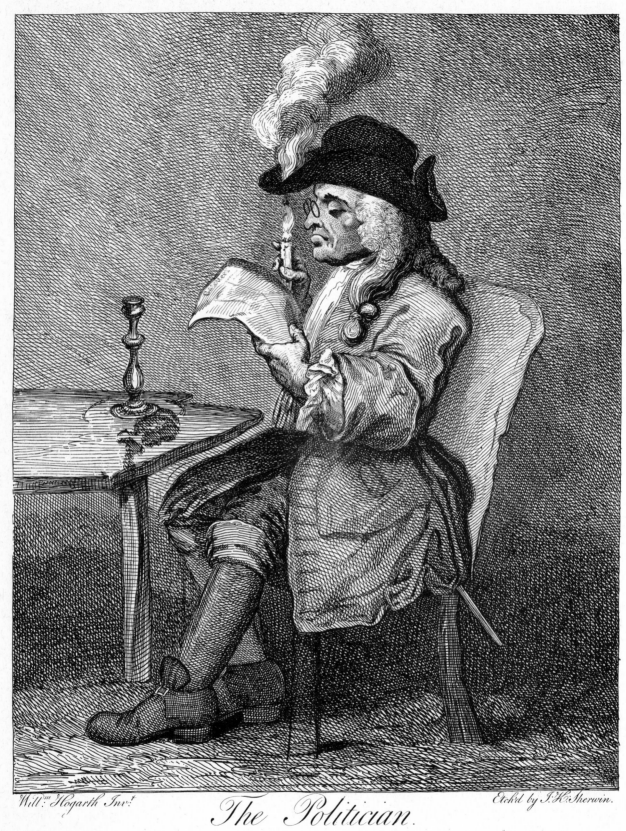

Will.^m Hogarth Inv.^t Etch'd by I.^s K.^e Sherwin.

The Politician.

Etch'd from an Original Sketch of W.^m Hogarth's, in the Possession of M.^r Forrest. Pub.^d as the Act directs by Jane Hogarth, 1775.

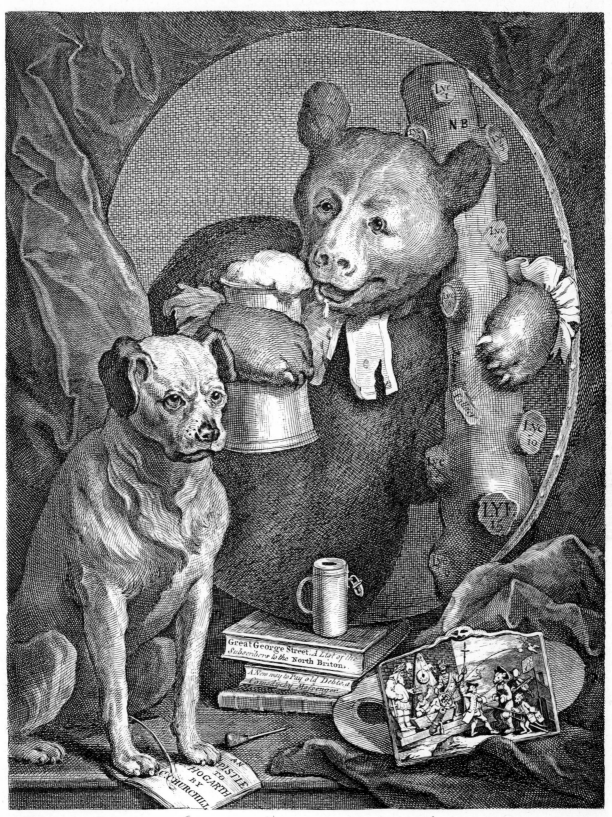

THE BRUISER, C. CHURCHILL (once the Rev.d) in the Character of a Russian Hercules, Regaling himself after having Kill'd the Monster Caricatura that so Sorely Gall'd his Virtuous friend, the Heaven born WILKES.

— But he had a Club this Dragon to Drub, Or he had ne'er don't I warrant ye. —— Dragon of Wantl.

Design'd and Engraved by W.m Hogarth. Publish'd according to Act of Parliament.

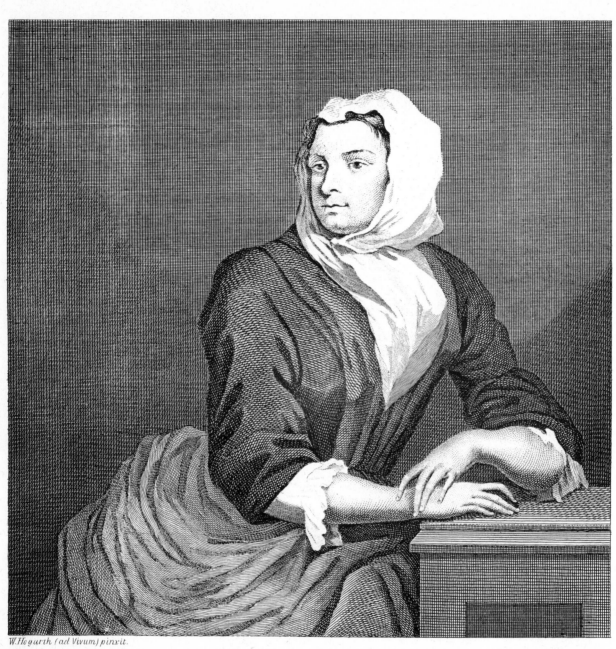

W.Hogarth (ad Vivum) pinxit.

SARAH MALCOLM.

103

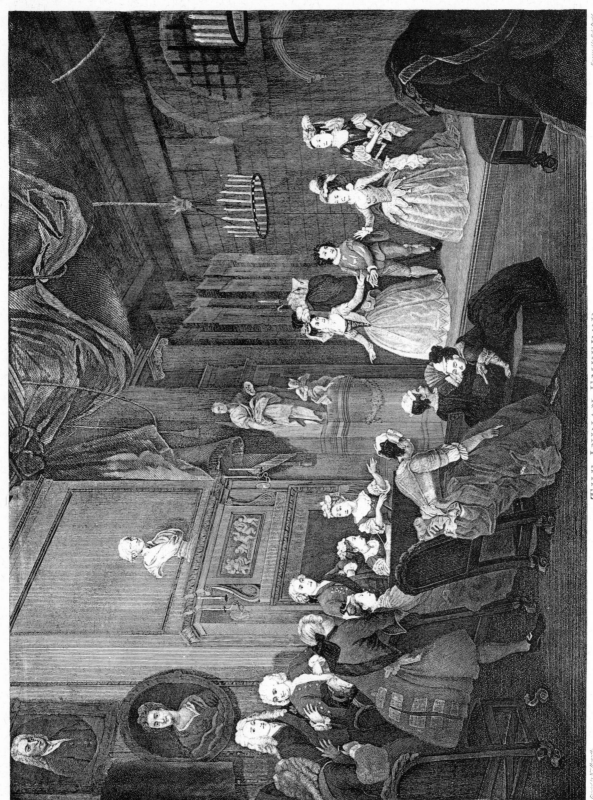

THE INDIAN EMPEROR.

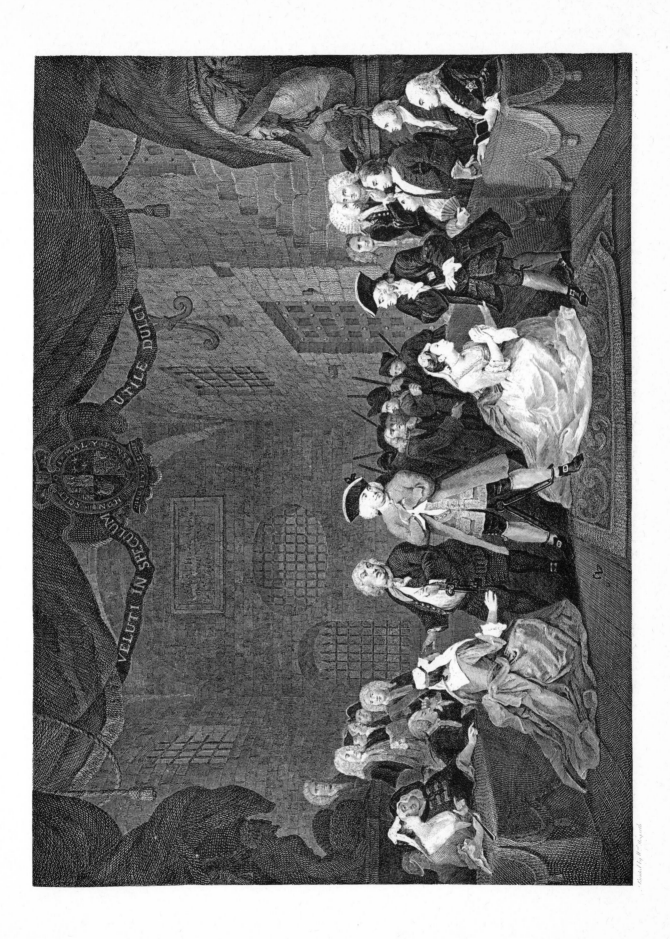

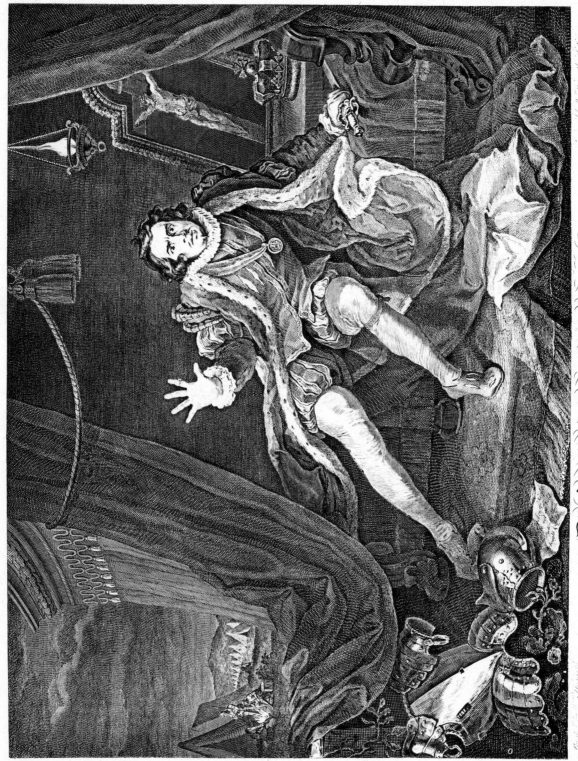

Mr Garrick in the Character of Richard the 3.d

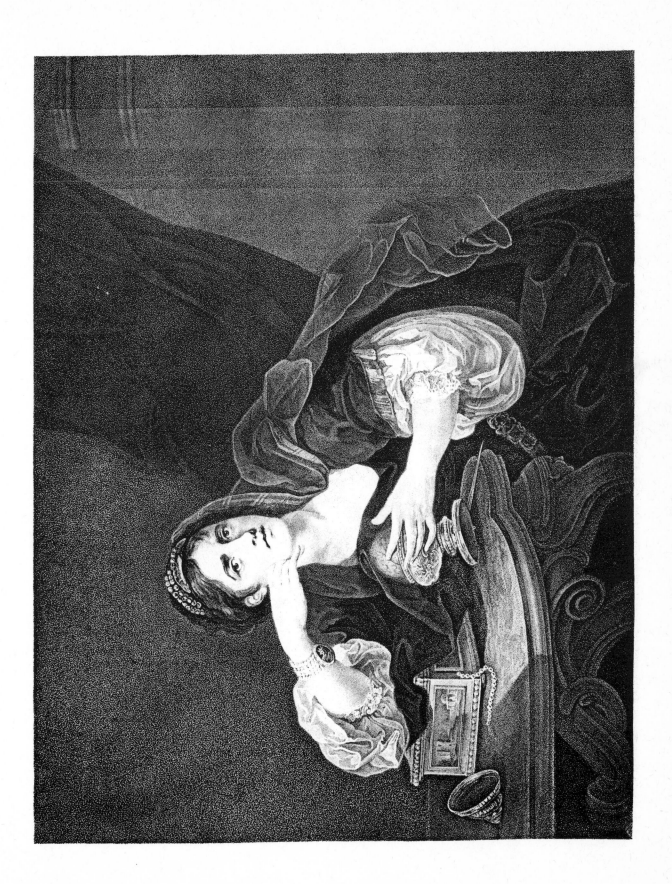

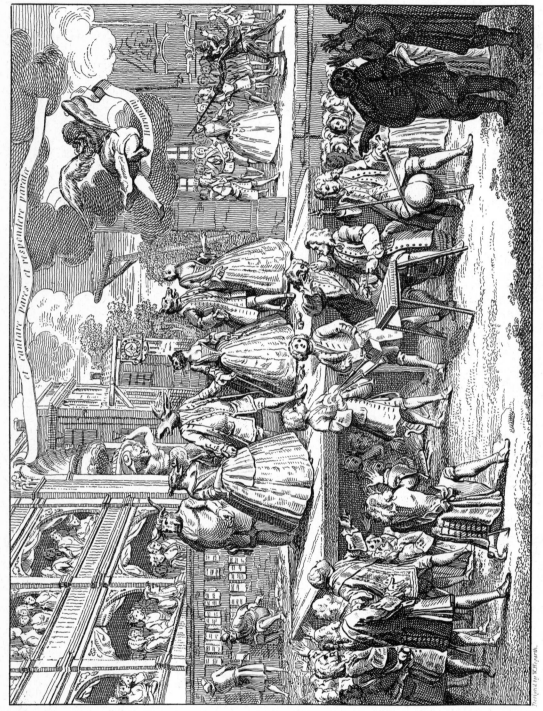

THE BEGGARS OPERA.

Britons attend — view this harmonious Stage,
And listen to those notes which charm the age.
Thus shall your tastes in Sounds & Sense be shewn,
And Beggars Opras ever be your own.

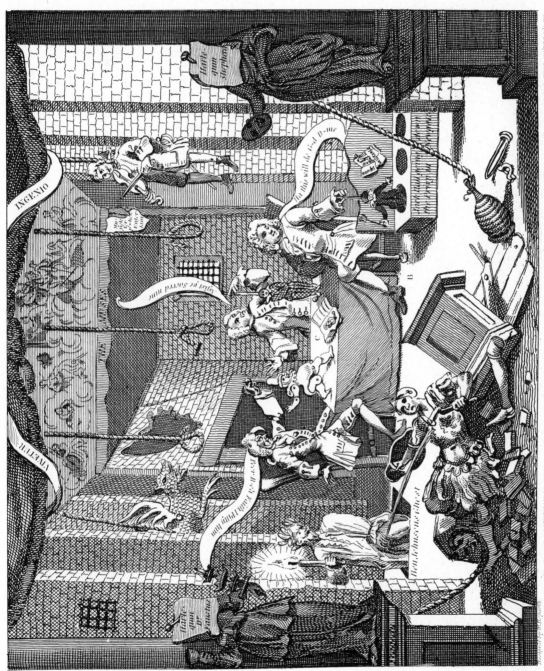

A JUST VIEW OF THE BRITISH STAGE, OR THREE HEADS ARE BETTER THAN ONE, SCENE NEWGATE, BY MDVA

This Print represents the tragicomic and wonderous Entertainments of harlequin Shepherd, to which will be added, Scaramouch Jack Hall the Chimney-Sweepers Escape from Newgate through ye privy, with ye comical humours of Ben Johnsons Ghost. Concluding with the Hay-Dance Perform'd in ye Air by ye Figures A.B.C. assisted by Ropes from ye Muses. N.B. there are no Conjurers concern'd in it as ye ignorant imagine. The Bricks, Rubbish &c. will be real but the Excrements upon Jack Hall will be made of the best Chamber ardent to prevent offence. Vivat Rex.

109

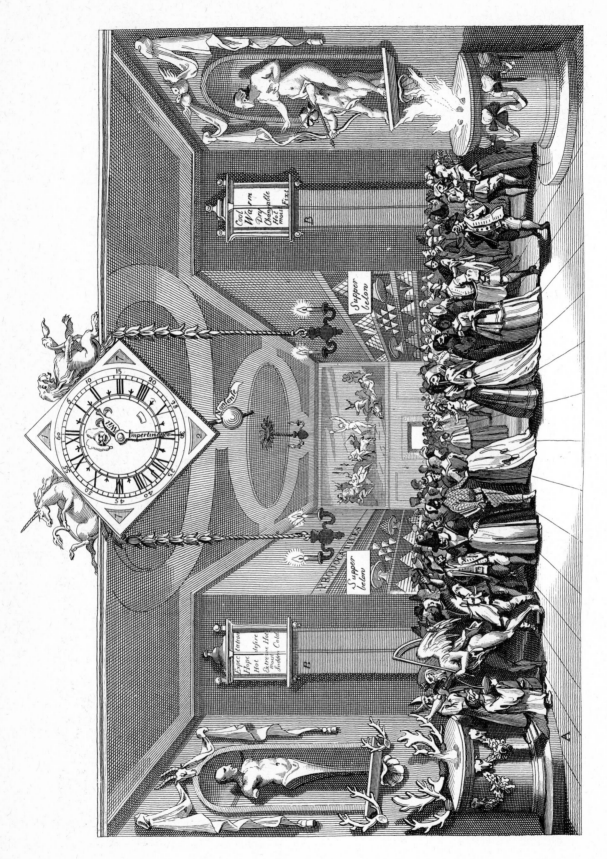

Masquerade Ticket

110

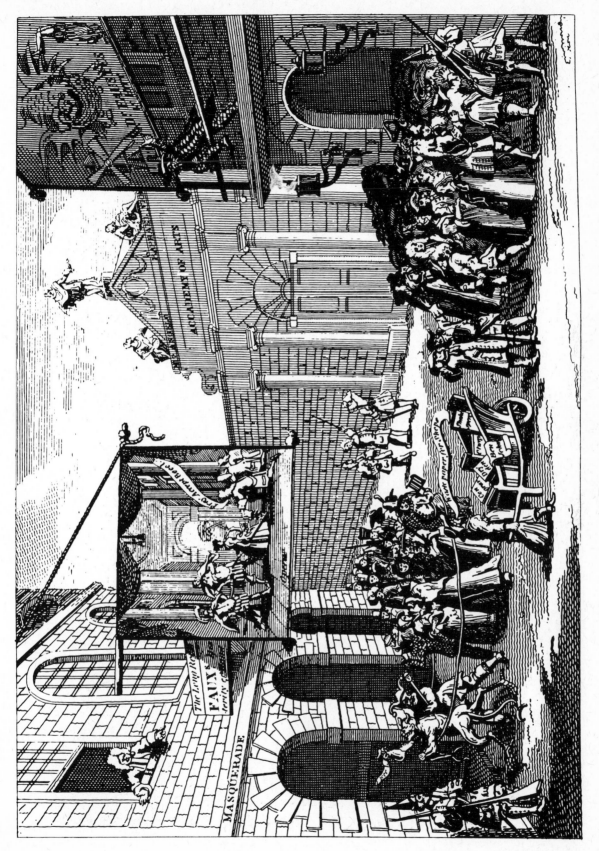

Masquerades and Operas. Burlington-Gate.

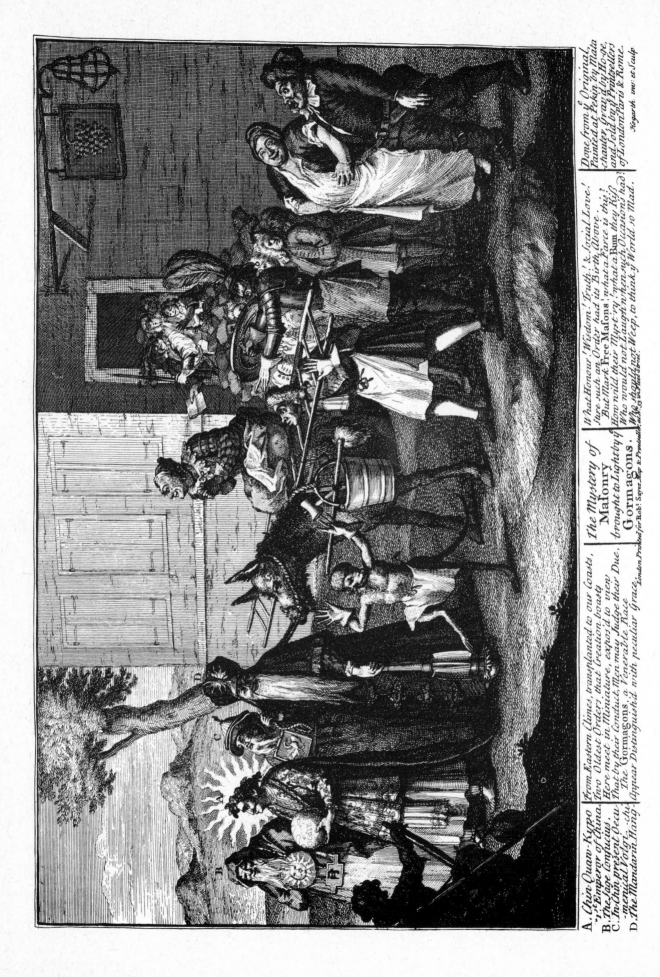

A. *Chin-Quaw-Kypo* ⎱ From Eastern Climes, transplanted to our Coasts, ⎱ The Mystery of ⎱ What Honour,! Wisdom,! Truth! & Social Love! ⎱ Done from y.e Original,
 Emperor of China. ⎰ Two Oldest Orders that Creation boasts. ⎰ Masonry ⎰ sure such an Order had its Birth Above. ⎰ Painted at Pekin by Mata-
B. *The Sage Confucius.* Here meet in Miniature, expos'd to view ⎱ brought to Light by y.e ⎱ But Mark Free Masons, what a Farce is this? ⎱ chauter, gray'd by Ho-ge,
C. *Tu-Chin present Occu-* that by their Conduct, Men may Judge their Due. ⎰ How wild their Myst'ry, what a Bum they Kiss ⎰ and Sold by y.e Printsellers
 -menical Wolgi ...chi. The Gormagons, a Venerable Race. ⎱ Who would not Laugh when such Occasions had? ⎱ of London Paris & Rome.
D. *The Mandarin Hang* ⎰ Appear Distinguish'd with peculiar Grace. ⎰ Gormagons. ⎰ Who should not Weep, to think y.e World so Mad.

London Printed for Rob.t Sayer, Map & Printseller N.o 53 in Fleet Street

Hogarth inv. et Sculp

112

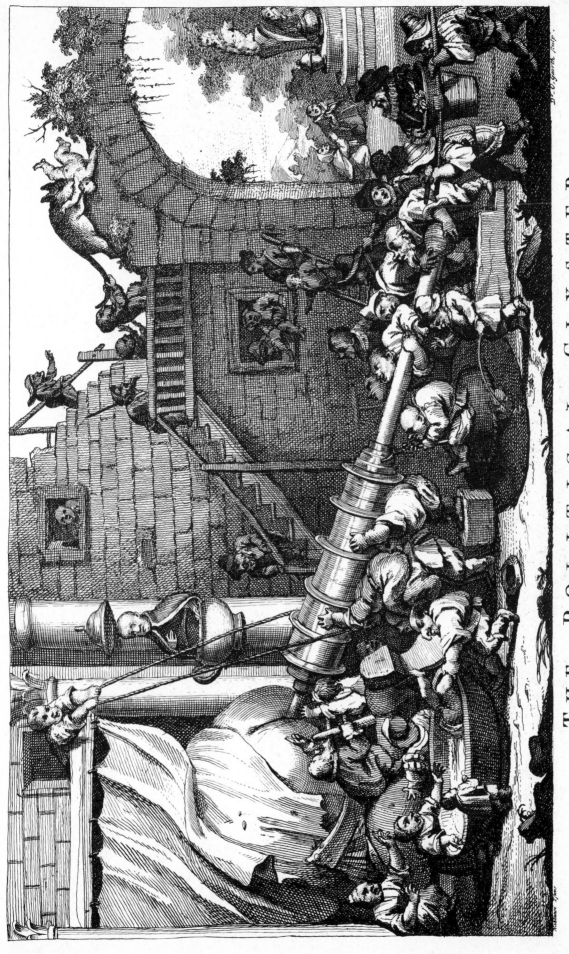

THE POLITICAL CLYSTER

This Print is exactly Engrav'd after ÿ Celebrated Altar-Peice in S.t Clements Church which has
been taken down by Order of ÿ Lord Bishop of London as tis thought) to prevent Disputs and
Laying of wagers among ÿ Parrishioners about ÿ Artists meaning in it. for publick satisfaction
here is a particular Explanation of it humbly Offerd to be writ under ÿ Original, that it may be
put up again by which means ÿ Parishes 60 pounds which thay nisely gave for it, may not be Entirely lost

1.st Tis not the Pretenders Wife and Children as our weak brethren imagin
2.ly Nor S.t Cecilia as the Connoisseurs think but a Choir of Angells playing in Consort

A	an Organ	E	An Angel tuning an Harp		H	the other leg judiciously Omitted to
B	an Angel playing on it	F	the inside of his Leg but whether			make room for the harp
C	the Shortest Ioint of the Arm		right or Left is yet undiscoverd		I	1.st Smaller Angells as appears by
D	the longest Ioint	G	a hand Playing on a Lute		K	2.ly their Wings.

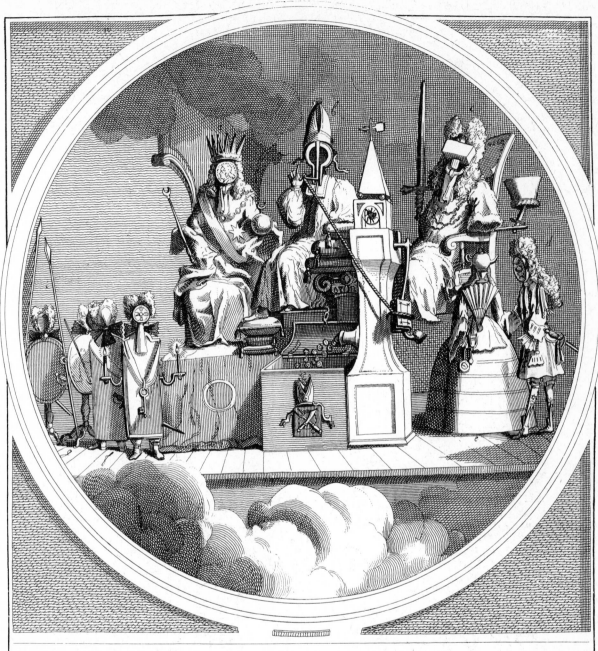

Some of the Principal Inhabitants of y^e MOON, as they Were Perfectly Discover'd by a Telescope brought to y^e Greatest Perfection \intince y^e last Eclip$\int e$; Exactly Engraved from the Objects, whereby y^e Curious may Gue\int at their Religion, Manners, &c.

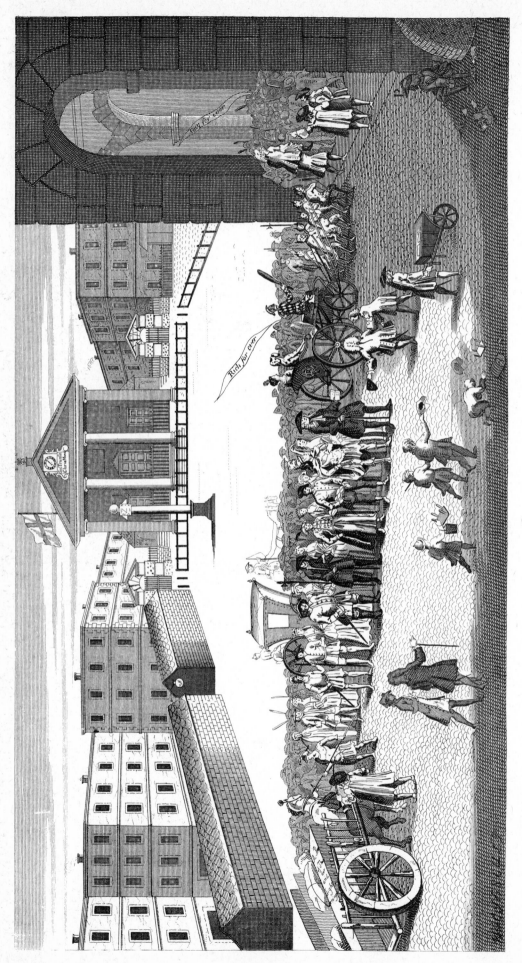

Rich's Triumphant Entry.

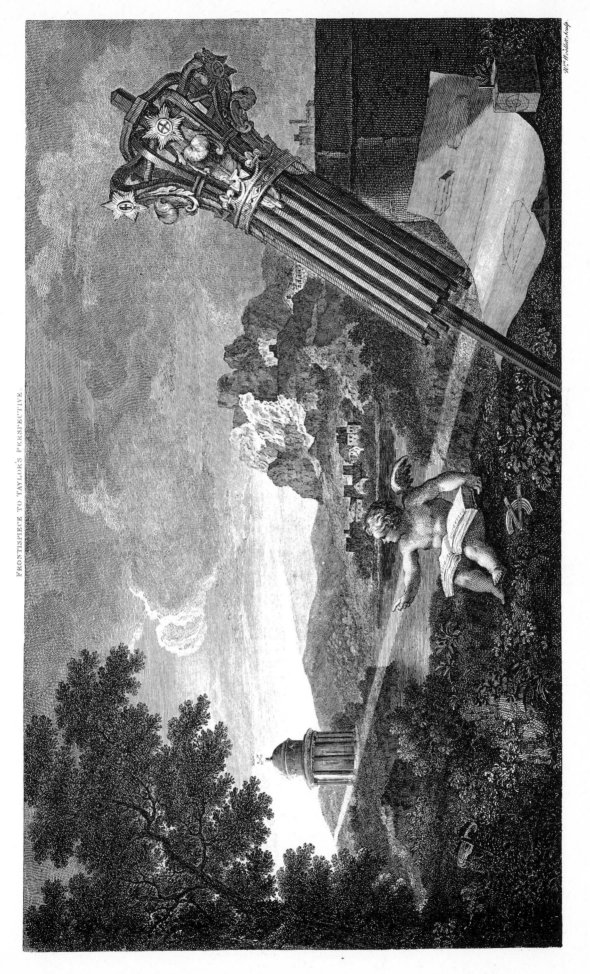

117

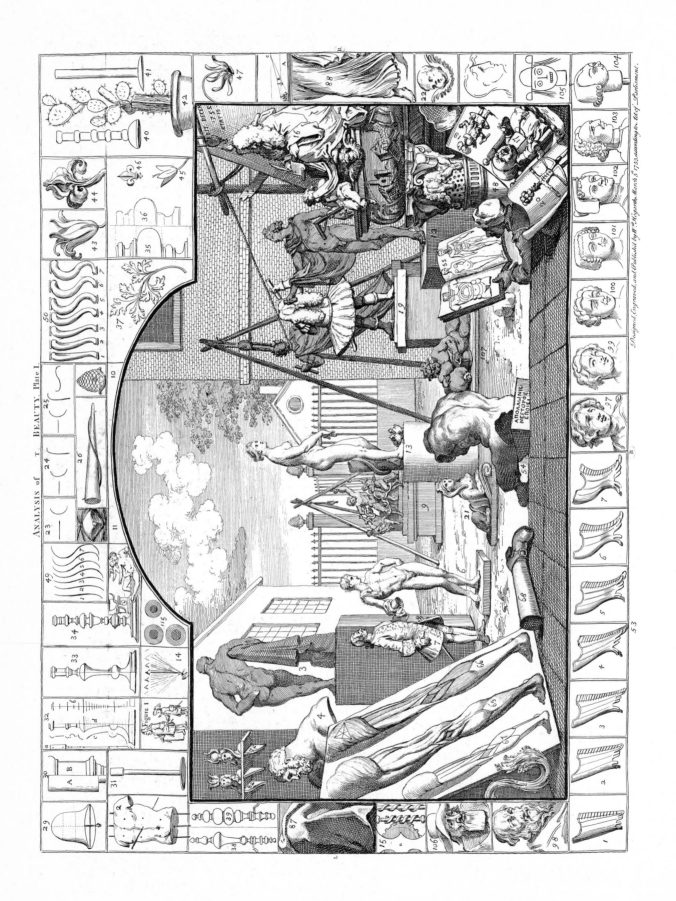

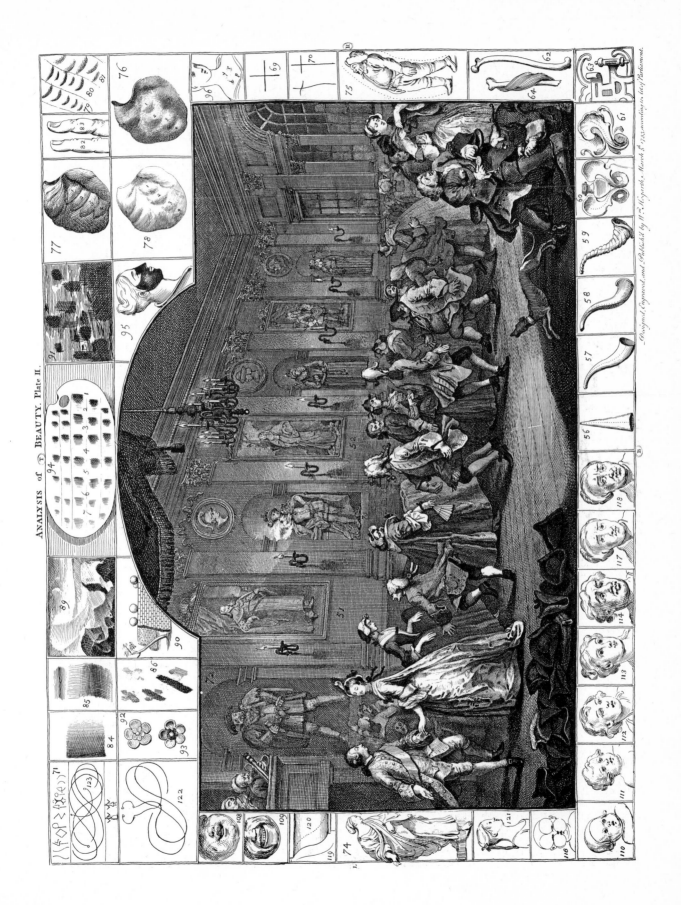

ANALYSIS of THE BEAUTY. Plate II.

Designed, Engraved, and Published by W.m Hogarth, March 5.th 1753, according to Act of Parliament.

119

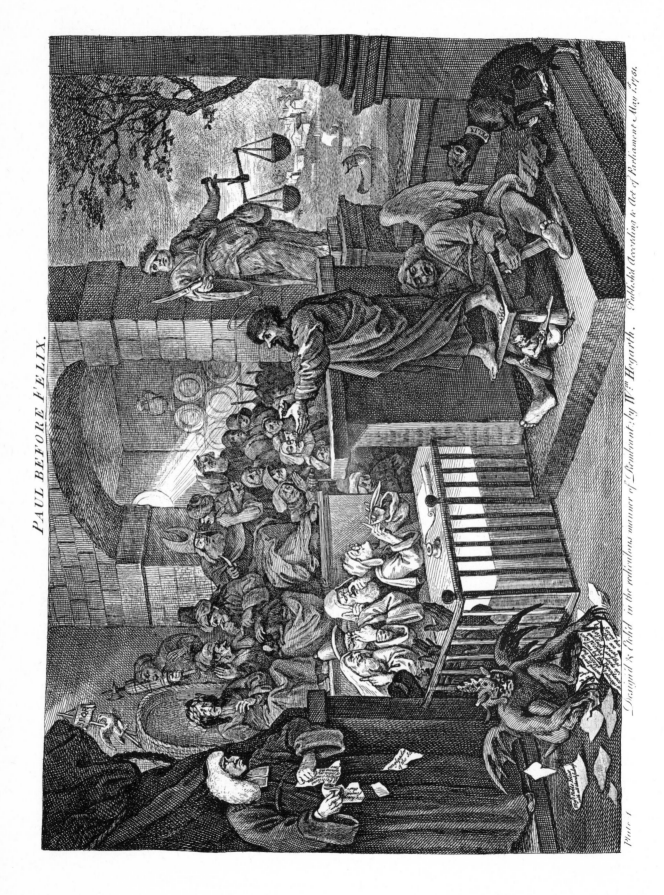

PAUL BEFORE FELIX.

Plate 1

Designed & Etched in the ridiculous manner of Rembrant; by W.ᵐ Hogarth. Published According to Act of Parliament May 1751.

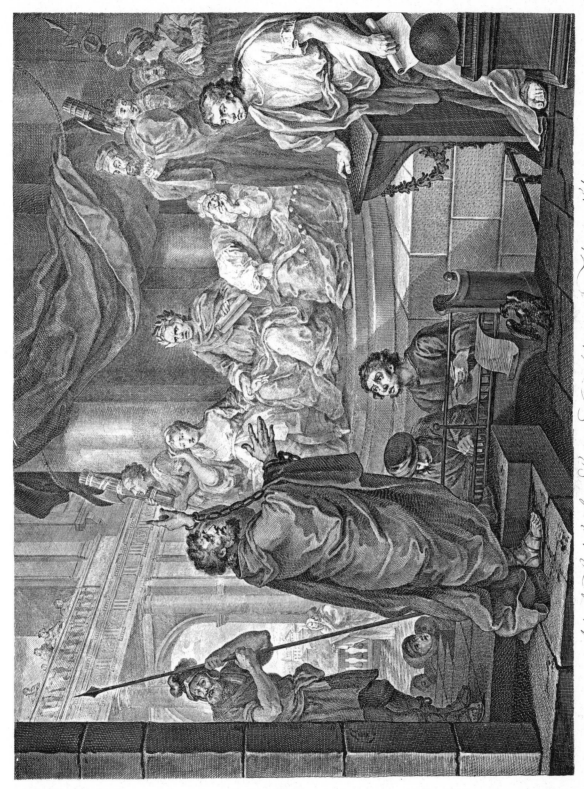

And as he reasoned of righteousness, temperance, and judgment to come, Felix trembled;

Engraved by Wm Hogarth from his Original Painting in Lincolns Inn Hall, & Published in the thirtieth of June 1762.

Plate 1

121

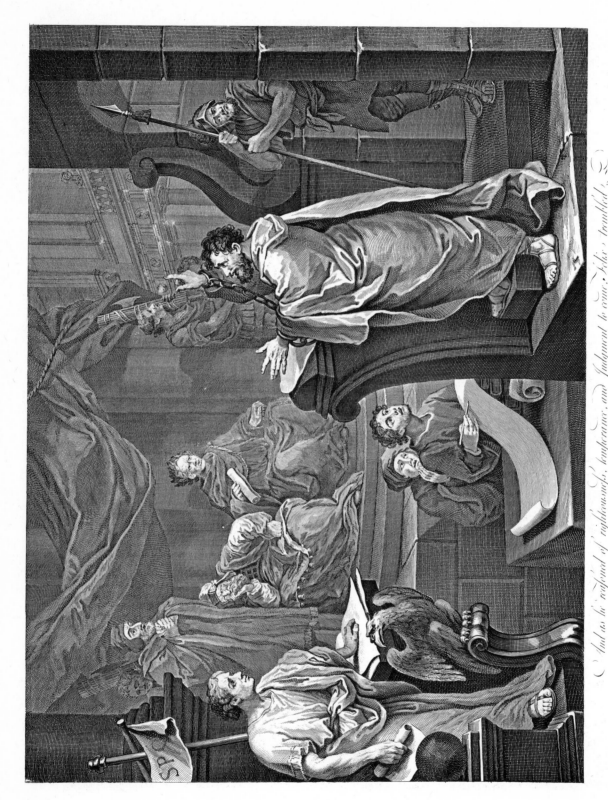

And as he reasoned of righteousness, temperance, and Judgment to come, Felix trembled.

From the Original Painting in Lincolns Inn Hall painted by W.ᵐ Hogarth.

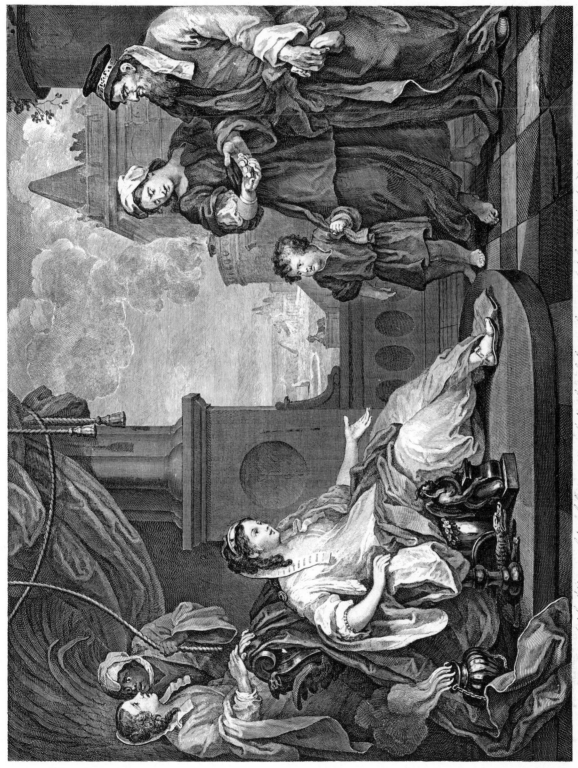

And the child grew, & she brought him unto Pharaoh's daughter & he became her son : And she called his name Moses.

From the Original Painting in the Founding Hospital & Duke Sullivan.

Designed by Wm. Hogarth & Pub:

Published as the Act directs Feb 15, 1752.

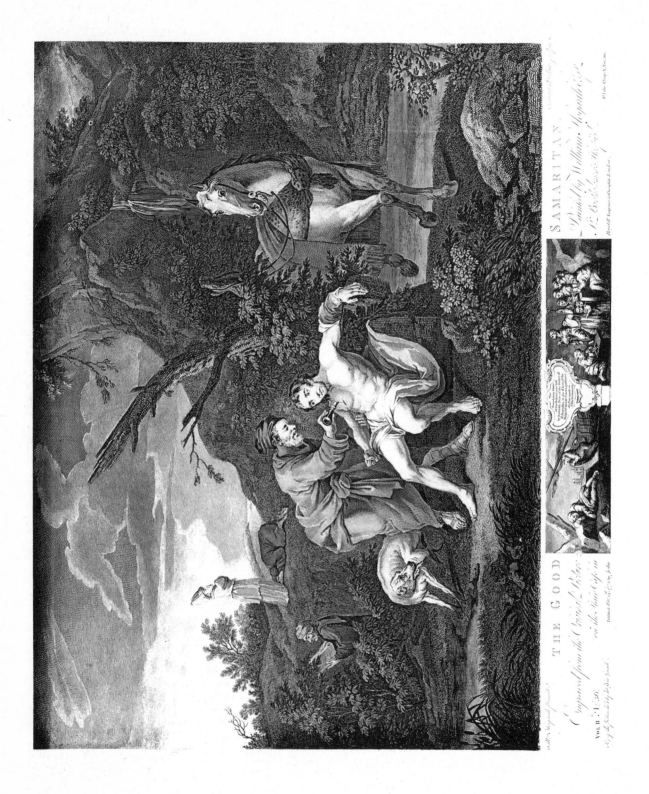

THE GOOD SAMARITAN.

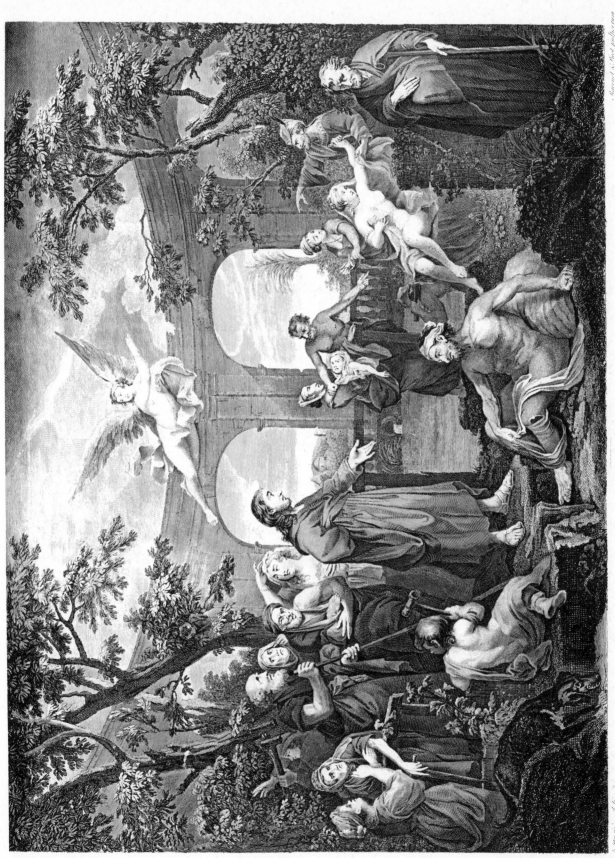

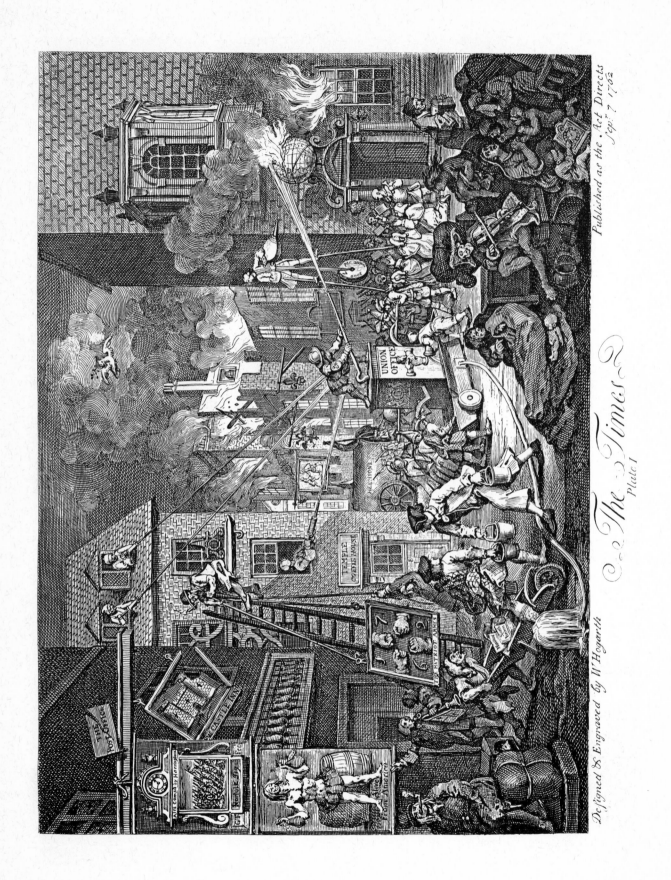

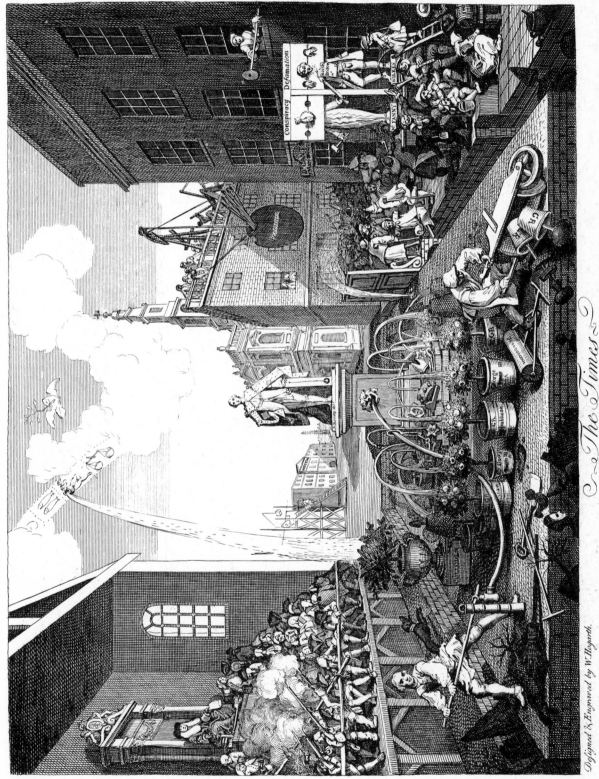

The Times
Plate II

Designed & Engraved by W. Hogarth.

127

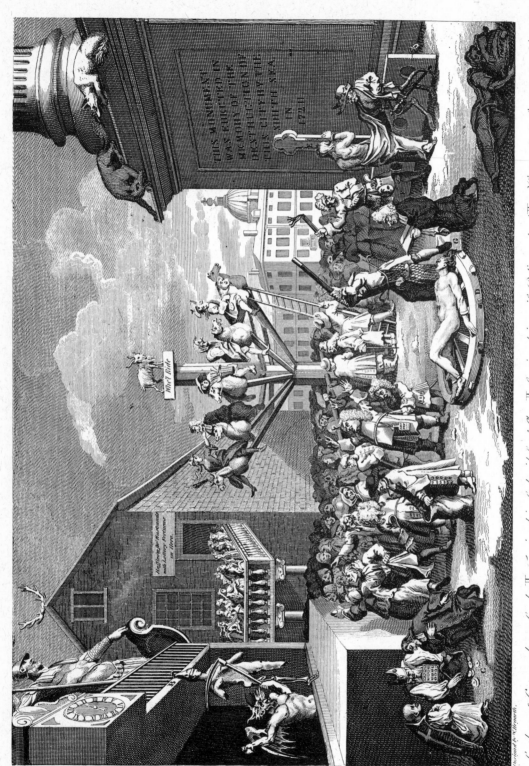

See here y.^e Causes why in London,
So many Men are made, & undone,
That Arts, & honest Trading drop,
To Swarm about y.^e Devils Shop, (A)
Who Cuts out (B) Fortunes Golden Haunches,

Trapping their Souls with Lotts & Chances,
Shareing em from Blue Garters down
To all Blue Aprons in the Town.
Here all Religions flock together,
Like Tame & Wild Fowl of a Feather,

Leaving their strife Religious bustle,
Kneel down to play at pitch & Hustle;(C)
Thus when the Sheapherds are at play,
Their flocks must surely goe Astray:
the woeful Cause y.^t in these Times,

(E) Honour, & (D) honesty, are Crimes
That publickly are punished by
(G) Self Interest, and (F) Vilany;
So much for monys magick power,
Guess at the Rest you find out more.

Designd by Hogarth.

An emblematic print on the SOUTH SEA.

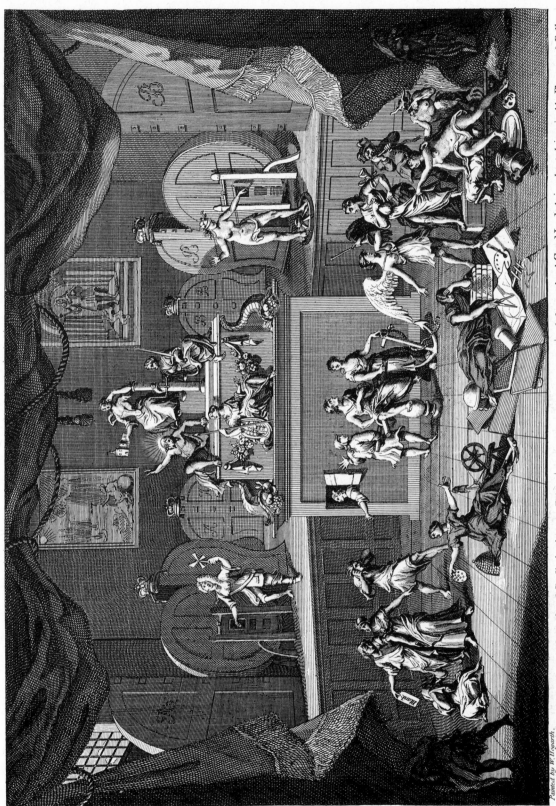

Painted by W. Hogarth.

The Explanation. 1. Upon the Pedestal National Credit leaning on a Pillar supported by Justice. 2. Apollo shewing Britannia a Picture representing the Earth receiving enriching Showers drawn from hence! (An Emblem of State Lotterys.) 3. Fortune Drawing the Blanks & Prizes. 4. Wantonness drawing y.ᵉ Numbers. 5. Before the Pedestal Suspence turnd to & fro by Hope & Fear.

6. On one hand Good Luck being elevated is seized by Pleasure & Folly Fame persuading him to raise sinking Virtue Arts &c. 7. On the other hand Misfortune opprest by Grief Minerva supporting him points to the Sweets of Industry. 8. Sloth hiding his head in y.ᵉ Curtain 9. On the other side Avarice hugging his Money &c. Fraud tempting Despair with Money at a Trap Door in the Pedestal.

THE
LOTTERY.

129

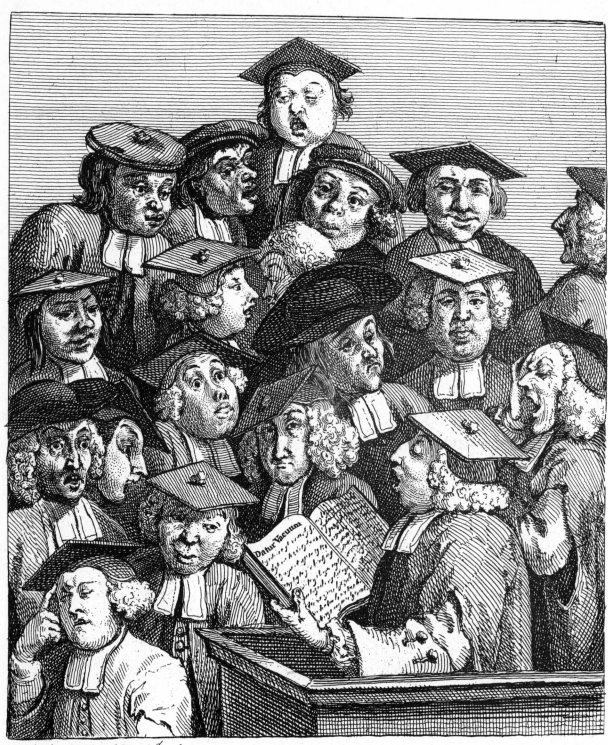

Publish'd by W. Hogarth March 3.d 1736

130

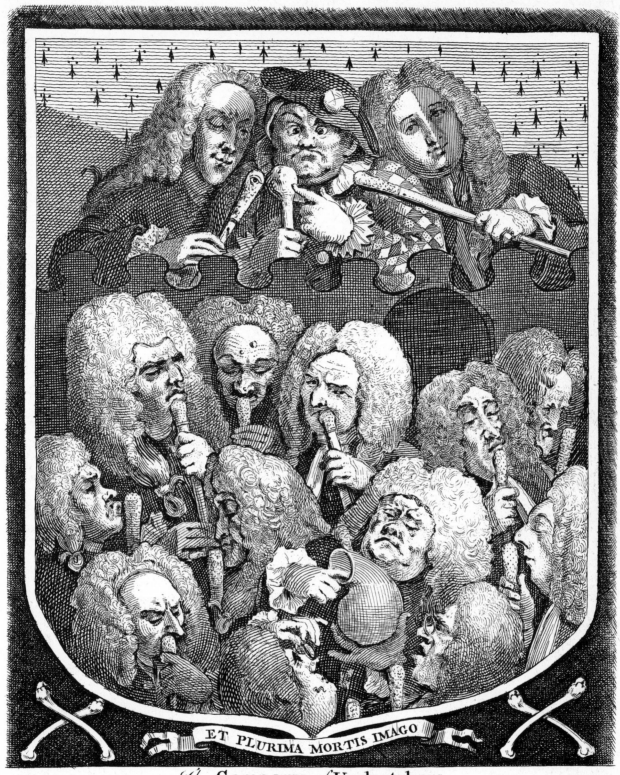

ET PLURIMA MORTIS IMAGO

The Company of Undertakers

Beareth Sable, an Urinal proper, between 12 Quack-Heads of the Second & 12 Cane Heads Or, Consul-
-tant. On a Chief Nebulæ, Ermine, One Compleat Doctor issuant, checkie Sustaining in his
Right Hand a Baton of the Second. On his Dexter & Sinister sides two Demi-Doctors, issuant
of the Second, & two Cane Heads issuant of the third; The first having One Eye conchant, to-
wards the Dexter Side of the Escocheon; the Second Faced per pale proper & Gules, Guardent. ——
With this Motto ——————— Et Plurima Mortis Imago.

* A Chief betokeneth a Senatour or Honourable Personage, borrowed from the Greeks, & is a Word signifying a Head; & as the Head is the Chief Part in a Man, so the Chief in the Escocheon should be a Reward of such only, whose High Merites have procured them Chief Place, Esteem, or Love amongst Men. Guillim.
** The bearing of Clouds in Armes (saith Upton) doth import some Excellencie.

Invented by W. Hogarth March the 3d 1736

Price Six pence

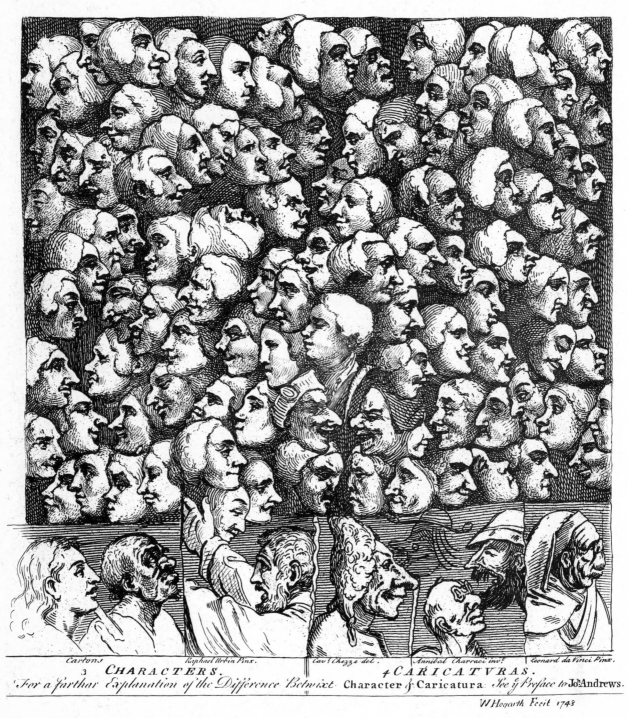

Cartons Raphael Urbin Pinx. Cav.ᵉ Chezze del. Annibal Charraci inv.ᵗ Leonard da Vinci Pinx.

3 *CHARACTERS.* 4 *CARICATVRAS.*

For a farther Explanation of the Difference Betwixt Character & Caricatura See y Preface to Jo.ˢ Andrews.

W Hogarth Fecit 1743

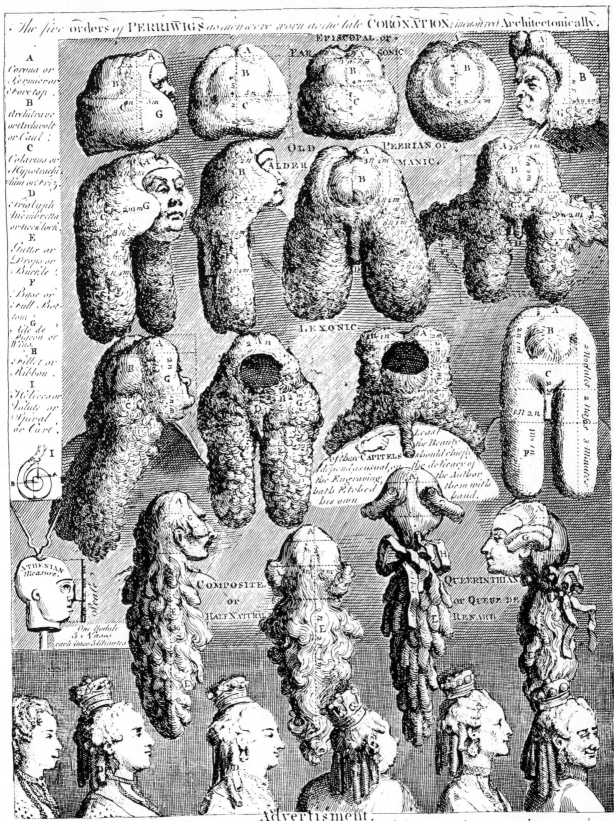

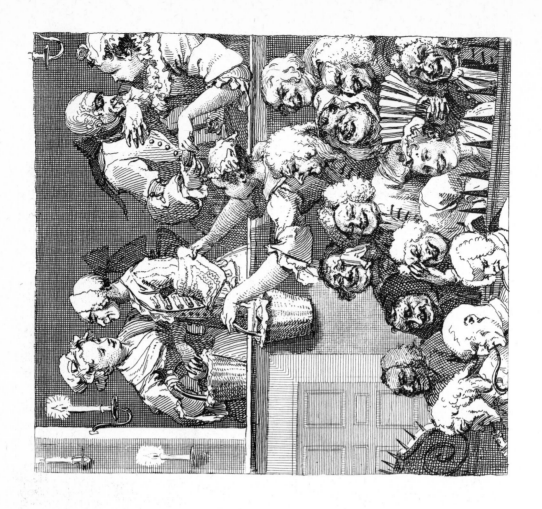

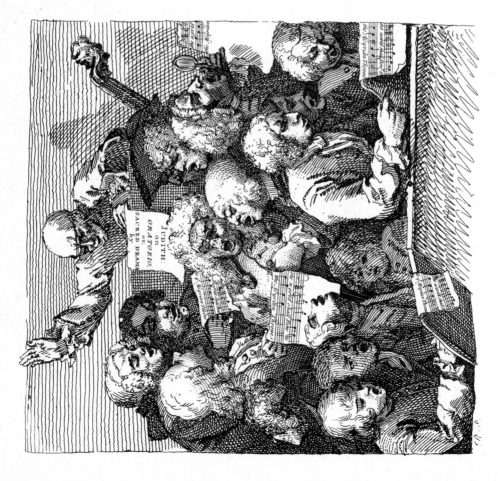

134

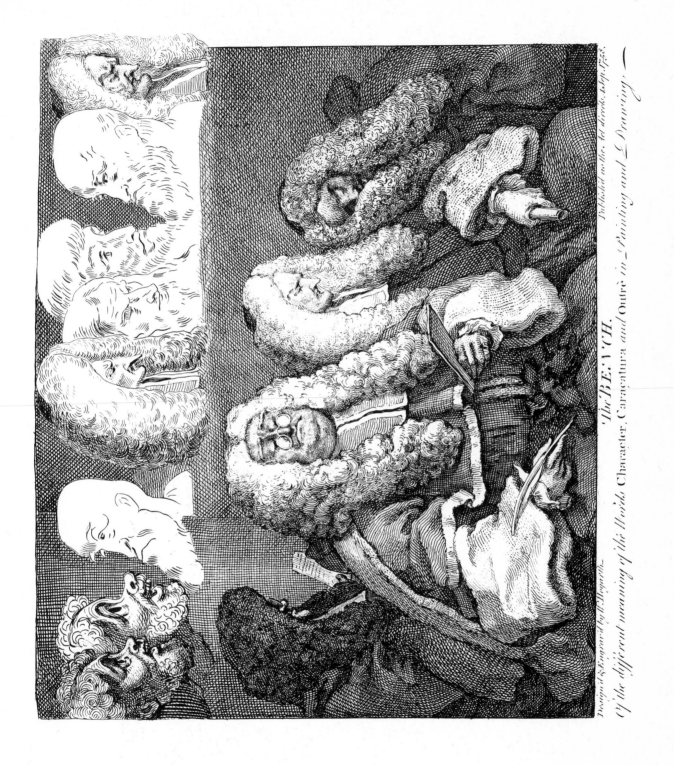

The BENCH.

Of the different meaning of the Words Character, Caracatura and Outré in Painting and Drawing.

Design'd & Engrav'd by W^m Hogarth. Published as the Act directs Sep^t 1758.

135

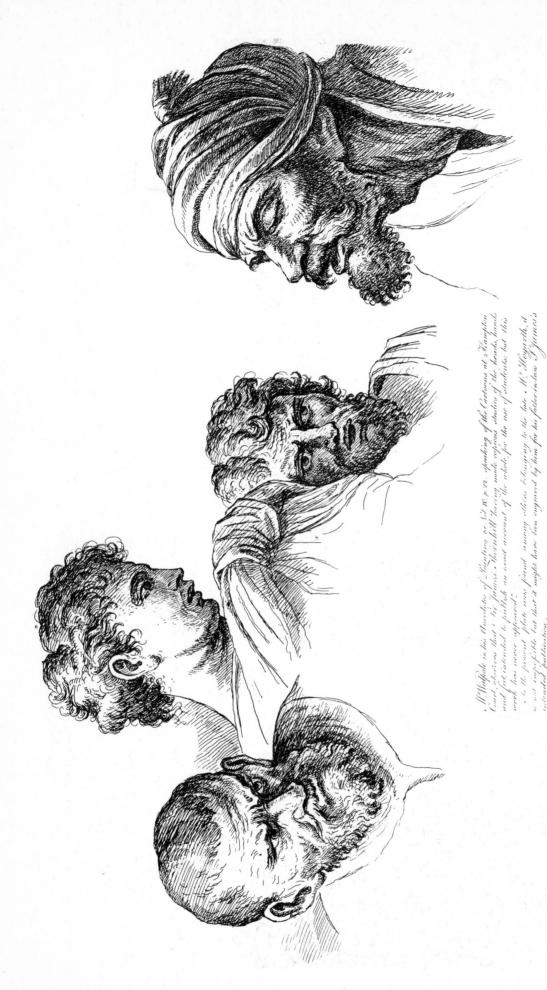

Mr Walpole in his Anecdotes of Painting &c Vol IV. p. 22. speaking of the Cartoons at Hampton Court, observes that: "his famous Thornhill having made copious studies of the heads, hands, and feet intended to publish an exact account of the whole; for the use of students: but this work has never appeared". As the present plate was found among others belonging to the late Mr Hogarth, it is not improbable but that it might have been engraved by him for his father-in-law Thornhill's intended publication.

Published as the Act directs May 14 1781. by Mr Hogarth, at the Golden Head, Leicester Fields.

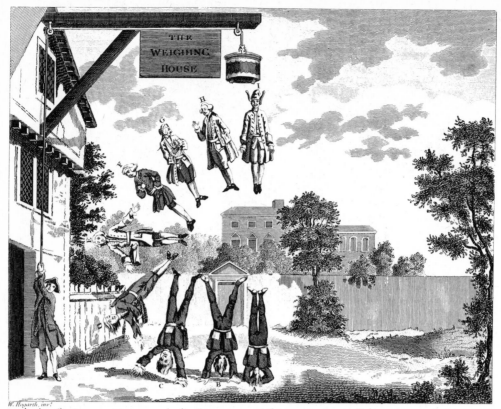

W. Hogarth, inv.

A. absolute Gravity. B. Conatus against absolute Gravity. C. partial Gravity. D. comparative Gravity. E. horizontal, or good sense. F. Wit. G. comparative Levity, or Coxcomb. H. partial Levity, or pert Fool. I. absolute Levity, or Stark Fool.

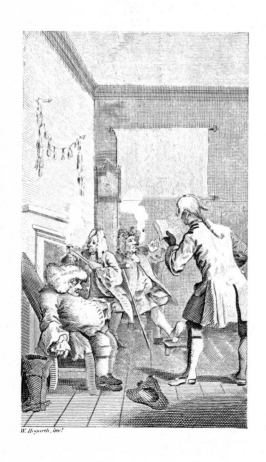

W. Hogarth, inv.

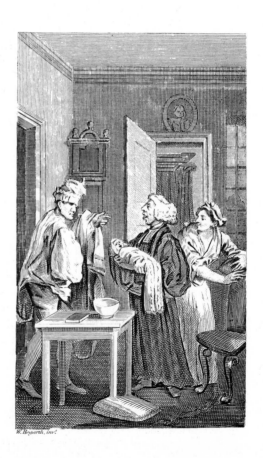

W. Hogarth, inv.

Frontispieces to Tristram Shandy.

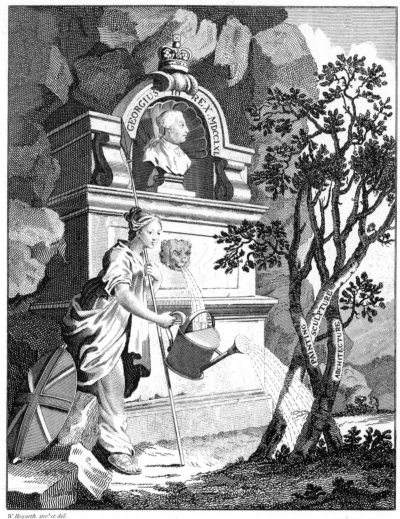

W. Hogarth inv.t et del.

Et spes & ratio Studiorum in Cæsare tantum.

Juv.

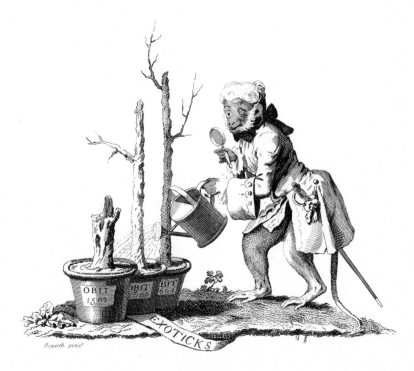

Hogarth. pinx.t

FRONTISPIECE AND TAIL PIECE TO THE ARTISTS' CATALOGUE 1761.

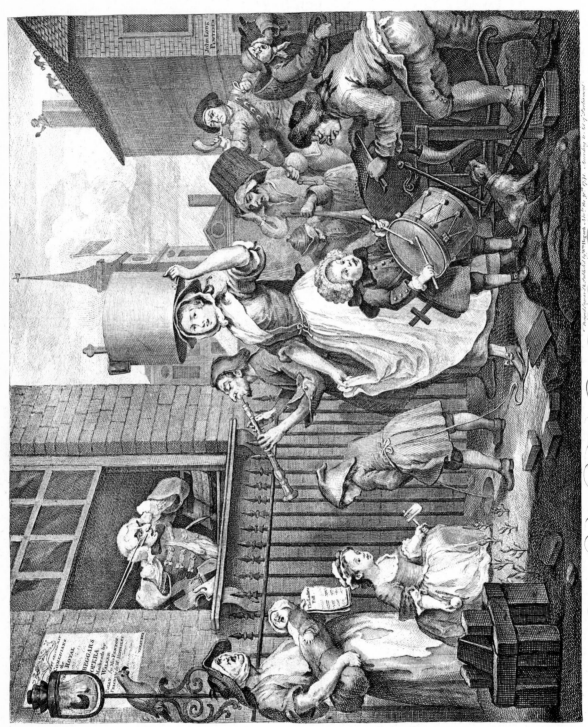

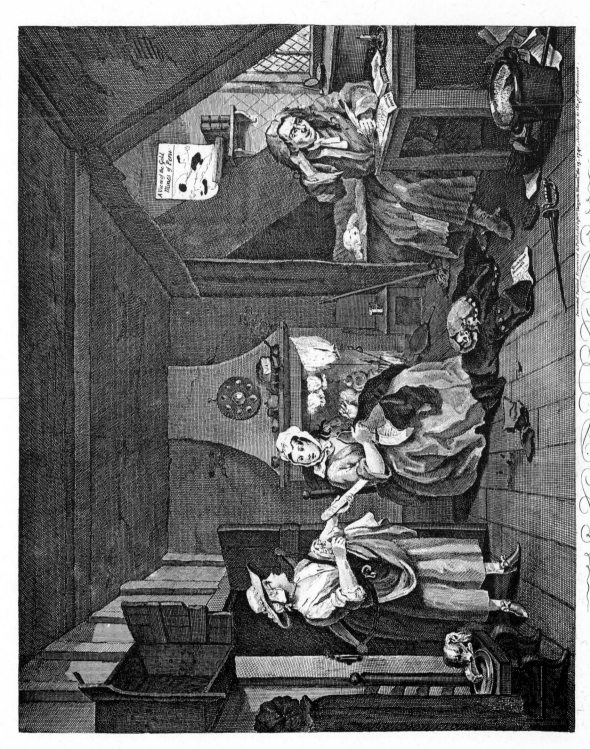

THE DISTREST POET.

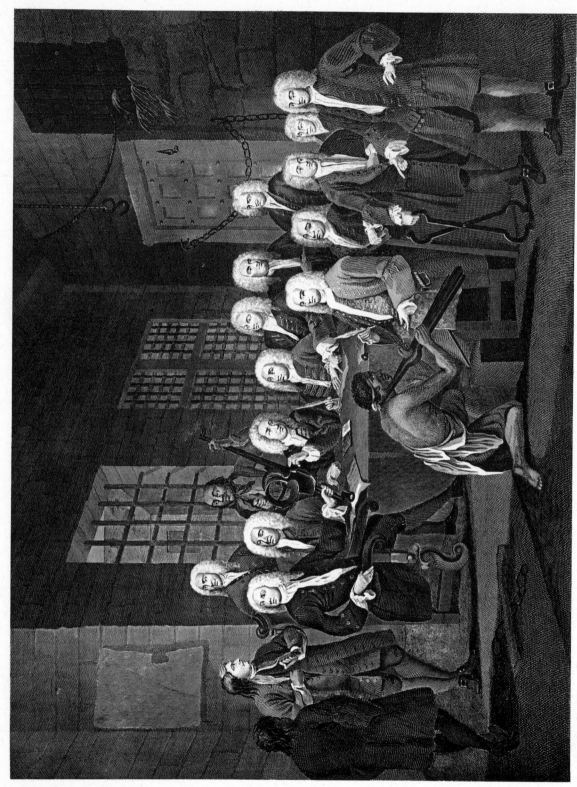

BAMBRIDGE ON TRIAL FOR MURDER BY A COMMITTEE OF THE HOUSE OF COMMONS.

Engraved by J. Cook from an Original Painting by Wm. Hogarth in the Possession of Mr. May.

Published Jan. 1st 1803 by G. & J. Robinson Paternoster Row London.

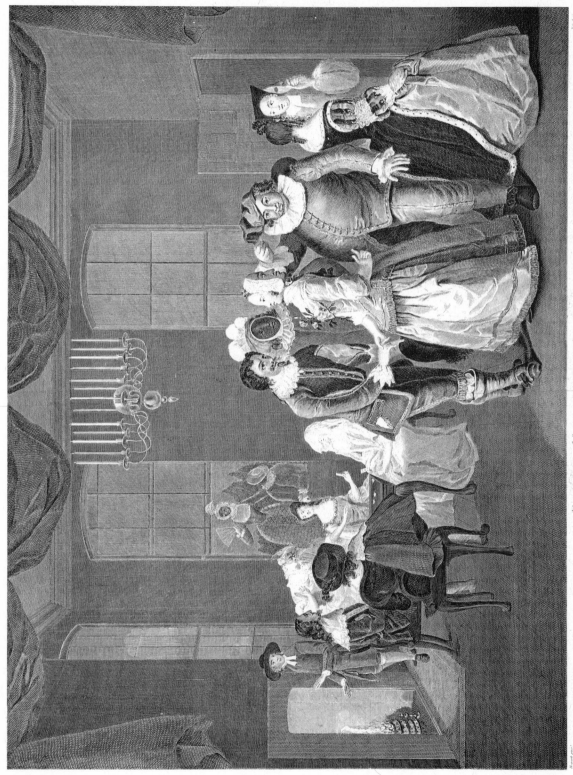

ROYAL MASQUERADE. *Somerset House.*

Engraved by J. Cook from an Original Picture finished by William Hogarth in the collection of Thomas Palmer, Esq.

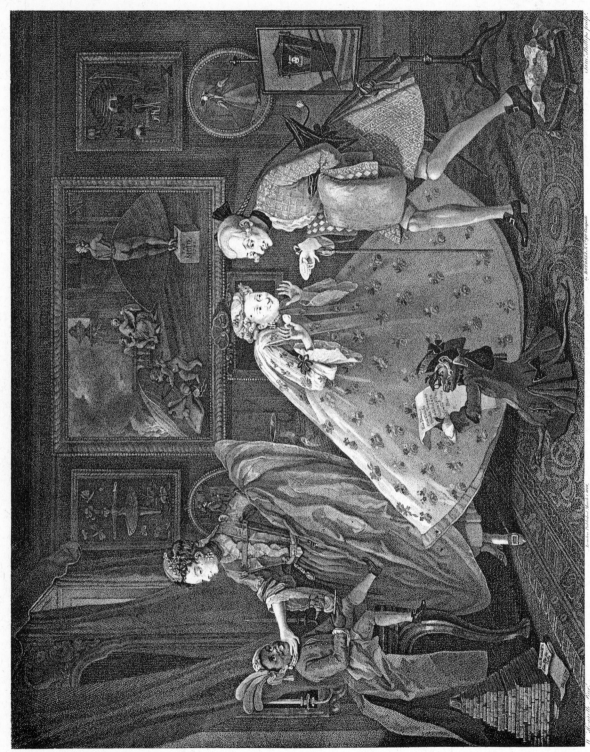

W. Hogarth Pinx.

by BOYDELL & Co 90 Cheapside

T A S T E in HIGH LIFE.

London Published March 1808

From the Original Picture painted by Hogarth in 1742 in the possession of their Right Hon.ble to whom this Plate is humbly Dedicated by her Royal Most Obe.t Serv.t

Engraved by Phillips Sculp.t

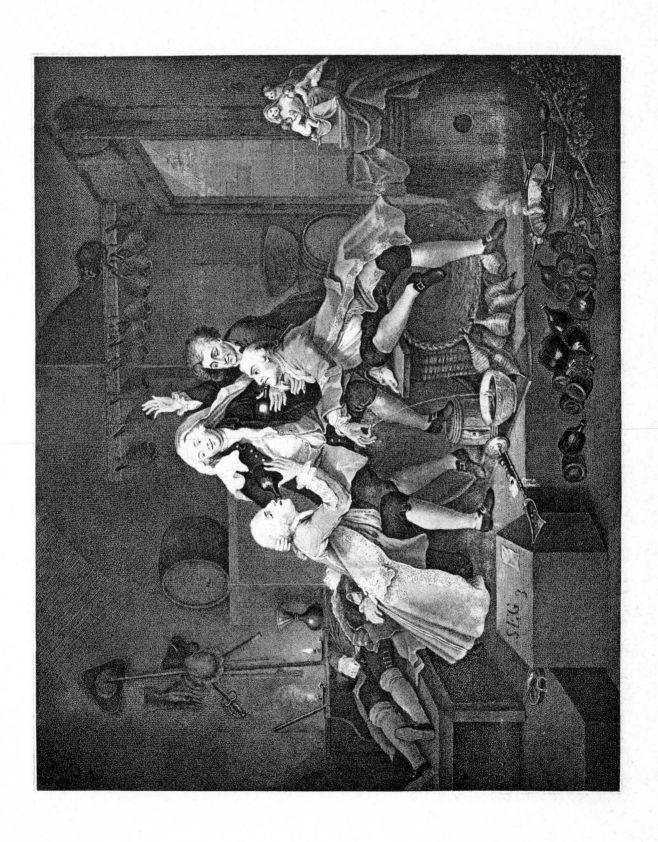

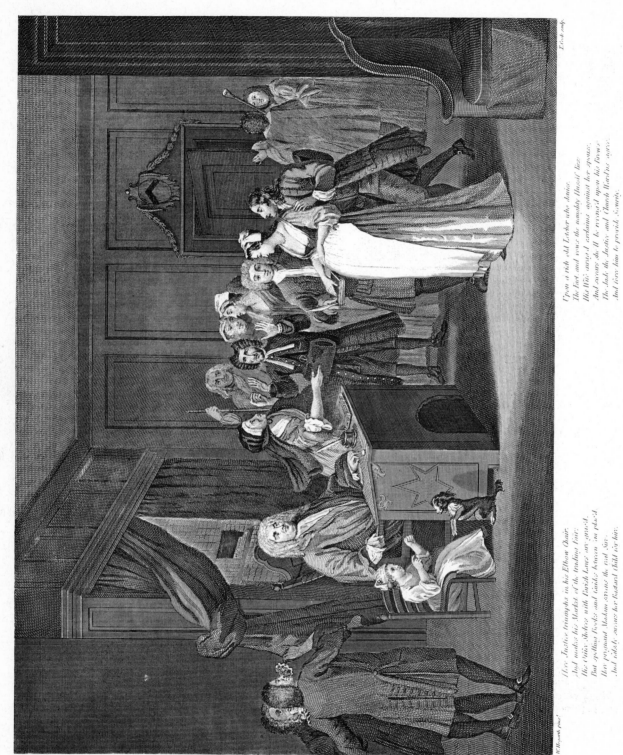

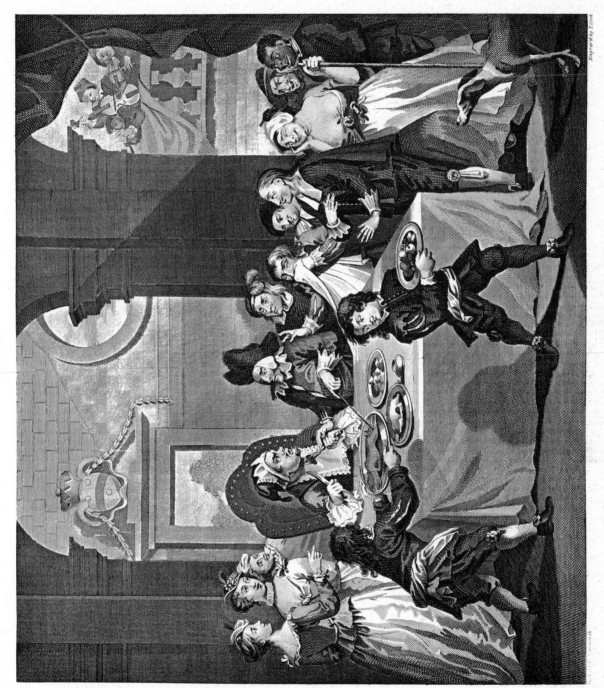

SANCHO AT THE FEAST STARVED BY HIS PHYSICIAN.

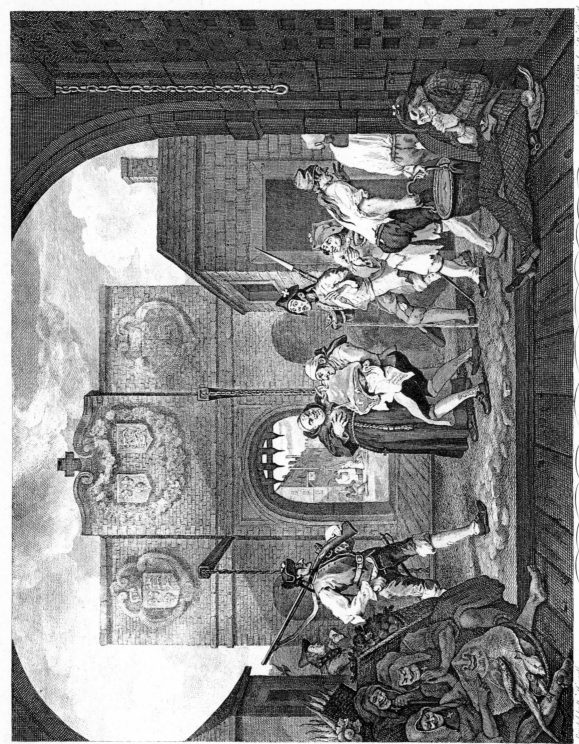

O THE ROAST BEEF OF OLD ENGLAND, &c.

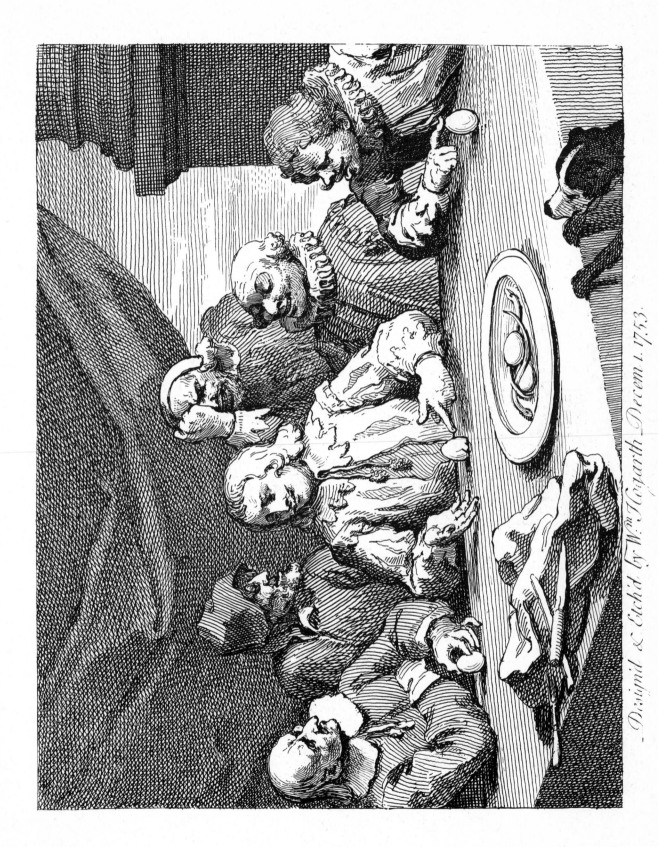

Designed & Etched by Wm Hogarth Decem l. 1753.

149

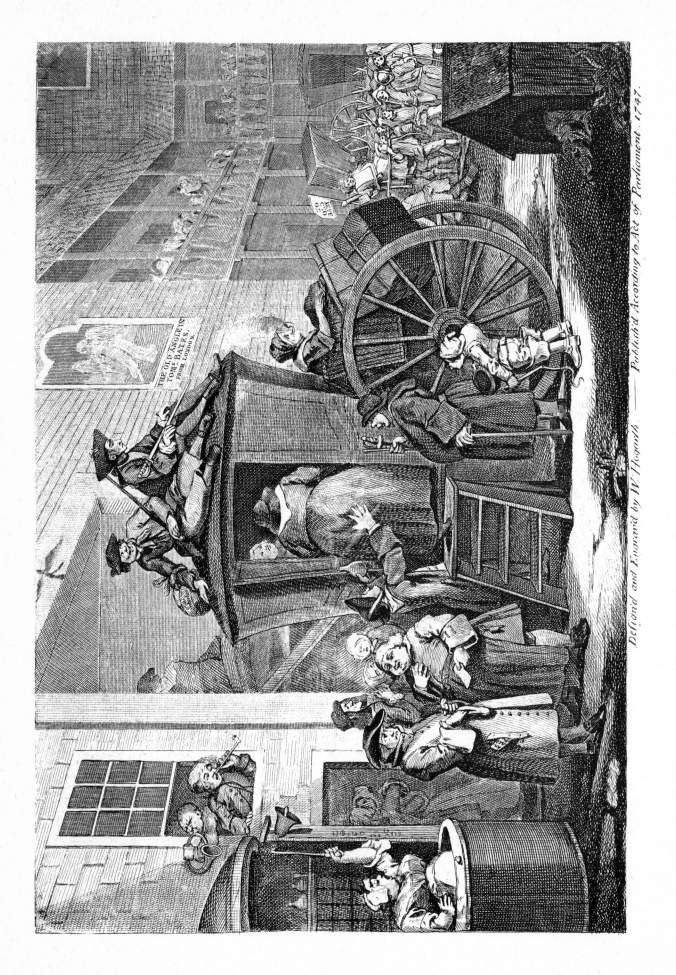

THE OLD ANGEL INN
TOM'S BALES
FROM LONDON.

Defign'd and Engraved by W. Hogarth. — Publish'd According to Act of Parliament. 1747.

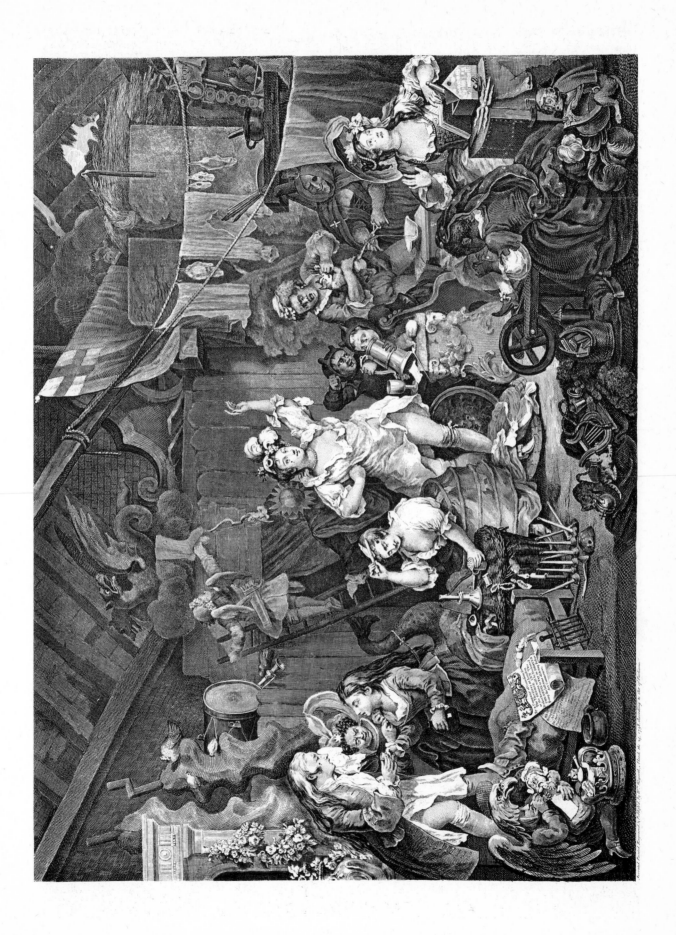

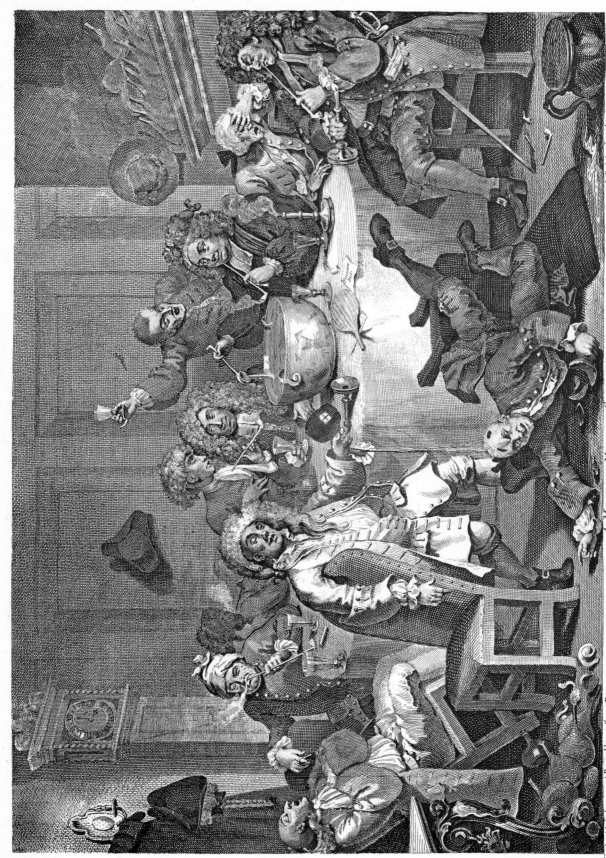

A MIDNIGHT MODERN CONVERSATION

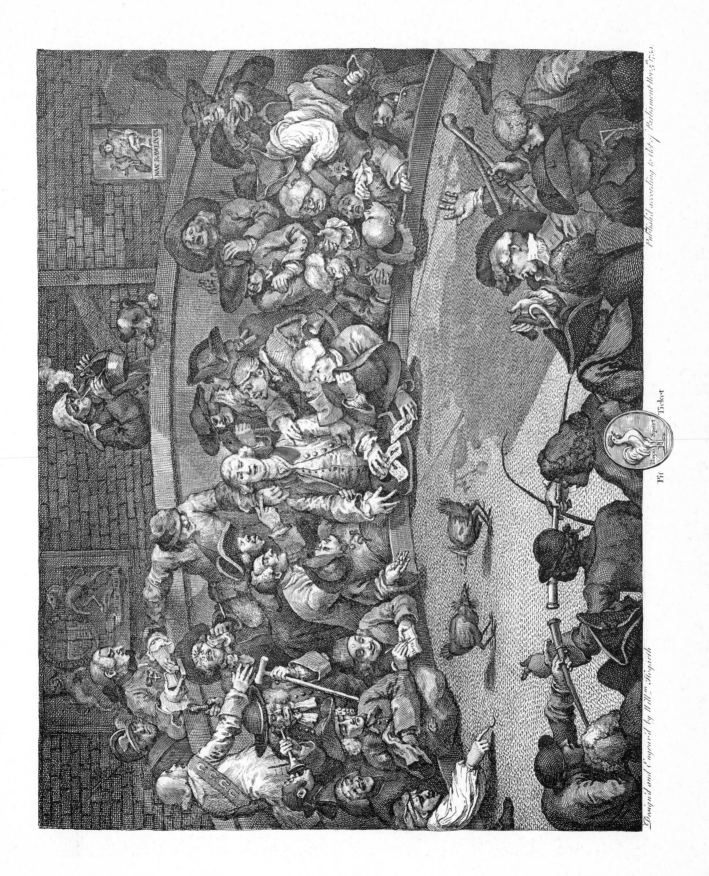

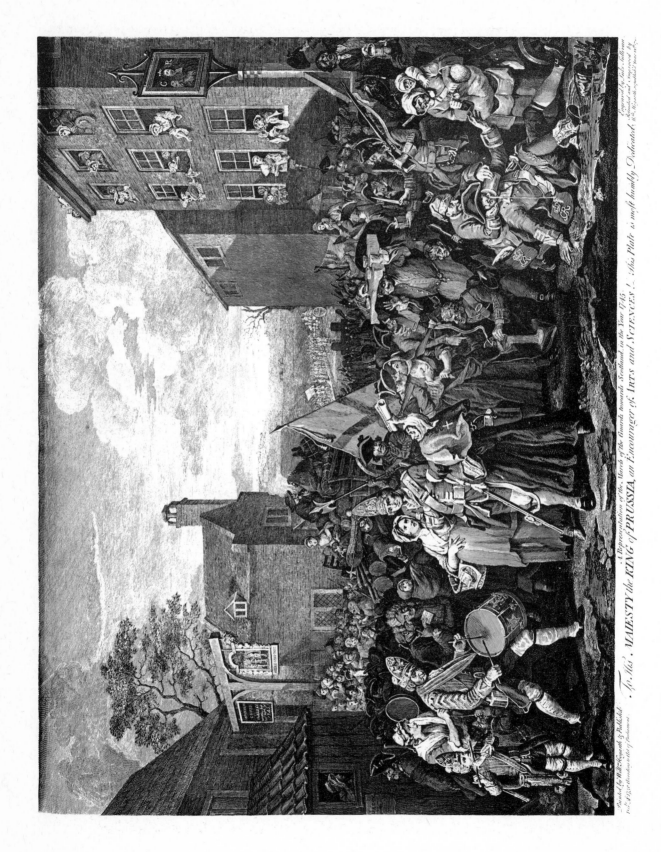

A Representation of the March of the Guards towards Scotland, in the Year 1745.

TO His MAJESTY the KING of PRUSSIA, an Encourager of ARTS and SCIENCES! This Plate is most humbly Dedicated, W^m Hogarth.

Painted by W^m Hogarth & Publish'd as the Act directs June y^e 30 1750 according to Act of Parliament.

Engraved by Luke Sullivan.

154

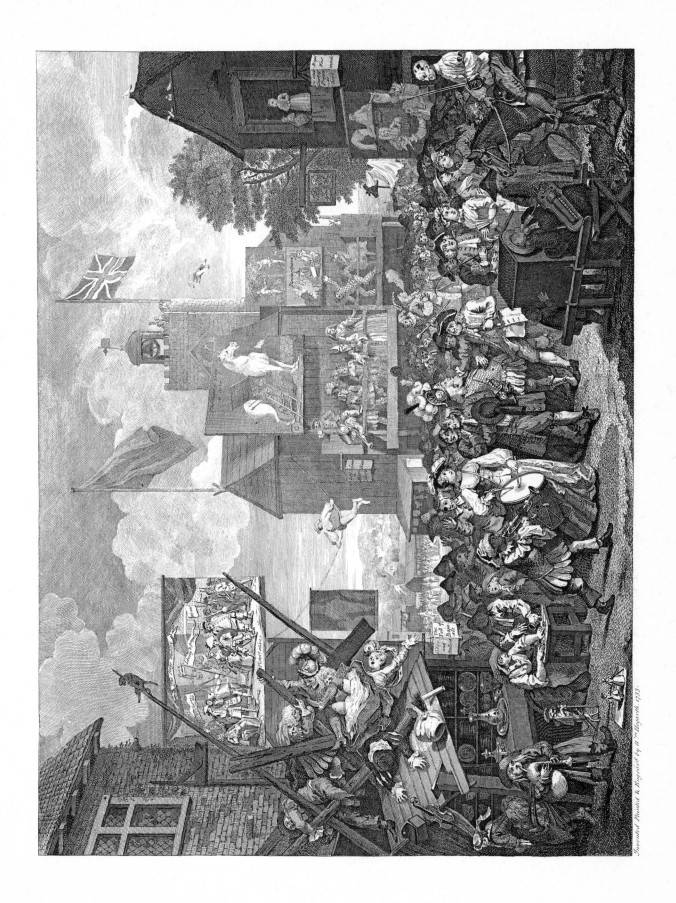

Invented Painted & Engraved by W^m Hogarth. 1733.

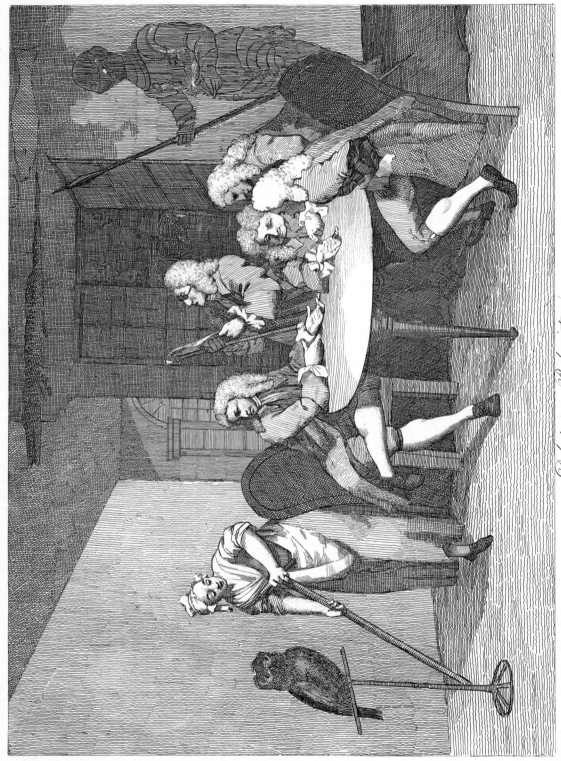

Debates on Palmistry.

From an Original Sketch in Oil by Hogarth, in the Possession of Mr Sam.ᵗ Ireland.

Etch'd by Jonᵉ Hayneˢ Pupil to the late Mʳ Mortemer.

Published as the Act directs Feb.ʸ 1 1792. at N.º 3 Clements Inn

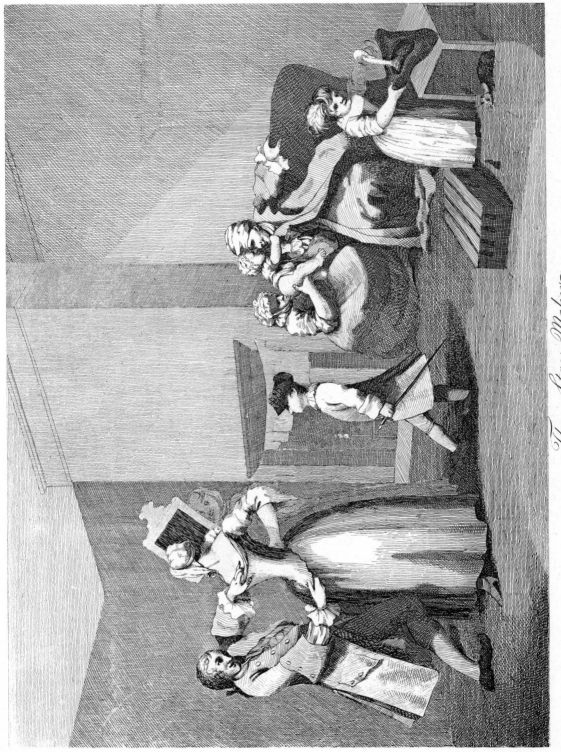

The Stay-Maker

From an Original Sketch in Oil by Hogarth in the Possession of M.ʳ Sam.ˡ Ireland

Etch'd by Jos. Haynes Pupil to the late M.ʳ Mortimer.
Published as the Act directs Feb.ʸ 11.ᵗʰ 1782. at N.º 5 Clement's Inn

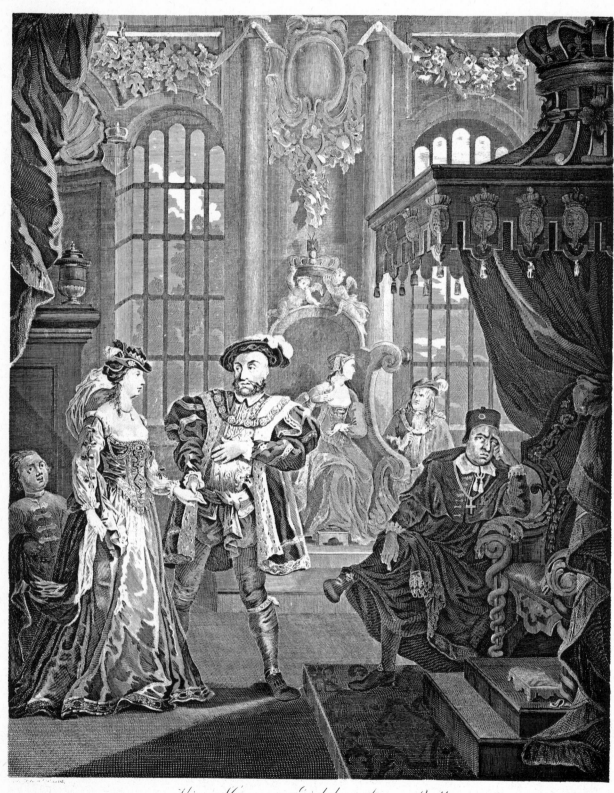

King Henry the Eighth & Anna Bullen.

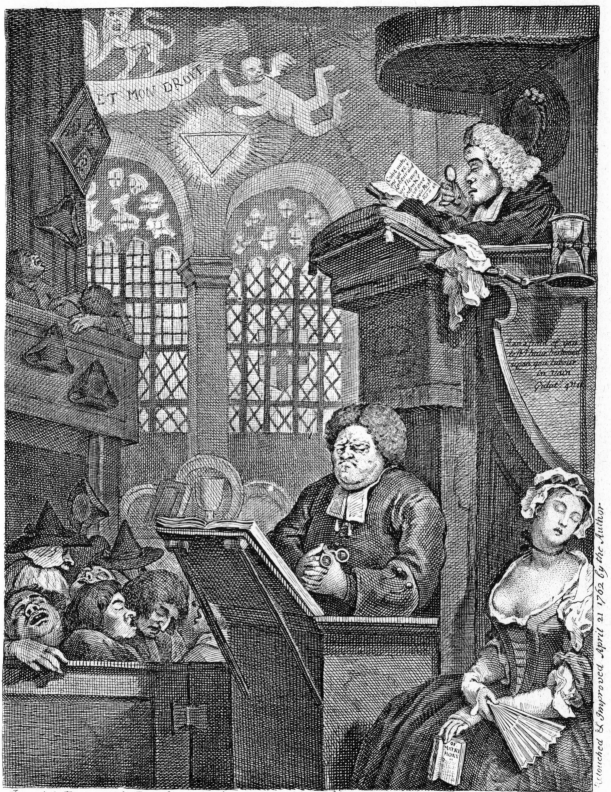

ET MON DROIT

Invented Engraved & Published October 26: 1736 by W^m Hogarth Pursuant to an Act of Parliament.

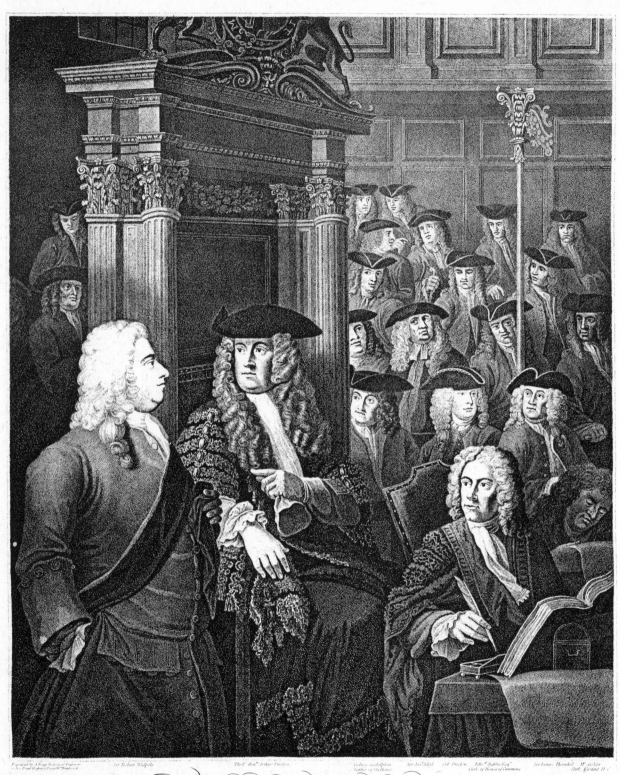

To the Right Honble Earl Onslow.

This Plate representing the HOUSE of COMMONS in Sir Robert Walpole's Administration.

Is with Permission dedicated by His Lordships most obedient humble Servt E. Harding.

From an original Picture painted by Hogarth and Sir James Thornhill in the collection of Earl Onslow.

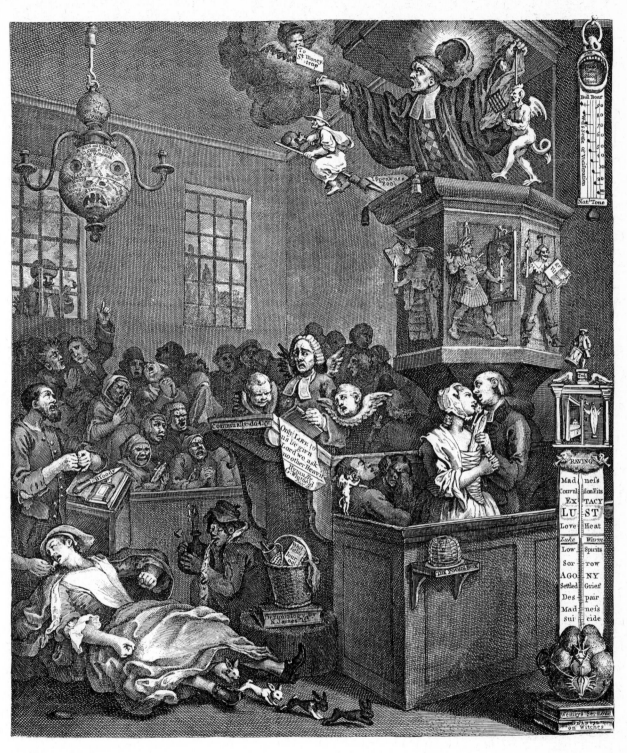

CREDULITY, SUPERSTITION, and FANATICISM.
A MEDLEY.

Believe not every Spirit, but try the Spirits whether they are of God: because many false Prophets are gone out into the World.

1 John. Ch. 4. V. 1.

Design'd and Engrav'd by Wm. Hogarth.

Publish'd as the Act directs March ỹ 15th 1762.

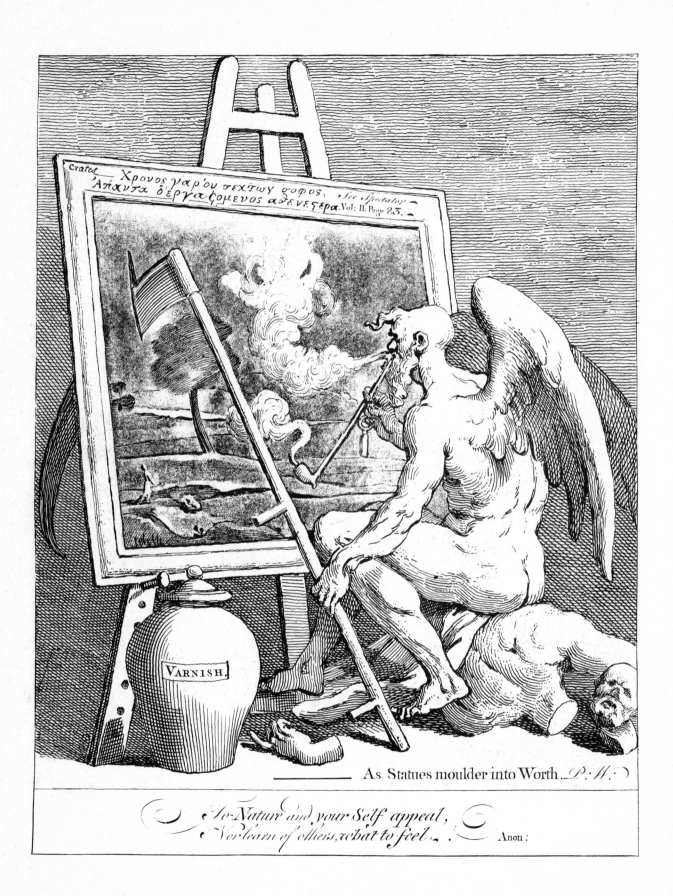

As Statues moulder into Worth. *P. H.*

To Nature and your Self appeal,
Nor learn of others, what to feel. Anon:

W.^m Hogarth delin. James Basire. Sculp.

The Farmer's Return.

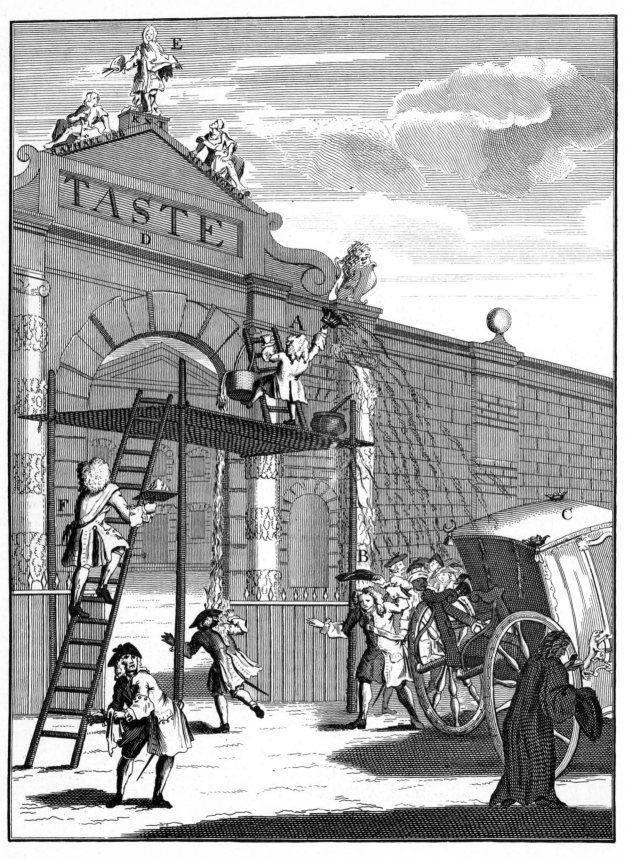

The Man of Taste.

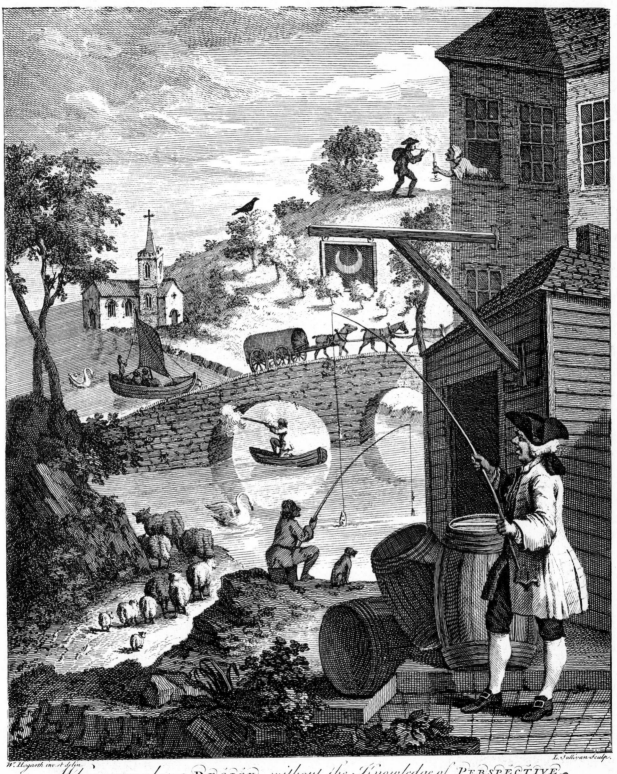

W. Hogarth inv.et delin. L. Sullivan Sculp.

Whoever makes a DESIGN *without the Knowledge of* PERSPECTIVE
will be liable to such Absurdities as are shewn in this Frontispiece.

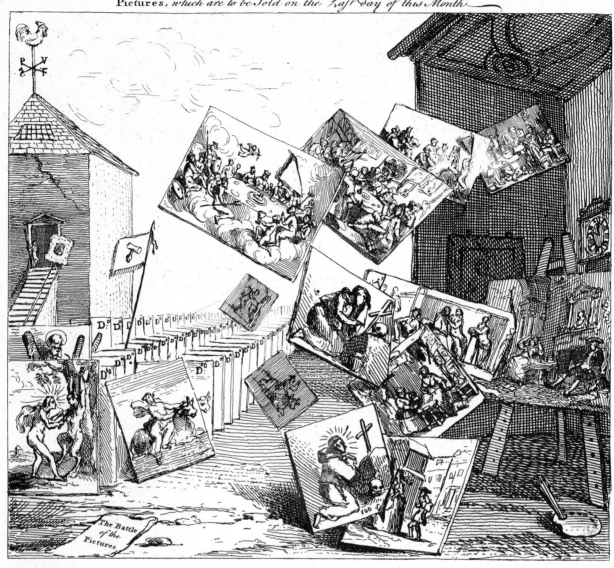

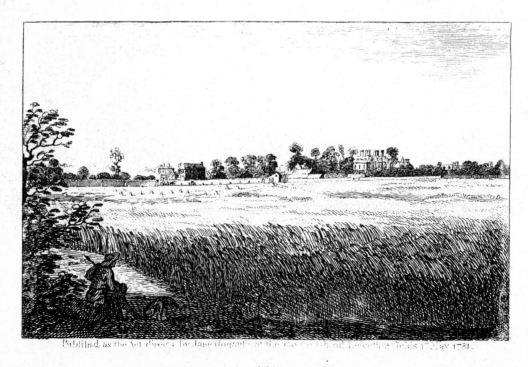

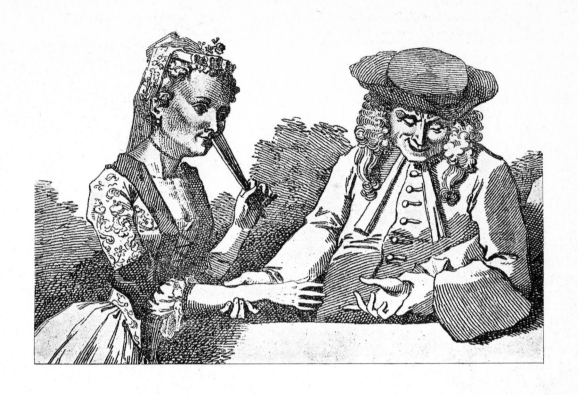

167

Design'd, Etch'd & Publish'd, as the Act directs, by W.^m Hogarth, March 20.th 1754.

In humble & gratefull Acknowledgment
of the Grace & Goodness of the *Legislature,*
Manifested,
In the *Act* of *Parliament* for the Encouragement
of the Arts of Designing Engraving &c;
Obtain'd
by the Endeavours & almost at the Sole Expence
of the designer of this Print in the Year 1735:
By which
not only the Professors of those Arts were rescued
from the Tyranny Frauds & Piracies

of Monopolising Dealers
and Legally entitled to the Fruits of their own Labours,
but Genius & Industry were also prompted
by y.^e most noble & generous Inducements to exert them-
selves, Emulation was Excited,
Ornamental Compositions were better understood,
and every Manufacture where Fancy has any concern
was gradually rais'd to a pitch of perfection before unknown.
Insomuch that those of *Great Britain*
are at present the most Elegant
and the most in Esteem of any in *Europe.*

Rec.^d of 15.^s being the first Payment
for three Prints, representing the Polling for Members of Parliament, Canvassing for Votes, &
Chairing y.^e Members; Which I Promise to deliver when finished, on y.^e Payment of 16.^s & 6.^d more.

N.B. The Price will be rais'd when the Subscription is over.

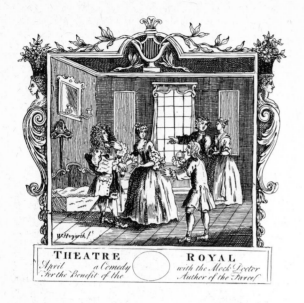

THEATRE · ROYAL
April a Comedy with the Mock Doctor
For the Benefit of the Author of the Farce.

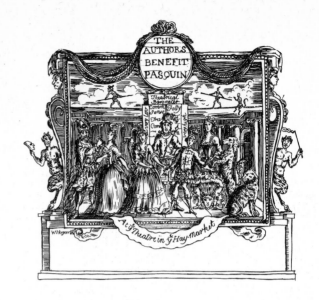

THE
AUTHOR'S
BENEFIT
PASQUIN

At y Theatre in y Hay-Market

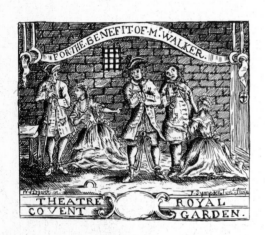

FOR THE BENEFIT OF M. WALKER.

THEATRE · ROYAL
COVENT GARDEN.

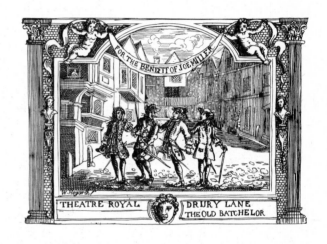

FOR THE BENEFIT OF JOE MILLER

THEATRE ROYAL DRURY LANE
THE OLD BATCHELOR

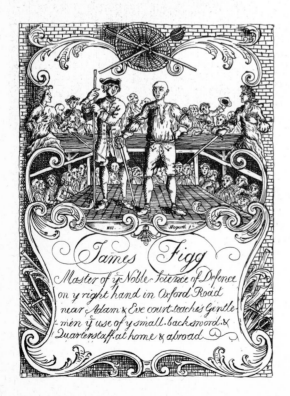

James Figg
Master of y Noble Science of Defence
on y right hand in Oxford Road
near Adam & Eve court, teaches Gentle
-men y use of y small back sword &
Quarterstaff at home & abroad

JOHN SHAW RAM · INN CIRENCESTER

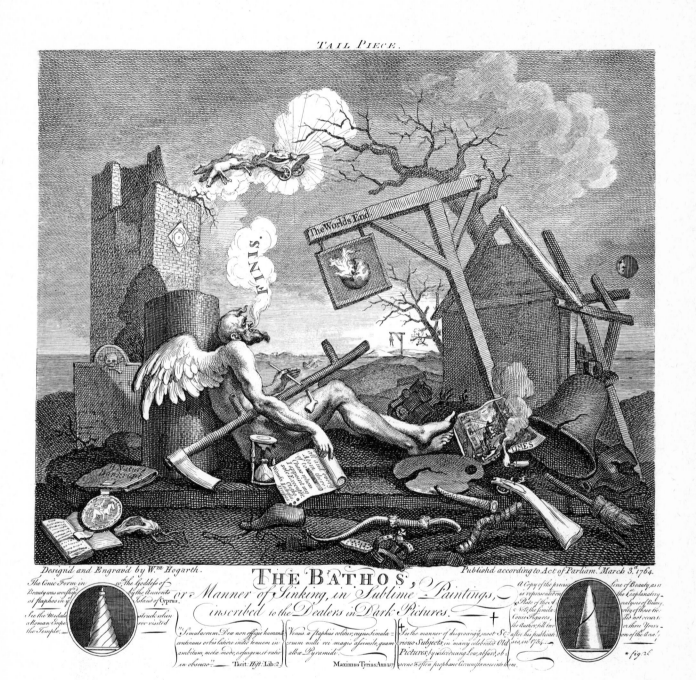

Design'd and Engrav'd by W.m Hogarth.

Publish'd according to Act of Parliam.t March 3.d 1764.

THE BATHOS,
or Manner of Sinking, in Sublime Paintings,
inscribed to the Dealers in Dark Pictures.

INDEX

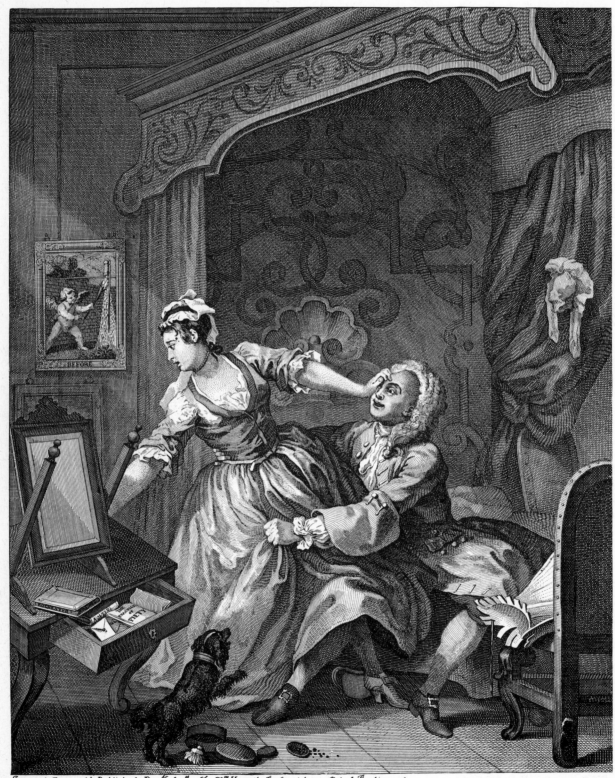

Invented Engraved & Published Dec.^r y.^e 15.th 1736 by W.^m Hogarth Pursuant to an Act of Parliament ..

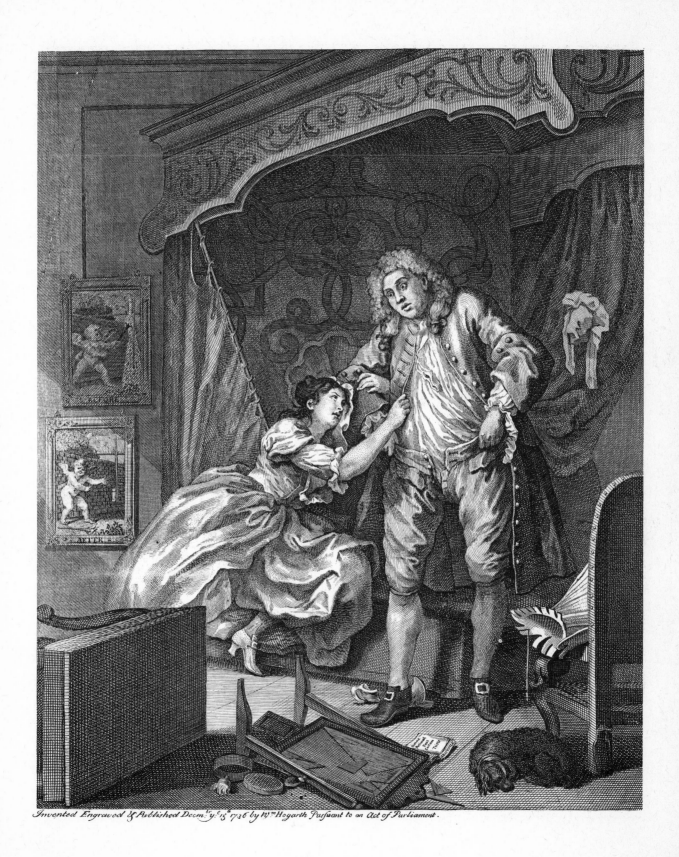

Invented Engraved & Published Decm.ry 15.th 1736 by Wm Hogarth Pursuant to an Act of Parliament.